The Drawings of Poussin

THE DRAWINGS OF

POUSSIN

ANTHONY BLUNT

YALE UNIVERSITY PRESS
NEW HAVEN & LONDON 1979

*Designed by Faith Brabenec Hart
and set in Compugraphic Garamond by
Red Lion Setters, Holborn, London.
Printed in Great Britain by
Westerham Press, Westerham, Kent.*

*Published in Great Britain, Europe
Africa, and Asia (except Japan) by
Yale University Press, Limited, London.
Distributed in Australia and New Zealand
by Book & Film Services, Artarmon, N.S.W.,
Australia; and in Japan by Harper & Row,
Publishers, Tokyo Office.*

Library of Congress Cataloging in Publication Data

Blunt, Anthony, Sir, 1907-
The drawings of Poussin.

Bibliography: p.
Includes index.
1. Poussin, Nicolas, 1594?-1665. I. Title.
NC248.P64B55 741'.092'4 75-43304
ISBN 0-300-01971-8

Preface

This book originated in an attempt to fulfil a commitment under-taken by Walter Friedlaender which he himself was prevented from fulfilling by his death in 1966.

When the first volume of the *Catalogue Raisonné* of Nicolas Poussin's drawings, published by the Warburg Institute, appeared in 1939, Walter Friedlaender wrote in the preface that he would in due course write an introduction in which he would describe the essential characteristics of Poussin's drawings. Unhappily the publication of the later volumes was delayed — partly owing to the war — and at the time of Friedlaender's death the fifth and final volume of the series was still unpublished. In the course of preparing this volume for the press I was led, inevitably, to re-examine the whole corpus of drawings by Poussin and to think about the problems which they presented, and I therefore began to prepare an introduction which I intended to present as a substitute — however inadequate — for what Friedlaender would have written.

Soon however it became apparent that the text was getting out of hand and that what was planned as an introduction was developing into a short book. Further it was clear to me that the text would only be intelligible if it could be accompanied by plates arranged in a sequence which followed the general argument and that the reader would become hopelessly confused if he attempted to follow it to the accompaniment of the plates in the *Catalogue Raisonné*, which are arranged according to the iconography of the drawings.

I therefore consulted Professor Sir Ernst Gombrich, then Director of the Warburg Institute, who generously agreed that I should publish my text separately from the main *Catalogue Raisonné* so that it could have the necessary illustrations appro-priately arranged. It is for this reason that what was originally planned as a short introduction has come to be published in this quite different form.[1]

I must express my gratitude to Miss Elizabeth Hasloch for her care and patience in typing the manuscript.

All of the drawings from the Royal Library, Windsor Castle, are reproduced by gracious permission of Her Majesty Queen Elizabeth II. There are numerous drawings and paintings reproduced from the collections of the Musée du Louvre (Cliché des Musées Nationaux), Paris; Musée Condé, Chantilly; Hermitage Museum, Leningrad; Musée Bonnat, Bayonne; Nationalmuseum, Stockholm; and Galleria degli Uffizi, Florence. Specific acknowledgement is as follows: (191) KdZ 24114, Kupferstichkabinett Staatliche Museen Preußischer Kulturbesitz, Berlin (West); (95-6) courtesy of the Fogg Art Museum, Harvard University, Cambridge, Massachusetts (95 — Gift of Mr. and Mrs. Donald S. Stralem, 96 — Gift of Mrs. Samuel Sachs, in memory of Mr. Samuel Sachs); (54, 70) Devonshire Collection Chatsworth. Reproduced by permission of the Trustees of the Chatsworth Settlement; (116-17) Nelson Gallery – Atkins Museum, Kansas City, Missouri (Nelson Fund); (26, 102, 105, 112) by courtesy of the Trustees of the British Museum, London; (113, 141) reproduced by courtesy of the Trustees, The National Gallery, London; (29) reproduced with permission of the National Gallery of Victoria, Melbourne (Felton Bequest 1948); (55) Fondation Custodia (coll. F. Lugt), Institut Néerlandais, Paris; (190) courtesy of the Pennsylvania Academy of the Fine Arts, Philadelphia; (81) National Gallery of Art, Washington, D.C. (Samuel H. Kress Collection, 1128). Drawings or paintings are also reproduced from the collections of the Musée municipal du Mont-de-Piété, Bergues; Fitzwilliam Museum, Cambridge; Musée des Beaux-Arts, Dijon; Staatliche Kunstsammlungen Dresden — Gemäldegalerie Alte Meister; Kunstmuseum der Stadt, Dusseldorf; Kunsthalle, Hamburg; Museum der bildenden Künst, Leipzig; Museum, Lidlochovice; Musée des Beaux-Arts, Lille; Biblioteca Ambrosiana, Milan; Institute of Fine Arts, Minneapolis; Musée Fabre, Montpellier; Alte Pinakothek, Munich; Staatliche Graphische Sammlung, Munich; Pierpont Morgan Library, New York; Ecole des Beaux-Arts, Paris; Pinacoteca Vaticana, Rome; Musée des Beaux-Arts, Rouen; and Biblioteca Reale, Turin. I am also grateful to the owners of drawings in private collections who have kindly given me their permission to reproduce them.

Contents

List of Plates

CHAPTER I

Introduction

Poussin's achievement as a draughtsman has been so much overshadowed by his work as a painter that although his drawings were already sought after by collectors in his own lifetime remarkably little has been written about them. Bellori in his life of Poussin, published in 1672, praises Poussin as a master of *disegno*, but in saying this he was referring to the draughtsmanship shown in the paintings, rather than to the drawings themselves. He refers to the fact that Poussin drew from the nude model, but of his original drawings he only says that they 'were not exactly worked out with their settings, but were composed rather of simple outlines and simple tones in wash, which however vividly rendered all the actions and expressions'.[1]

This idea that Poussin's drawings were executed quickly and simply as aids to working out his compositions was stated more elaborately by Jean-Pierre Mariette in what was the first real appreciation of Poussin as a draughtsman, written as a note in his catalogue of the collection of drawings owned by Pierre Crozat, printed in 1741. This analysis shows such insight into the qualities of Poussin's drawings and of his intentions as an artist that, in spite of its length, it is worth quoting in full.

There are very few finished drawings by Poussin. When he was drawing his only aim was to get his ideas down on paper, and they came out in such abundance that a single theme would stimulate in his mind an incredible number of different sketches. With a simple line, sometimes with the addition of a few brush strokes of wash, he was able to express clearly what his imagination had conceived. At this stage he was not concerned with correctness of drawing or with the truth of the expressions or with effects of chiaroscuro. It was when he was working on the canvas itself, brush in hand, that he attended to these matters. He was of the opinion that any other method merely held back his genius and slowed up his work. This argument was valid for small pictures, and Poussin painted very few big ones; but if we do not find drawings from the nude

1

by him, or detailed studies of heads or other parts of the body, this does not mean that he scorned the study of nature. Indeed no artist referred to it more frequently, and he cannot be accused of ever having worked from memory. This is why he followed for his landscapes a method different from the one which he adopted for figure painting. The absolute need to study the scene on the spot led him to make a large number of very careful landscape drawings from nature. Not only did he on these occasions observe the forms with reverent care, but he also paid special attention to unusual effects of light, which he then incorporated into his paintings with great success. On the basis of these studies he composed in his studio those noble landscapes which make the spectator feel that he has been transported to ancient Greece, to those enchanted valleys described by the poets. For Poussin's genius was in the highest degree poetical. The simplest and most arid subjects came alive in his hands. In the last days of his life, though hindered by a shaky and no longer nimble hand, his imagination was still lively and he put forth magnificent conceptions, which arouse deep admiration, while at the same time they cause a certain sadness by the clumsiness of their execution.[2]

Gault de Saint-Germain, whose widely read biography of Poussin was published in 1806, precisely reverses Mariette's estimate of Poussin's drawings and turns the artist into the ideal neoclassical master, assured, confident and never hesitating:

1. Toussaint Dubreuil. *Scene from Mythology or Romance.* Paris, Musée du Louvre. Drawing.

One of the characteristics of this great man's mind is that one can rarely follow in his drawings and sketches the development of his ideas. They do not show marks of unsteadiness, or those hesitations typical of a genius who tries out ideas, feels his way, or brings his ideas to maturity by means of his artistic skill. This proves that his imagination was never misled by chance ideas. He was a deep thinker, and his pencil expressed nothing but ideas already enriched with all the flowers of rhetoric, great and noble actions, suitable to his themes, and always in accordance with nature.[3]

Gault de Saint-Germain evidently did not study the drawings by Poussin in the Musée Impérial as closely as Mariette looked at the much smaller group available to him in the Crozat collection!

2

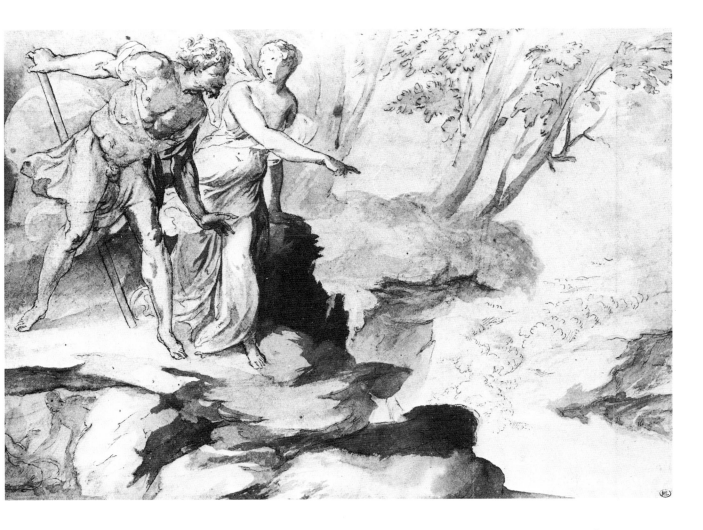

In the early nineteenth century, partly no doubt owing to the growing interest in the study of Old Master drawings in general, Poussin's drawings received greater attention and a number of them appear reproduced with extraordinary fidelity in the newly invented technique of aquatint in volumes such as William Ottley's *Italian School of Design* (London, 1823) and John Chamberlaine's *Original Designs of the Most Celebrated Masters of the Bolognese, Roman, Florentine and Venetian Schools* (London, 1812), in both of which Poussin appears as a member of the Roman school.[4]

This was however a flash in the pan. By the middle of the nineteenth century interest in Poussin had waned and even France saw nothing of importance written about him for several

decades. The few monographs published in this period contain the old commonplaces about the draughtsmanship in the paintings, but usually nothing at all about the drawings themselves. Generally speaking the only writers to mention them were the compilers of catalogues.

In 1869 J.C. Robinson catalogued the few drawings by the artist bequeathed by Malcolm to the British Museum, and in 1882 Both de Tauzia did the same for the much more important group left to the Louvre by His de la Salle. Seven years later in 1888 he made a summary list of all the drawings on exhibition in the museum. In 1863-5 the Royal Librarian, Bernard Woodward, produced the first substantial article on Poussin's drawings when he published a detailed notice, with dimensions and descriptions of the drawings brought together, mainly in Poussin's lifetime, by Cardinal Camillo Massimi and now in the Royal Library at Windsor Castle.[5]

In the early years of the twentieth century interest in Poussin revived and was signalised by the publication in 1914 of three monographs on the artist by Emile Magne, Otto Grautoff and Walter Friedlaender.[6] Each author referred to and reproduced drawings by the artist, but Friedlaender was the only one to discuss them in any detail both as works of art in their own right and as an essential factor in the understanding of Poussin's art as a whole. This interest continued to be of great importance for Friedlaender and for the next twenty-five years he continued to search for drawings by Poussin in the public and private collections of Europe (at that date few American collectors were interested in drawings and the only ones by Poussin in the United States were the four in the Pierpont Morgan Library). Eventually Friedlaender was persuaded by Fritz Saxl to transform his projected book on Poussin as a draughtsman into a complete catalogue of the drawings. This led to the publication of *The Drawings of Nicolas Poussin: A Catalogue Raisonné*, completed, with the assistance of the present writer and other scholars, in five volumes, which appeared between 1939 and 1974.[7]

2. Hendrik Goltzius. *Apollo and Midas.* Engraving.

Meanwhile a few volumes of plates illustrating Poussin's drawings had appeared, but no attempt was made in them to consider the traditional attributions to Poussin critically.[8] During the same years a few articles appeared, mostly on individual drawings and groups of drawings. After the Second World War the output of such articles increased greatly as interest in Poussin in general gathered momentum.[9]

In spite of this production however the study of Poussin's drawings lagged far behind that of his paintings. This is curious, because not only are the drawings of extraordinary beauty in themselves but they throw light on many important aspects of his methods of work and thought which cannot be studied in the paintings alone, such as his method of preparing a composition, his attitude towards antiquity and the problem of his 'studio'.

* * *

Since Poussin's drawings are so intimately linked with his production as a whole and with his development as a painter, it will be necessary to give a short account of his career and the evolution of his style before discussing the drawings themselves.

Nicolas Poussin was born at Les Andelys in Normandy in

5

1594,'and, after a schooling in his native town which was probably somewhat elementary but which included a grounding in Latin, went to Paris in 1612 with the intention of becoming an artist. He arrived in the capital at a moment when painting was at a low ebb and when the only models to be found among the living or recently dead were the painters of the Second School of Fontainebleau — Toussaint Dubreuil, Ambroise Dubois and Martin Fréminet — and the Flemings established in the Faubourg Saint-Germain, of whom the most important were Frans Pourbus the Younger and Hieronymus Franck the Elder. From their paintings Poussin picked up a form of late Mannerism which is traceable in his very early compositions, but he was also deeply affected by their drawings and engravings illustrating poetical or mythological subjects (Plates 1-2) which were to influence his own earliest drawings, those illustrating Ovidian themes made in 1623 for the Italian poet Giovanni Battista Marino whom he met in Paris and who was the first patron to recognize his talent (Plates 4-6). We have hardly any knowledge of his earliest paintings, but it is likely that they were influenced by the Flemish works which he saw in Paris, since he later recorded his admiration for Pourbus's *Last Supper*, now in the Louvre, and markedly Flemish features, both in technique and in figure types, are evident in the only surviving work connected with a painting of the Paris period, namely the watercolour *bozzetto* for the *Death of the Virgin*[10] (Plate 8).

3. Copy after Polidoro da Caravaggio. *Perseus and Phineus.* Paris, Musée du Louvre. Drawing.

Poussin himself later told his friends that during his years in Paris he had learnt more from the study of engravings after Raphael and his followers than from any artists living there at the time, and, although this statement was probably tinged by the artist's later admiration for Raphael and disapproval of Mannerism and Northern painting, it is undeniable that he was influenced from a very early stage of his career by the great masters of the Roman High Renaissance, and some of the drawings of battle scenes made for Marino show the influence of Polidoro da Caravaggio (Plate 3), if not of Raphael himself.

When he had finished what training he was able to get in Paris he spent some years wandering about France, picking up jobs where he could, and in 1624, after two abortive attempts, achieved his great ambition and reached Rome, where he was to spend the remainder of his life, except for a short visit to Paris in 1640-2.

His first six years in Rome were a time of struggle, hesitation and to some extent failure. A few months after he reached Rome his one contact with Italian patrons, Marino, moved to Naples where he died the next year. He had however given Poussin an introduction to Cardinal Francesco Barberini, the powerful nephew of the newly elected pope, Urban VIII, and it was from him that the artist received his earliest important commission in Rome to paint the *Capture of Jerusalem*, now lost. This was followed in 1628 by the much more important invitation to paint an altarpiece for St. Peter's, but Poussin's composition, the *Martyrdom of St. Erasmus* (Plate 18), received only qualified approval, and the artist seems to have realized that he was not going to succeed in the field of large scale religious art. Instead he developed the other type of painting which he had been practising since his arrival in Rome, that is to say relatively small canvases representing mythological or religious subjects. In these his main inspiration was Titian, whose *Bacchanals*, then in the Villa Ludovisi, he studied and copied.

The event in these early years which was to have the most far-reaching effect on his development was his meeting with Francesco Barberini's secretary, Cassiano dal Pozzo, who was the centre of a learned circle devoted to the arts and to the study of antiquity. Pozzo gave Poussin many commissions in his early years and no doubt introduced him to other patrons, but he exerted an even more important influence on the artist by initiating him into an atmosphere of learned antiquarianism that deepened Poussin's interest in the culture of the ancients which had already been aroused by the works of ancient art that he saw around him in Rome. He later said that he was a scholar of Pozzo's museum, which included a number of ancient marbles but consisted above all of a huge collection of drawings after every kind of ancient object, which he was in the process of forming when Poussin arrived in Rome. An examination of Poussin's works confirms that he studied the drawings with passionate interest, storing his memory with images gathered from them and making copies of many of the drawings themselves.[11]

During the 1630s Poussin's admiration for Titian continued and he produced his most splendid paintings in his 'Venetian' style, but after about 1633 he began also to look for inspiration to the works of Raphael and his school which he had known through engravings while still in Paris but which he could now study in the original. His admiration was also aroused by the artists who represented the Raphaelesque approach to painting in his own century, Annibale Carracci and Domenichino, in whose studio he drew from the life. Under the influences of these artists the composition of his paintings became more considered, the construction of space more lucid, and the expression of the subject more dramatic. At the same time the glowing warmth of the early paintings became gradually modified by the use of cooler tones and more controlled handling.

This change in style was in part the expression of a new tone of seriousness in Poussin's works. Even the mythological paintings of the mid-thirties, in particular the *Bacchanals* commissioned by Cardinal Richelieu in 1635-6, are much more deliberately designed than the earlier paintings, and a completely new mood appears in the series of the *Seven Sacraments* painted for Cassiano dal Pozzo in the second half of the decade, in which for the first time Poussin executed one of those 'meditations' on a religious

4. Poussin. *The Birth of Adonis.* Windsor Castle, Royal Library. Pen and brown ink with grey wash. 183 x 325mm. (C.R. 154).
Plates 4 to 6 are from the series of drawings made by Poussin in Paris in 1623 for the poet Marino. They show that though his style of draughtsmanship was vigorous at this age — he was twenty-nine — he had not attained the accomplishment which would have been normal in a good student of twenty to twenty-five in a Roman studio.

8

theme which were to be among his major preoccupations in his later years and which were to win the greatest favour with his French patrons.

In the late 1630s landscape began to play a more important part in Poussin's paintings. At first this was manifested in the greater prominence which he gave to nature in the backgrounds of his figure compositions, but gradually landscape took over and by the early 1640s he was producing paintings in which the figures play a quite subordinate part. At the same time we find among his drawings a number of fresh and brilliant sketches in which he recorded his impressions of the countryside in the Campagna around Rome.

In 1640, after more than a year of resistance, Poussin was forced to leave Rome for Paris to work for Louis XIII and Cardinal Richelieu. In Paris he was commissioned to paint large altarpieces for the King, ceiling paintings and over-mantels for the Cardinal, and, worst of all, to direct the decoration of the Long Gallery

which linked the Louvre to the Tuileries, a room more than four hundred metres long and less than eight metres wide. Obviously he could not cope with such work unaided and he was compelled for the first and only time in his life to break with his natural habit of executing his works entirely with his own hand, and to use assistants organised into something like a studio. It was no wonder that he was unhappy and that he escaped to Rome at the first opportunity.

Once back in Rome, which he reached in the last days of 1642, he returned to his normal habits of work and to his old manner of life which was one of great simplicity and seclusion, removed from the bustling and highly competitive artistic life which surrounded the papal court and the great princes of the church. He cut himself off more and more from this world and devoted himself exclusively to his art, which became increasingly personal. Even in the 1630s he had been something of an excep-

5. Poussin. *Polyphemus, Acis and Galatea.* Windsor Castle, Royal Library. Pen and grey-brown wash. 186 x 325 mm. (C.R. 160).

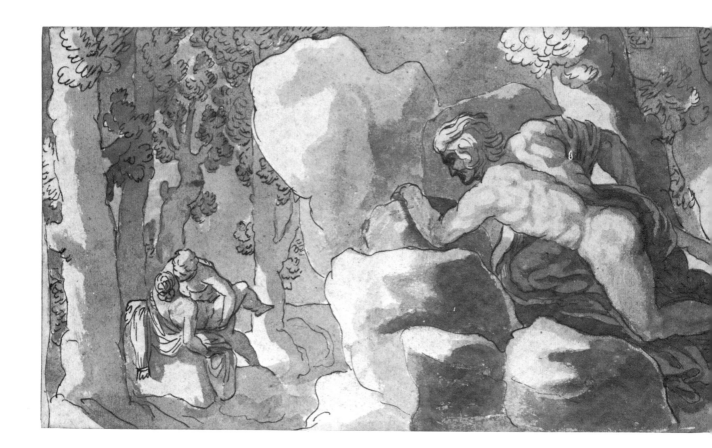

tion in Rome in rejecting the methods of Baroque artists and in concentrating on his own ideas and visions, but now this tendency became even more marked. His art became more austere both in choice of subject and in method of execution. He abandoned the poetic Ovidian themes which had been his main preoccupation in his earlier years and turned instead for his subjects to the Stoic historians — principally Plutarch — and the central and theologically most significant parts of the Bible. These subjects he rendered with a simplicity and an economy appropriate to his themes, sometimes setting his figure groups in landscapes of a grandeur and monumentality which reflected the dignity of the stories which he was relating. These paintings, particularly the second series of the *Seven Sacraments*, executed between 1644 and 1648, were regarded as his masterpieces by his contemporaries, particularly his friends and patrons in Paris, and by the immediately succeeding generation of art-lovers.

6. Poussin. *The Death of Chione.* Windsor Castle, Royal Library. Pen and grey-brown wash. 187 x 317 mm. (C.R. 156).

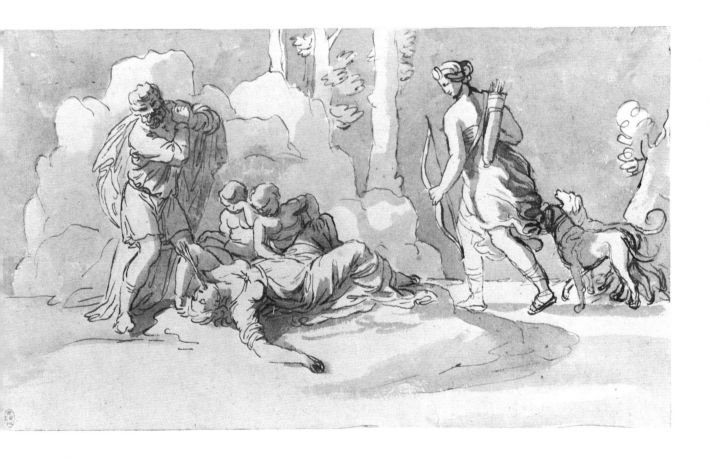

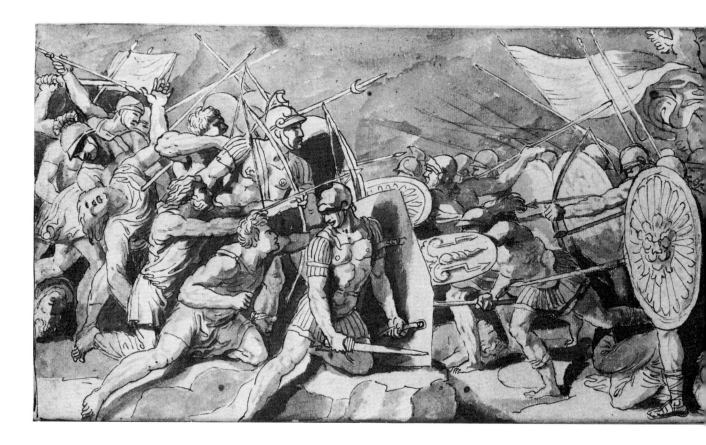

In the last fifteen years of his career Poussin's isolation from
artistic life in Rome became even more complete. He continued
to correspond with his Parisian friends, particularly with Paul
Fréart de Chantelou, who had been his constant adviser during
his visit to Paris, but in Rome he saw hardly anyone. He lived in
a small house in the Via Paolina, now the via del Babuino, with
his wife, one of her brothers who acted as his secretary, and a
single servant. He consorted with a few artists, such as Claude
Lorraine who remained one of his close friends till the end of his
life, and he admitted to his studio a very few enthusiasts for his
art. The most important and the most intelligent of these was
Cardinal Camillo Massimi, who was the first patron to collect
Poussin's drawings. In 1664 Poussin gave Massimi the painting
of *Apollo and Daphne*, now in the Louvre, which he realized he
was too ill to finish, and the Cardinal was one of the few people to
visit him during his last illness in 1665.

In this last period of his life Poussin's art underwent yet

another change. Landscape continued to play an important part but it took on a new grandeur, revealing the overwhelming power of nature which became for Poussin an almost obsessive idea. This power is also represented through symbolism based on Poussin's early love, Ovid, whose stories are now treated as allegories for the fertility of nature and for her cyclical processes. The great masterpieces in this vein are the *Birth of Bacchus* of 1657, now in the Fogg Museum, and the *Four Seasons* and the *Apollo and Daphne* in the Louvre, which embody an almost pantheistic philosophy, compounded of Christian and pagan elements. The same spirit is reflected in the drawings made for these paintings, in which we can see Poussin struggling to attain complete expression of his ideas in spite of his ill-health and shaky hand.

He died in Rome in 1665, greatly revered but little imitated. Collectors — particularly in France — were queuing up on the doorstep to obtain his works, but nothing would make him deviate from his set way of working slowly — increasingly so with age — and executing every stroke with his own hand. This austere method of work was so contrary to those of his Baroque contemporaries that it is not surprising that they learnt little from him. In France he was held up as a model of *le peintre raisonnable*, but few of his followers realized that for him reason included in itself what we should call imagination, and none of them approached the poetical quality of his greatest works. In the nineteenth century his reputation fell to its lowest point, though some great artists — Ingres, Delacroix, Cezanne and Degas — admired and imitated him, and it was not till the middle years of the present century that his qualities began once more to be appreciated by a wide public. Now every museum has to have its Poussin!

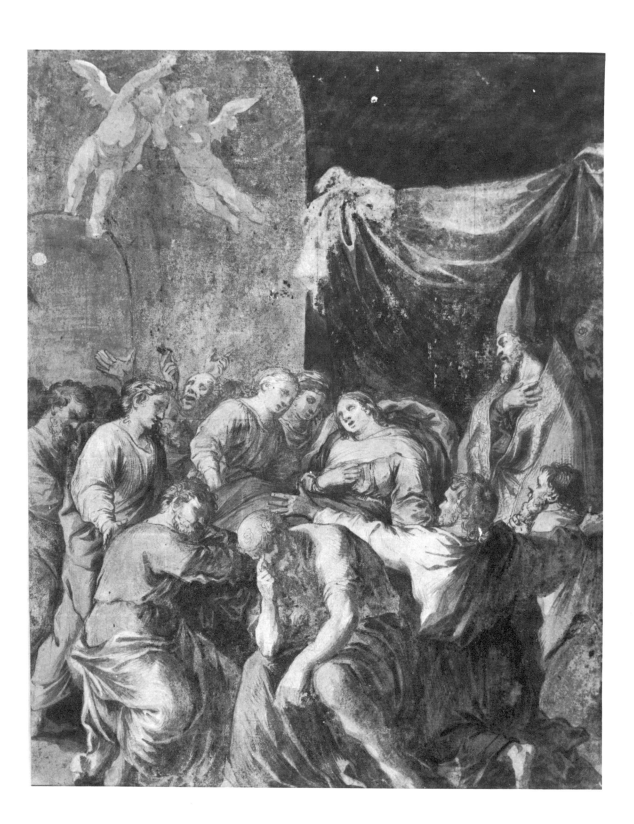

The History of the Drawings

Only a small proportion of all the drawings made by Poussin have survived. This is of course true of almost all artists of the seventeenth century, but in the case of Poussin it is more than usually difficult to understand why certain groups of drawings have survived and others have disappeared. For some paintings — for instance the Richelieu *Triumph of Pan* — we have up to a dozen studies; for others none. Nor is it a question of one period being rich and another poor in existing drawings. There are six drawings known for the *Crossing of the Red Sea* and none for its pair, the *Worship of the Golden Calf*, though enough survive in copies to prove — if it were not otherwise obvious — that many must have existed; there are three for the *Landscape with a Man killed by a Snake* and none for either of the Phocion landscapes;[1] and so on.

The inventory made at the artist's death records no drawings at all, and, though it was evidently incomplete, even the much more elaborate list made in 1678 by Jean Dughet of what he claimed to have inherited from the artist's studio records remarkably few. There was a volume of 160 drawings after the Antique and earlier masters, another with the same number of 'diversi pensieri disegnati della sua inventione', and a third containing fifty drawings of landscapes and twenty of animals and heads.[2] If we compare this with the 1750 drawings bequeathed by Domenichino to his pupil Raspantino or the 3000 which passed from Lebrun's studio into the French Royal Collection the contrast is striking.

Further some whole categories of drawings which Poussin certainly made have vanished. There are, for instance, no surviving drawings from the posed model and none certainly based on the direct observation of human beings, though we know from the early biographers that Poussin drew from the model in the studios of Domenichino and Sacchi, and that he was in the habit of carrying about with him a sketchbook in which he made notes of the people and things that interested him.[3]

In the case of these two categories it is possible — even likely

8. Poussin. *The Death of the Virgin*. Hovingham Hall, Yorkshire, Collection of Sir Marcus Worsley, Bt. Pen and brown ink with watercolour. 395 x 310 mm. (C.R. 405).

This is one of the very few drawings by Poussin made to serve as a *modello* to be shown to the patron commissioning a work, in this case the newly created archbishop of Paris. Technically it shows the strong influence of Flemish artists on Poussin during his early years in Paris.

— that Poussin destroyed the drawings. He would have regarded them as simply means to an end, and, though he probably kept them during his working career on the grounds that they might have come in useful later on, when about a year before his death he realized that he would not be able to paint any more, it is quite probable that he would have ordered them to be burnt. It is not so easy to see why he should have kept the drawings of landscapes and animals, but this may have been chance. The drawings after the Antique must have had a special importance for him, and it seems likely that he intended them to be preserved for posterity.[4]

There is, however, another and more general reason for the erratic survival of the drawings. Unlike artists such as Domenichino, who seems to have preserved every sheet he drew, Poussin appears to have been quite unconcerned about the preservation of his own drawings. Sometimes he reused the sheets in the most casual manner. There is, for instance, a drawing in the British Museum (Plate 79) with two sketches for a Holy Family across which Poussin has drawn a line, cutting across one of the sketches, in order to use the blank part of the sheet for drafting a letter to his friend Chantelou. One may ask why he kept the sheet at all and the explanation is probably that it has on the *verso* a landscape study which he had not used in a painting but which is connected with several later compositions.

Where he needed a large sheet of paper he sometimes joined together several sheets containing drawings which he had finished with. It is not surprising to find this happening in his early years, as for instance when, in the late twenties, he joined together various studies for the *Triumph of David* to make a large sheet to trace and transfer a group of figures from one part of the composition to another so that the pricking is still visible on one of the sheets which has survived (Plate 103); but even in his later career, when he had less need to economize in paper, he continued to use the same method. In 1650 he stuck together five sheets containing sketches for the *Europa*, the 1649 *Moses striking the Rock*, and a *Madonna*, in order to have a large enough sheet for the final version of the *Europa* (Plates 87-8), which is in fact the biggest of his surviving drawings.

Such lack of interest in his sketches would be entirely in character with Poussin who certainly regarded drawings as a means of clarifying his ideas and of approaching the final

16

expression of them in the painting itself, and he would perhaps even have preferred to destroy what he felt were imperfect attempts to give form to his ideas.

Luckily his friends must have thought differently and it is no doubt owing to their intervention that so many drawings actually survive. At a date before 1649 Cardinal Massimi formed what seems to have been the first collection of Poussin's drawings, which is now in the Royal Library at Windsor.[5] This volume incorporates the drawings from Ovid commissioned by Marino in Paris in 1623, and to these Massimi added some fifty drawings dating from a period running from the late twenties to the mid-forties, including some of Poussin's finest studies. The Cardinal died in 1677, and before the end of the century his brother, Fabio Camillo, who inherited the drawings, commissioned a catalogue of them with detailed descriptions of the subject and composition of each drawing. This is probably the earliest known catalogue of this kind, just as the Massimi volume probably represents the first occasion when a collector composed a volume devoted to the work of a single living artist.

It has been suggested that the Marino drawings passed to Cassiano dal Pozzo on the poet's death, and though this is probably incorrect he almost certainly owned another series of drawings by the artist which came to the Royal Library with the Albani collection formed by Pope Clement XI and bought from his nephew Cardinal Alessandro Albani by George III in 1762.[6] From the same source came all the drawings after the Antique made for Pozzo by Pietro Testa and others which Clement had bought from his heirs in 1703.

Pozzo and Massimi seem to be the only Italian collectors of the seventeenth century known to have owned drawings by Poussin, but there is reason to believe that one further group existed in Rome at latest in the early eighteenth century, though it belonged to a foreigner. Mariette records that the great eighteenth-century collector Crozat, who will be discussed below, obtained a number of drawings by Poussin from someone whom he calls 'Carlo degli Occhiali'.[7] This may be a mistake for Gasparo degli Occhiali, the Roman name for Gaspard van Wittel (1653-1736), the Dutch painter of landscapes and *vedute* and father of the architect Luigi Vanvitelli, or it may refer to a relation with the name of Charles. According to Mariette's note

in the Crozat catalogue Carlo degli Occhiali obtained the drawings 'des héritiers même de Poussin'. Unfortunately none of these sheets can be identified, as in the Crozat catalogue they are mixed with drawings from two other collections, those of Stella and Jabach to be discussed below.

Drawings by Poussin can be traced in a certain number of French seventeenth-century collections. Poussin's Paris friend Paul Fréart de Chantelou was not, generally speaking, a collector of drawings, but he owned some by Poussin, five of which can be identified today by the paraph, or hand-written mark, which they bear. He also owned a set of copies, made for him under Poussin's direction, of the artist's drawings illustrating Leonardo's treatise. The originals, which belonged to Pozzo, are now in the Ambrosiana, and Chantelou's copies are in the Hermitage.[8] Jabach, the great banker-collector, a German by birth who lived all his life in Paris, made two collections of drawings both of which contained works by Poussin. He sold the first collection to Louis XIV in 1671 and the drawings, which are now in the Louvre, included *Armida carrying off Rinaldo* (Plate 43), *Moses and the Daughters of Jethro* (Plate 77) and the *Holy Family on the Steps* (Plate 83). He soon started collecting again, and his second collection included three of the finest drawings connected with the second series of *Sacraments* (Plates 57, 64, 127) and the *Camillus* (Plate 26)[9]. Some of these drawings passed into the possession of Crozat who also acquired drawings by Poussin from the collection of the artist's friend Jacques Stella. The drawings passed by inheritance to his niece, Claudine Bouzonnet Stella, and are listed in the inventory of her goods drawn up in 1693, but although the subjects are given none of them can be identified with certainty.[10] Before the end of his reign Louis XIV had added many drawings by Poussin to those which he had acquired from Jabach; indeed a great part of those at present in the Louvre bear the mark of the keeper of his collection, Robert de Cotte, though their origin is for the most part unrecorded.

The only seventeenth-century collector outside Italy and France who is known to have owned drawings by Poussin is that master in the field, Sir Peter Lely, who died in 1680, only fifteen years after the artist, but who put his mark on two drawings by Poussin traceable today, and may well have owned others.

The eighteenth century was the great age for the collecting of drawings, and interest in those of Poussin spread widely. Italy seems to drop out, though groups of drawings probably brought together in the eighteenth century are to be found in the Uffizi and the Royal Library at Turin. French collectors however showed increasing enthusiasm for Poussin's drawings. In France Watteau's friend and patron, Jean de Jullienne, owned some, of which five are preserved today in the Hermitage. Crozat, who collected on an even grander scale, owned a much larger number, but, although he bought from the good collections mentioned above, he seems to have been unlucky in his choice and a high proportion of those coming from his collection are now rejected by scholars, although they were catalogued in his sale by Mariette under the name of Poussin.[11] Mariette himself however had in his collection, together with some of Poussin's finest drawings, a number which have also not stood up to the test of modern scholarship, though over some of them, particularly the landscape drawings, opinions are not unanimous.[12] At his sale many of the most important drawings were bought for the Royal Collection and are now in the Louvre.

In the eighteenth century English *amateurs* also began to collect drawings by Poussin. At an early date — possibly in 1695-6 — Dr. Richard Mead, the famous physician whom Watteau came to London to consult, acquired the Massimi volume of drawings mentioned above which he sold to Frederick, Prince of Wales, son of George II and father of George III, through whom it came into the Royal Collection. To this George III added the volume of drawings which was almost certainly put together by Cassiano dal Pozzo and later belonged to the Albani family. The two Richardsons — father and son — Hudson and Reynolds all owned important groups of drawings by Poussin, including some of his finest works. The tradition was carried on into the nineteenth century by Sir Thomas Lawrence whose collection was unhappily scattered after his death in 1830.

At the same period collectors in central and eastern Europe began to be interested in the drawings of Poussin. Count Brühl, minister to the Elector of Saxony and King of Poland, brought together an important group, which was acquired in 1769 with the whole of his collection by Catherine the Great. The year before the Empress had bought the collection which Count Karl

Kobentzl had formed in Brussels. These two collections formed the nucleus of the great series of drawings by Poussin now in the Hermitage.

In the eighteenth century Swedish collectors entered the field and Count Tessin bought a number of drawings from the Crozat collection at the sale in 1741 (including some of those now rejected by scholars). These are now in the National Museum at Stockholm, the great glory of which in this field is the huge drawing of *Europa*, one of the most moving of Poussin's later drawings (Plates 87-8).

Apart from Brühl, German collectors of the eighteenth century do not seem to have been much interested in drawings by Poussin and it is remarkable that the Albertina, so rich in almost every kind of drawing, should be so weak in those of Poussin.

At the end of the century however one Viennese collector, Moritz von Fries, acquired a large number of drawings by Poussin, including an important series of those after the Antique. A number of these also bear the mark of the French collector Lagoy, who seems to have made exchanges with von Fries.[13] Many of those which belonged to Lagoy and von Fries later came into the possession of Lawrence, but many others were scattered throughout Europe and they frequently appear in the sale room today.

In nineteenth-century France the most important collectors of Poussin drawings were the duc d'Aumale, the painters François-Xavier Fabre and Léon Bonnat, and the connoisseur His de la Salle. The duc d'Aumale bought largely from Frédéric Reiset, keeper of the Cabinet des Dessins in the Louvre, a secretive man who never recorded the sources from which he acquired his drawings. Aumale's collection, which now forms part of the Musée Condé at Chantilly, is mixed, but it contains some of Poussin's most splendid drawings.[14] Fabre and Bonnat bequeathed their collections to the museums which they founded in their native cities of Montpellier and Bayonne. His de la Salle bequeathed the finest of his drawings to the Louvre where they went to augment the great collection formed under the Ancien Régime, but others were sold privately and dispersed to various public and private collections. They appear fairly frequently in the sale room.

The great collections formed in England by the Richardsons,

9. Poussin. *Diana hunting*. Windsor Castle, Royal Library. Pen and brown ink on blue paper. 151 x 239 mm. (C.R. 200).
An unusually fine example of Poussin's vigorous pen style in the early Roman years.

Reynolds and Lawrence were broken up and it is a surprising fact that the aristocratic collectors of the day, who bought all the most important paintings by Poussin that came on the market showed little interest in his drawings. A few are to be found at Chatsworth and Holkham, but the number is trivial, and even the British Museum, which has by far the richest collection of drawings by Claude in the world, is weak in Poussin. The one important group in the country is that in the Royal Library, consisting of the Massimi and Pozzo volumes and a few further drawings from unknown sources, the whole collection containing about eighty originals, a group excelled only by that in the Louvre and perhaps equalled by that in the Hermitage.

In the last half century American collectors have begun to be interested in Poussin's drawings. The Pierpont Morgan Library has several including the superb *Death of Hippolytus*, the Metropolitan Museum has a dramatic *Lamentation* and other important drawings are to be found in private collections. There is every reason to think that this interest will increase in the future.

Chronology, Technique and Stylistic Development

Out of a total of about four hundred and fifty drawings attributed to Poussin more than one hundred and eighty can be dated with some accuracy. The evidence for dating varies in different cases. A few of the drawings are on sheets of paper with dated or datable letters, but by far the greater number are studies for documented paintings. Dating based on this link is not of course quite precise since the artist may have taken a considerable time in the evolution of his composition, but this does not seem to have been the case very frequently. When Poussin was occupied with a series such as the *Sacraments* he sometimes made a drawing for one composition while he was painting another, but even here, since the whole period involved was only four years, the possibility of error is limited.

Further indications of dating can be deduced by noting drawings which are on the *verso* of a sheet with a datable drawing on the *recto*. There is of course the possibility that Poussin used a sheet which had been lying about in the studio and on which he had made a drawing some years earlier, but this does not appear to have been his practice and there is only one case in which it seems more or less certain that he in fact did so. The drawing for *Christ healing the Blind* of 1650 has on the other side three studies, two for the Richelieu *Triumph of Pan* and a third for the first version of *Extreme Unction,* datable to about 1635-6 (Plates 37-8).[1]

It would in my opinion be unwise and pointless to try and date every drawing to a precise year, because, although Poussin's methods of working were very rational, his style did not necessarily evolve with absolute logic, and the best that we can hope to attain is a picture of its development by stages, which will vary in length according to the nature of the material.

The problem of chronology is complicated by the fact that the datable drawings are very unevenly distributed. The illustrations to Ovid made for Marino in Paris in 1623 and the study for the

10. Poussin. *Acis, Galatea and Polyphemus*. Chantilly, Musée Condé. Pen and bistre wash over red chalk. 130 x 180 mm. (C.R. 215).

Death of the Virgin commissioned for Notre-Dame in the same year provide a firm starting point for the early style, though nothing remains from the period before 1623. There are enough drawings either in the same manner as the Marino series or connected with early Roman paintings to establish the artist's style of draughtsmanship in the early Roman years. There are two studies for the *St. Erasmus* of 1628-9, one drawing probably related to the *Plague at Ashdod* of 1630-1 and two for the *Adoration of the Kings* of 1633, but there are no firm clues to help in dating the drawings of small religious and mythological subjects which almost certainly belong to the period before 1633, but cannot be more precisely placed. For the second half of the thirties the evidence is more abundant, and for the forties it is positively rich, with drawings — particularly those for the second series of *Sacraments* — datable to a single year or even to a period of months. After 1650 when Poussin's pace slowed up, partly owing to illness, the number of drawings decreased, but surprisingly enough a large and varied group survive for the last painting on which he worked, the *Apollo and Daphne* in the Louvre.

11. Poussin. *Apollo and the Muses on Parnassus*. Paris, Wildenstein Collection. Pen and bistre wash. 175 x 240 mm. (C.R. 180).

The series of drawings made by Poussin for Marino in 1623 consists of eleven representing stories from Ovid's *Metamorphoses* — nine oblong and two upright — and four showing battle scenes from the early history of Rome (Plates 4-7).[2] They belong to a type of composition frequently produced in the Low Countries in the late sixteenth century by artists such as Goltzius and Martin de Vos to illustrate editions of Ovid (Plate 2), and Marino very probably commissioned them with the idea in mind that they should be engraved for a printed edition or a translation of the poet.

The nine oblong drawings of Ovidian subjects and the four battle scenes are drawn with a pen and bistre ink with washes of grey and grey-brown and the two upright compositions are drawn and washed in grey. The line is thick and the pen was either a coarse quill, or a reed, of a type which Poussin continued to use for some years after his arrival in Rome. On the other hand he never again employed grey or grey-brown wash, but almost invariably used bistre for the pen outlines and for the washes.

The Marino drawings are rich in invention and varied in composition. In most of them Poussin follows the text of the poet

24

accurately, but in some he takes liberties which make the interpretation of the composition difficult.[3] Some are disposed like bas-reliefs in a highly classical manner (Plate 4); in others the artist exploits contrasts of scale in a spirit more akin to Mannerism (Plate 5). In some cases the pen drawing is rapid and vividly descriptive, but in others it is coarse and the proportions of the figures are heavy. Details are often indicated in a sort of shorthand, eyes by a single stroke, feet by a triangle sometimes broken up by a series of dashes for the toes, and trees by little tufts of foliage growing out of the trunk. The effect of the drawings depends mainly on the use of wash, which is laid on in broad luminous areas in the landscape setting and in smaller touches on the figures to indicate the modelling. This technique is ultimately Flemish in origin and was transmitted to Poussin through members of the second school of Fontainebleau such as Ambroise Dubois and Toussaint Dubreuil (Plate 1), but the use of the white paper as a positive element in the whole effect and the luminosity

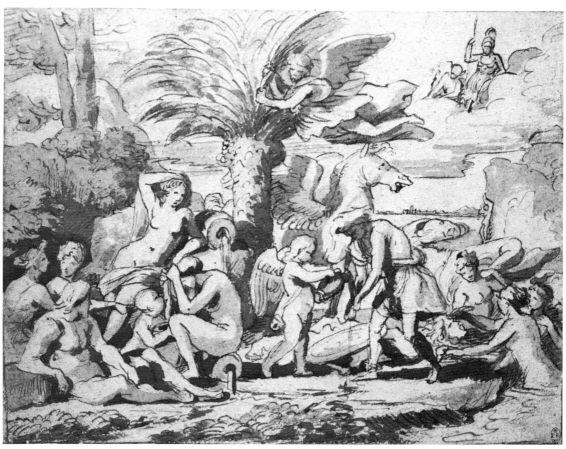

of the skies and backgrounds seem to be his own personal invention.

Even more precisely Flemish is the only other drawing which can be assigned to Poussin's years in Paris before his final removal to Rome. This is the *Death of the Virgin* (Plate 8), made in connection with the painting, now lost, commissioned by the Archbishop of Paris in 1623 for the cathedral of Notre-Dame. It is unique in Poussin's work in being executed in watercolours, a technique which was unusual in France at this time, but which the artist could have learnt from Flemish artists working in Paris.

The few drawings which can be certainly assigned to Poussin's first years in Rome show that for the most part he continued to work in the style which he had employed for the Marino series. These include a study in the British Museum for the *Germanicus* of 1626 (C.R. 129), one in the Fitzwilliam Museum, Cambridge, for the *Victory of Joshua over the Amorites* of 1625 in Moscow (C.R. 388) and one for the *Triumph of David*, probably begun in 1627 (C.R. 30). To these may be added a drawing at Windsor of the *Victory of the Israelites over the Midianites* (C.R. 387) which appears to be for a battle-piece of the same type as the pair in Russia, a number of mythological subjects (Plates 10-13) and one study of a genre scene, apparently unique in Poussin's oeuvre (Plate 14).[4] In all these the dominant feature is the vigorous somewhat coarse pen work, which establishes the actions of the figures with great clarity but states the problem of anatomy in very brief terms. The sketches were however sufficient guide for Poussin in the working out of his compositions.

The *Diana hunting* and the genre drawing, called in the Massimi catalogue *Le Fanciulle Rusticane*, stand slightly apart from the others, in that they are drawn in pen only, without wash, on blue paper. In the case of the *Diana* the paper is slightly faded but the *Fanciulle Rusticane* remains in pristine condition. It appears to have been made as a complete study in itself, not as a preparation for a painting. For this reason it has a sort of finality lacking in the other drawings of the period.

There are however a few drawings dating from this period which are in a slightly different style, in a rather scratchy line owing probably to the fact that the artist was using a fine quill pen instead of the thick reed which is typical of this phase. Two of these drawings — one at Chantilly (Plate 15) and one in the

12. Poussin. *The Kingdom of Flora*. Windsor Castle, Royal Library. Pen and brown wash over red chalk. 212 x 293 mm. (C.R. 214).
 On stylistic grounds this drawing must be dated *c*.1626-7, but Poussin used it for the painting, now in Dresden, painted in 1631 for the Sicilian diamond merchant Valguarnera. The drawing on Plate 13 is a pair to it and there was probably a third in the series representing Venus and Adonis hunting, since three fair copies by an assistant are known, which clearly form a series representing the three compositions in question.

13. Poussin. *The Origin of Coral (La Tintura del Corallo)*. Windsor Castle, Royal Library. Pen and brown wash over red chalk. 228 x 314 mm. (C.R 224).
 The drawing shows Perseus washing the blood of the sea-monster off his hands after saving Andromeda. Meanwhile the head of Medusa which had been laid on the grass turns it into red coral. The third composition in the series, Venus and Adonis hunting, embodies a similar theme because, according to Ovid, Venus pricked her foot on a rose and the blood turned it red. For the fair copy, see Plate 177.

27

collection of M. Robert Lebel[5] are for the *Germanicus* (Plate 16), and another belonging to M. Daniel Wildenstein (Plate 11) is for the Prado *Parnassus* which probably dates from 1627. This group emphasises the fact — obvious but often forgotten — that an artist's style is rarely uniform at any single moment and may be affected by, amongst other things, the actual tool that he is using.

The next firm point in the chronology of Poussin's drawings is provided by the two studies for St. Erasmus (Plate 17 and C.R. 409a), datable to 1628, when the commission for the painting was given (Plate 18). These are entirely executed in line without wash, though the pen used was so thick — once again probably a reed rather than a quill — that the hatching produces the effect of deep wash. The energy characteristic of all the early drawings here reaches its highest point and is perfectly suited to the drama of the scene and the almost Baroque movement of the design.[6] Precisely similar in style, though strengthened with wash, is the study for the *Massacre of the Innocents* at Lille (Plate 19) which evidently dates, like the painting at Chantilly (Plate 20) for which it is a study, from the same years as the *St. Erasmus.*[7] The extraordinarily vigorous style of these drawings seems to have been a personal invention of Poussin and has no obvious parallel in the

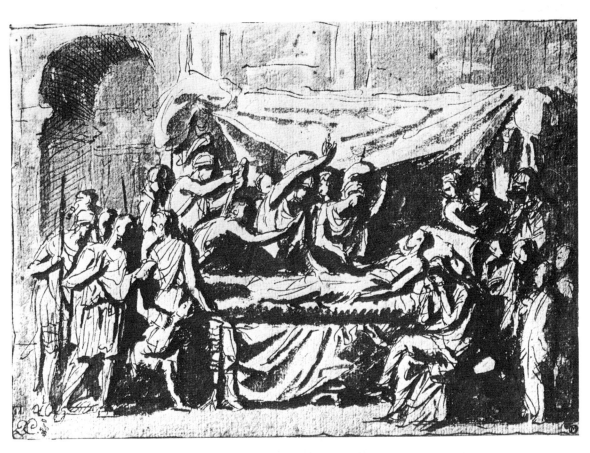

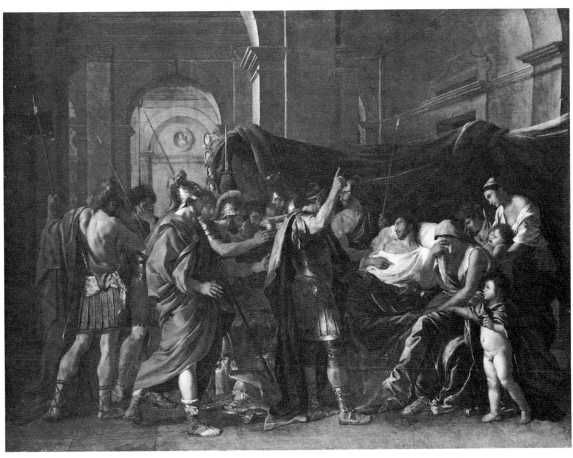

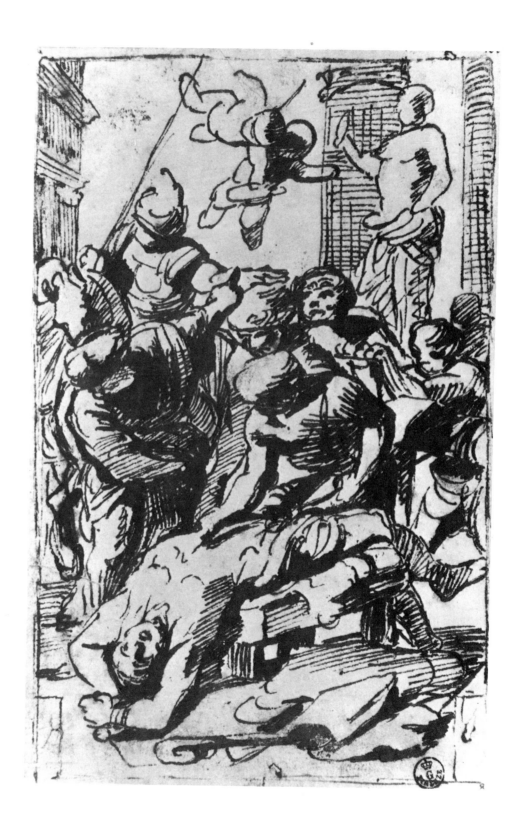

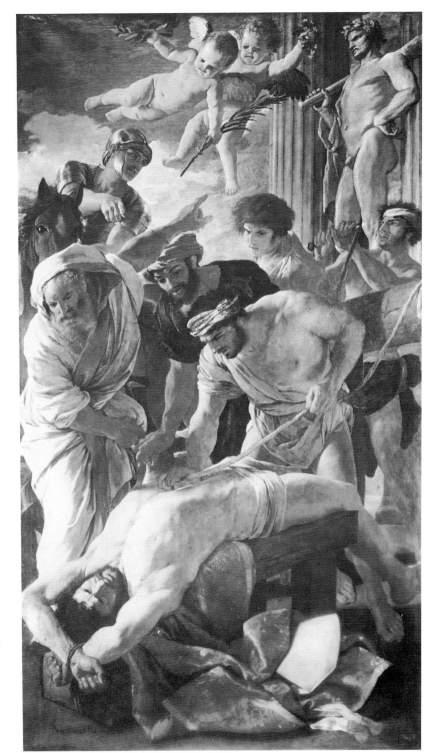

17. (left) Poussin. *The Martyrdom of St. Erasmus.* Florence, Uffizi. Pen and brown ink. 204 x 132 mm. (C.R. 73).

Study for the altarpiece painted for St. Peter's in 1628-9, Poussin's one public commission in Rome. This and the *Massacre of the Innocents* (Plate 19) are among the most dramatic drawings that Poussin made. He is still using the thick pen, possibly a reed, as in the drawings shown in Plates 12-14, but he adds vigorous cross-hatching to create shadows.

18. (right) Poussin. *The Martyrdom of St. Erasmus.* Vatican, Gallery. Painting. 320 x 186 cms.

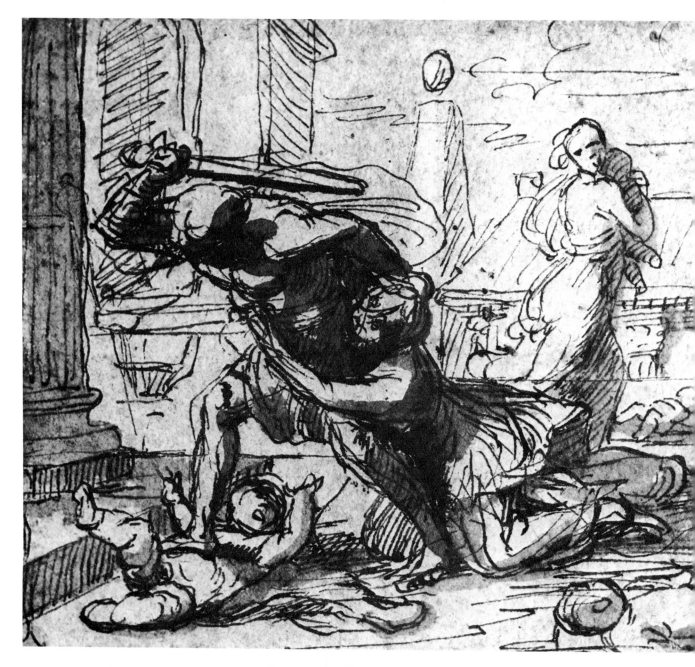

work of contemporary or earlier artists, though one could well
imagine that the drawings of certain followers of Caravaggio — of
which hardly any survive — might have had something of the
same quality, and there is some analogy with the single etching
ascribed to Caravaggio himself.

There is unfortunately no drawing certainly by Poussin which
can be firmly assigned to the years between the *St. Erasmus* of
1628-9 and the *Adoration of the Kings* of 1633.[8] There is

32

however one which has a reasonable claim to a place in these years. This drawing of the *Plague at Ashdod* (Plate 21), which is either an original or a copy of a lost drawing is, I believe, probably a study for the painting of this subject in the Louvre which can be precisely dated to the end of 1630 and the first months of 1631.[9]

If this drawing is accepted as an original of this date it shows that Poussin's style of draughtsmanship was changing: the outlines are looser and the details of features are almost entirely omitted. The artist seems to be concentrating on establishing a clear space in which the action takes place, on defining the principal masses of the figure groups and giving force to the gestures with which the individual figures express their horror at the scene. These are features which scarcely occur in the earlier drawings and they prepare the way for the mature compositions of the mid-thirties.

Round this drawing it is possible to group tentatively a few others which still have the general characteristics of the Marino

19. (left) Poussin. *The Massacre of the Innocents.* Lille, Musée des Beaux-Arts. Pen and brown ink with some wash. 146 x 169 mm. (C.R. 61).
Study for the painting (Plate 20) commissioned by the Marchese Vincenzo Giustiniani and now at Chantilly. The technique is the same as in the *St. Erasmus* but Poussin replaces the cross-hatching by simple hatching strengthened with dark brown wash.

20. (right) Poussin. *The Massacre of the Innocents.* Chantilly, Musée Condé. Painting. 147 x 171 cms.

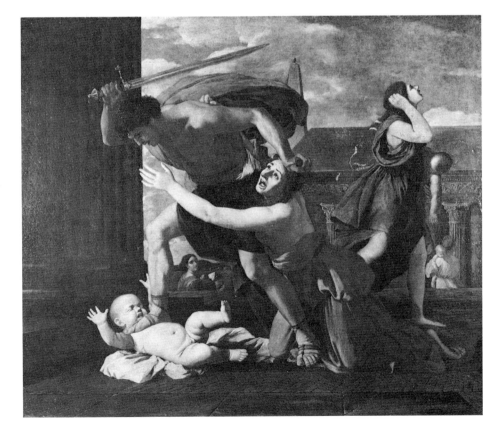

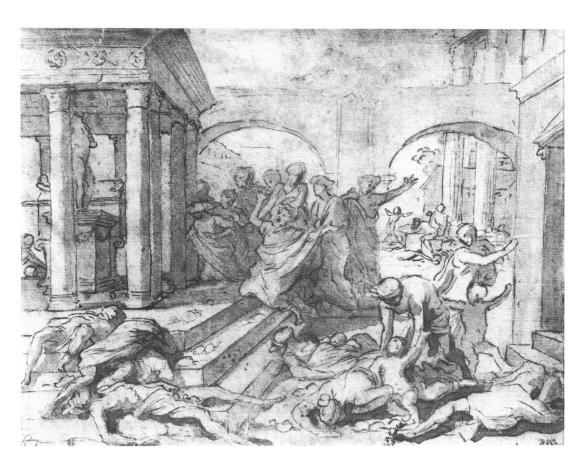
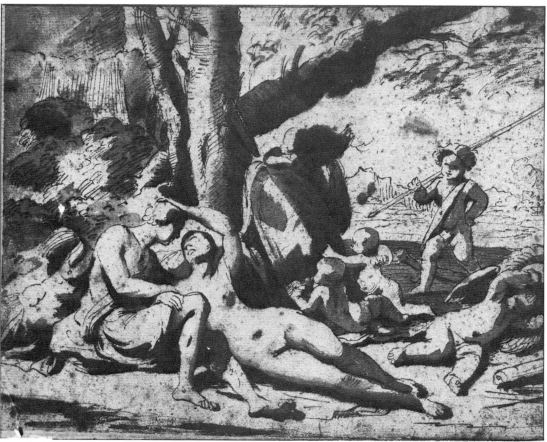

21. (upper left) Poussin
(copy after?). *The Plague at
Ashdod.* Paris, Musée du
Louvre. Pen and brown wash
over red chalk. 190 x 252
mm. (C.R. 389a).

The authenticity of this
drawing has often been
challenged on account of
certain weaknesses in the
drawing of hands and feet,
and it may be an early copy
after a lost original. In any
case it is connected with the
painting of 1630 in the
Louvre and is one of the first
drawings to illustrate
Poussin's interest in expres-
sive action and gestures.

22. (lower left) Poussin.
Mars and Venus. Chantilly,
Musée Condé. Pen and
brown wash. 196 x 261
mm. (C.R. 206).

Poussin here applies the
dramatic chiaroscuro of the
St. Erasmus and the
Massacre drawings to a more
lyrical subject. Appropriately
he makes the line less violent
and applies the rich washes
to give a luminous, almost
sunlit effect.

23. (upper right) Poussin.
The Adoration of the Kings.
Chantilly, Musée Condé. Pen
and brown wash. 220 x 320
mm. (C.R. 38).

Study for the painting
dated 1633, now in Dresden
(Plate 24). It is not known
who commissioned the paint-
ing, but Poussin evidently
attached great importance to
it, making several elaborately
finished drawings for it and
signing the painting itself
with a Latin inscription
which mentions the fact that
he had become a member of
the Academy of St. Luke.

24. (lower right) Poussin.
The Adoration of the Kings.
Dresden, Gemäldegalerie.
Painting. 181 x 162 cms.

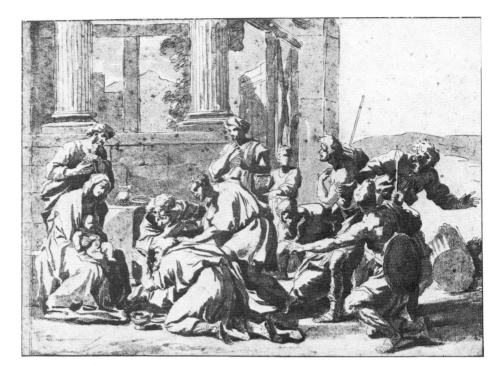

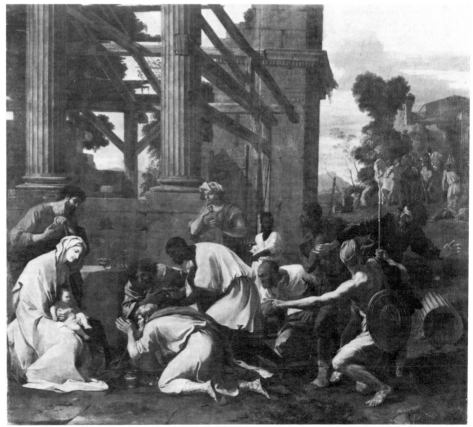

series but with a slightly freer use of the pen. Two of these, the *Mars and Venus* in the Louvre (Plate 199) and the *Putti fighting on Goats* (C.R. 232), are studies for paintings which probably date from 1629-30.[10] A third at Chantilly, particularly brilliant in execution (Plate 22), also represents Mars and Venus but does not seem to be directly connected with the painted version.[11]

The *Adoration of the Kings* in Dresden (Plate 24), signed and dated 1633, marks a turning-point in Poussin's career as a painter and the two preliminary drawings connected with it reflect a similar change. In the painting it is evident that Poussin has finished his short flirtation with the Baroque, and is seeking after different ideals; the interest in spatial construction visible in both the painting and the drawing of the *Plague at Ashdod* now becomes dominant, and the model which the artist has in mind is the history paintings in the *Loggie* of Raphael rather than any

25. Studio of Giulio Romano. *The Continence of Scipio.* Paris, Musée du Louvre. Drawing.

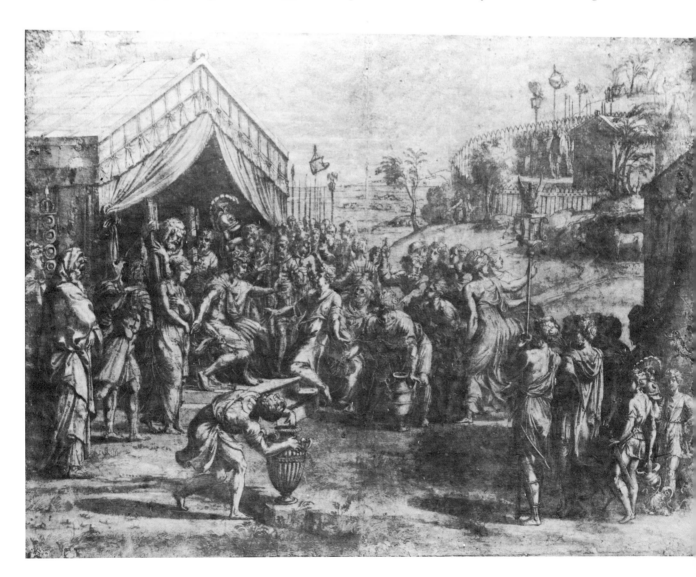

contemporary work, though it is Raphael seen through the eyes of Annibale Carracci and Domenichino. The same tendency can be seen in the composition of the drawings (Plate 23 and C.R. 37) but it is a curious fact that, although Poussin admired Annibale Carracci and Domenichino and was certainly influenced by them in his paintings, his surviving drawings do not suggest that he learnt anything from them in this field. It is possible — indeed likely — that his studies from life may have been in the tradition which they had established, but his composition studies are entirely different. He hardly ever used chalk, which was their favourite medium, and when he did so it was in a quite different spirit; and his pen drawings have nothing of the quick fluid quality of the two Italian masters' work. In fact in his drawings as in his paintings Poussin seems at this moment to have turned to the early sixteenth century for his models, not so much to

26. Poussin. *Camillus and the Schoolmaster of Falerii.* London, British Museum. Pen and brown wash. 336 x 495 mm. (C.R. A30).

The authenticity of this unusually large drawing has been challenged on account of its highly finished quality, but it was almost certainly made as a *modello* to show to the patron commissioning a painting of the subject, in this case probably Poussin's close friend Michel Passart.

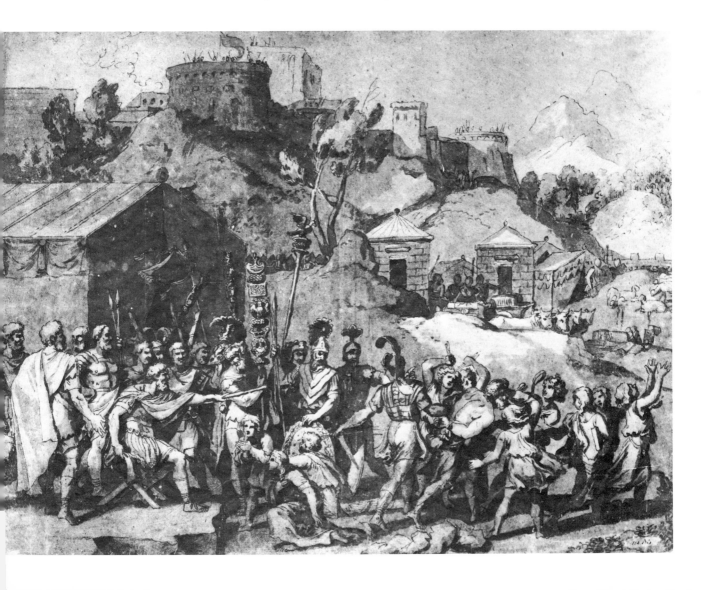

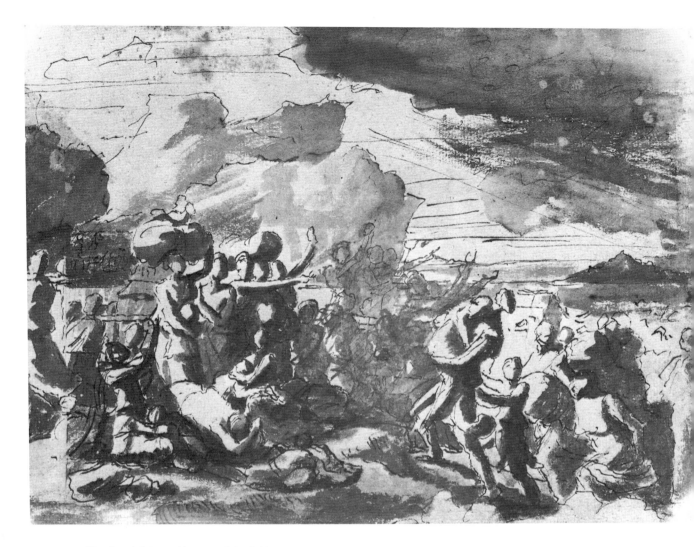

Raphael himself as to his followers, particularly Giulio Romano and Perino del Vaga.

Technically the drawings for the *Adoration* are quite different from Poussin's previous works. They are drawn with the thin quill pen which he used in the studies for the *Germanicus* and the *Parnassus* but in a more careful, almost hesitant manner, entirely without the *bravura* of the St. Erasmus studies, and with a far greater care for the delineation of limbs and draperies. The wash, which was previously laid on in large areas with a single sweep of a broad brush, is now used in a more complicated manner. The main masses are still indicated with broad washes but the artist goes over the individual forms emphasising the details of modelling with little strokes, made with the point of a fine brush almost as if with a pen. This is precisely the method used by the followers of Raphael and there can be little doubt that Poussin

27. (above) Poussin. *The Crossing of the Red Sea.* Leningrad, Hermitage. Pen and brown ink. 185 x 266 mm. (C.R. 17).

28. (upper right) Poussin. *The Crossing of the Red Sea.* Leningrad, Hermitage. Pen and bistre wash. 183 x 257 mm. (C.R. 19).

29. (right) Poussin. *The Crossing of the Red Sea.* Melbourne, National Gallery of Victoria. Painting. 156 x 215 cms.

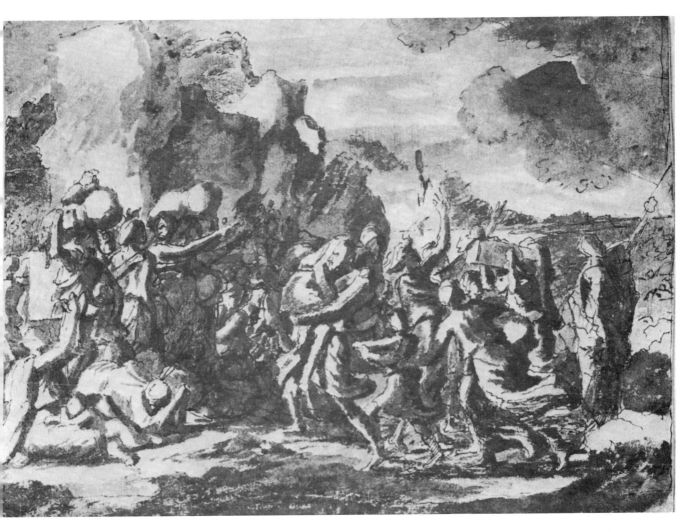

The drawings illustrated on Plates 27 and 28 are two of four surviving studies made for the painting commissioned by Cassiano dal Pozzo's Milanese cousin, Amadeo, in the mid-thirties. They are remarkable for the dramatic use of broad washes of dark brown ink, but they also illustrate Poussin's elaborate way of working out a composition by moving figures and groups about, as if on a stage, and varying the lighting and the landscape setting (see below, pp. 95-113 and Plates 114-31).

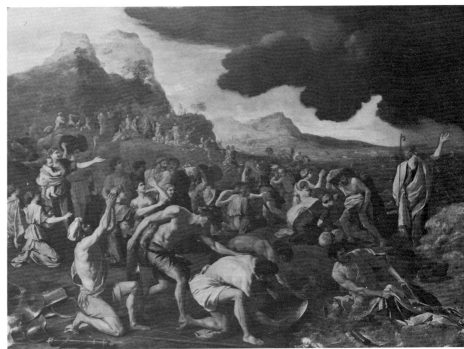

must have seen drawings by them (cf. Plate 25). In one feature he does not imitate his models: they frequently strengthen their drawings by heightening the lights with body-colour, but — perhaps by a characteristic gesture of self-denial — Poussin confines his means to pen and wash.

This new technique is used with great effect in a few very finished drawings dating from the years 1635-6, of which the most important are the *Triumph of Pan* at Windsor (Plate 119), connected with one of the Richelieu *Bacchanals*, and the first version of the *Camillus and the Schoolmaster of Falerii* in the British Museum (Plate 26). These drawings were probably made as works complete in themselves and it is no doubt for this reason that Poussin has treated them with such minute care. In other cases he still uses the old technique with broad washes, but when he does so he is usually aiming at an effect of drama as in the *Crossing of the Red Sea* (Plates 27-8).

Having learnt the new discipline displayed in the finished

30. Poussin. *The Rape of the Sabines*. Windsor Castle, Royal Library. Pen and brown wash over black chalk. 114 x 197 mm. (C.R. 117).

31. Poussin. *The Rape of the Sabines*. Windsor Castle, Royal Library. Pen and brown wash. 116 x 81 mm. (C.R. 116). Study of a group showing a Roman soldier carrying off a Sabine woman.

Poussin painted two versions of this subject, now in the Louvre and the Metropolitan Museum, New York, both dating from the middle or later thirties. The drawings connected with the two paintings are remarkably similar in character — which suggests that the paintings were executed within a very short interval of time — but in fact the smaller study (Plate 31) is directly connected with the Louvre version, whereas the larger one (Plate 30) — which is clearly a fragment — corresponds in its general disposition more closely with the Metropolitan composition. Both drawings show Poussin's mastery in the 1630s of a vigorous, wiry line, within which the forms are modelled by sharp, staccato touches of dark brown wash.

drawings of this phase Poussin very soon adapted it in a highly personal manner, simplifying it and making it more expressive.

The new approach can be seen in the drawings for the *Rape of the Sabines* (Plates 30-1). Here Poussin's first object has been to fix the actions of the various figures and to form them into groups conceived almost in terms of sculpture. To achieve this he eliminates all detail — even the features of the face are often left out — and concentrates on clear unbroken outlines which sum up the essence of the movement: the dragging action of the soldier on the right, the violent resistance of the woman in the central group, coupled with the clumsy attempt of her father to save her from the soldier, the perhaps over-elegant gesture of the girl on the left, carried off by a vigorous Roman. The foreground groups are all firmly modelled in wash, but even the struggling figures in the distance indicated in the roughest of pen-strokes have great life, and with their ingenious network pattern form a vivid background to the principal action.

Even more brilliant are the *Death of Virginia* (Plate 32), the *Saving of the Infant Pyrrhus* (Plate 33), and the *Bacchus and Ariadne* (Plate 36), because in them the simple but expressive outline is combined with an exceptionally luminous use of wash, the effect of which is made the more striking by the fact that the drawings are in an immaculate state of preservation.

These drawings probably represent Poussin's highest achievement as a virtuoso draughtsman. From now onwards, although he sometimes makes drawings which are evidently intended to stand as works of art in their own right, he generally treats them simply as instruments to be used in the development of his compositions.

In a few of the drawings of the mid-thirties Poussin uses a thin quill pen without wash as he had done in some of his earlier drawings, but he now does so in a slightly different spirit, to note down as rapidly as possible some idea which one may feel has come to him almost out of the blue. One of these sheets, at Windsor (Plate 37), contains three such 'notes' — one could almost call them *aides-mémoire*; in the middle and on the right two alternative ideas for the nymph decorating a herm in one of the Richelieu *Bacchanals* and on the left a quick sketch, much more dramatic in character, for one of the mourning figures in the *Extreme Unction* from the first series of *Sacraments*.[12]

41

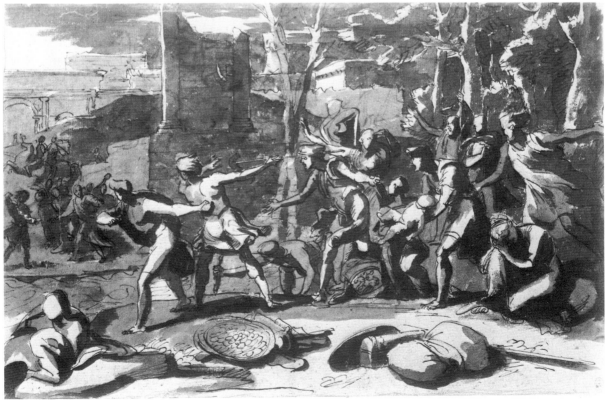

32. (upper left). Poussin.
The Death of Virginia.
Windsor Castle, Royal
Library. Pen and brown
wash. 174 x 230 mm. (C.R.
122).

This and the *Pyrrhus*
(Plate 33) are among
Poussin's most brilliant vir-
tuoso performances as a
draughtsman. In both, the
freshness of the wash is
perfeclty preserved; but it is
used for different purposes in
the two drawings. In the
Virginia it is clear, transpa-
rent and luminous, in the
Pyrrhus the ink is a darker
brown and is used to create
the dramatic atmosphere of a
storm at night.

33. (lower left) Poussin. *The
Saving of the Infant Pyrrhus.*
Windsor Castle, Royal
Library. Pen and brown ink
over red chalk. 210 x 346
mm. (C.R. 108).

The drawing illustrates the
story of the infant Pyrrhus,
son of King Aeacides of
Epirus, who was saved by
the King's friends and taken
to Megara. In the drawing
they are shown throwing
messages across the swollen
river to the Megarans who
came and saved them.
Poussin was to return to the
story of the child Pyrrhus in
a series of very late drawings
(see Plates 196-7).

34. (upper right) Poussin.
*Bacchanal in front of a
Temple*. Windsor Castle,
Royal Library Pen and brown
wash. 208 x 316 mm. (C.R.
194).

35. (lower right) Poussin.
*Bacchanal in front of a
Temple.* Chantilly, Musée
Condé. Pen and brown wash.
155 x 210 mm. (C.R. 195).

The mid-thirties were the
time of the great Bacchanals
(see below, p. 99 and Plates
111-20). *The Bacchanal in
front of a Temple* is known
from these two fluently
drawn and dramatically
washed drawings and in a
number of painted versions,
none from Poussin's own
hand.

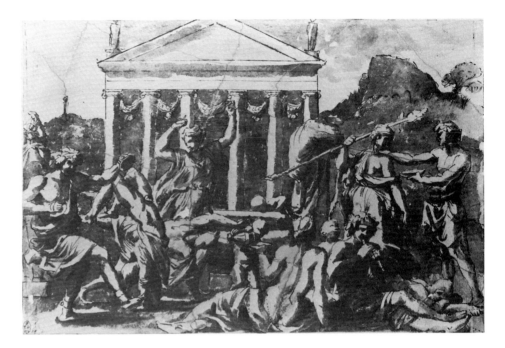

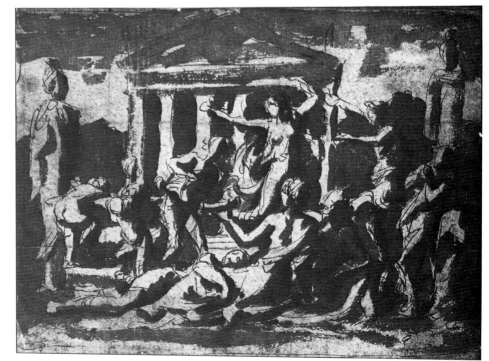

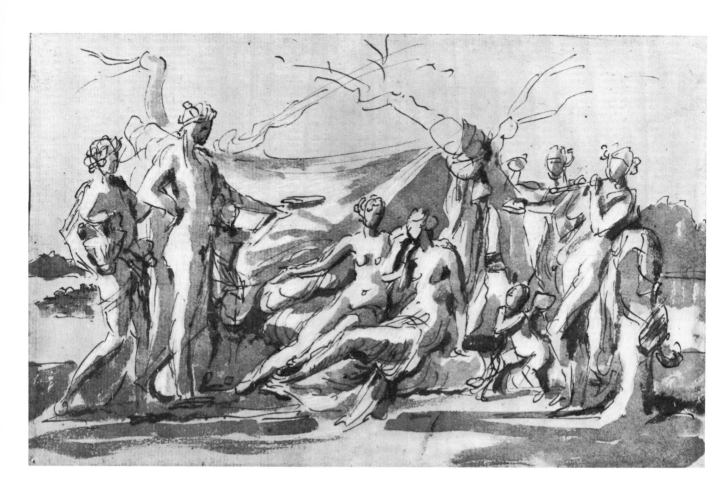

The period around 1637 was for Poussin one of transition, and the drawings of these years are, like the paintings, particularly varied in style. Some, like the *Moses striking the Rock* connected with the Sutherland painting (Plate 41), or the *Hercules carrying off Deianira* (Plate 42), are highly finished experiments in the technique which Poussin had first displayed in the drawings for the *Adoration of the Kings*, whereas the *Camillus and the Schoolmaster of Falerii* (Plate 44) is treated like the *Sabines* drawings with strong areas of dark wash, which in the *Armida carrying off Rinaldo* (Plate 43) fill almost the whole of the sheet.

A new and more dramatic style involving strong light effects is apparent in two drawings which seem to date from this period: the *Agony in the Garden* (Plate 45) and the *Lamentation over the dead Christ* (Plate 46), both at Windsor. In the former a ray of light from the sky to which one of the angels points illuminates the whole scene with a suddenness unusual for Poussin; in the latter the crosses picked out by the light in the left background provide a similarly unexpected focus of interest.

36. (above) Poussin. *Bacchus and Ariadne* (?) Windsor Castle, Royal Library. Pen and brown wash, 156 x 250 mm. (C.R. 182).

An unusually fresh and well-preserved example of Poussin's luminous use of wash in the mid-1630s. The subject has usually been identified as Bacchus and Ariadne, but it may well represent a Roman marriage ceremony of the type shown in the Aldobrandini Wedding fresco (see Blunt, *Nicolas Poussin,* London, 1967, p. 112).

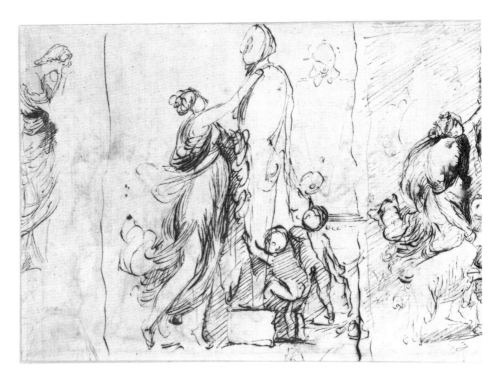

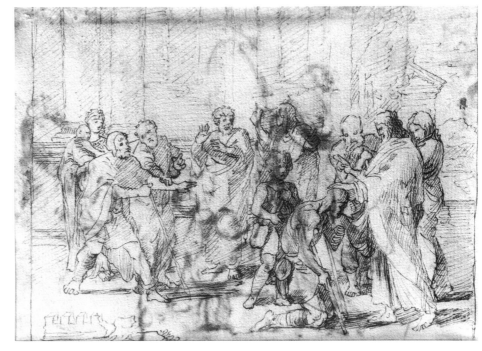

37 & 38. (right) Poussin. *Sheet of Studies* (*recto* and *verso*). Windsor Castle, Royal Library. Pen and brown ink. 142 x 208 mm. (C.R. 188 and V, p. 90).

A series of rapid notes showing on the left a mourning figure in *Extreme Unction* from the first series of *Sacraments* and two studies for the *Triumph of Pan* in the Morrison Collection. Both of these paintings date from about the mid-1630s but Poussin must have kept the sheet lying about in his studio, since he used the back of it to make a study for *Christ healing the Blind*, now in the Louvre, painted in 1650, parts of which show through the very thin paper and can just be seen in the reproduction on Plate 37. A comparison of the *recto* and *verso* of this drawing shows how much Poussin's draughtsmanship had lost in brilliance and fluency between the mid-thirties and the fifties — but perhaps gained in expressive intensity.

39. Poussin. *Roger carried away from Bradamante on the Hippogriff.* Present whereabouts unknown. Pen and brown ink. 192 x 110 mm. (C.R. 428).

The subject is taken from the fourth canto of Ariosto's *Orlando Furioso* and is the only surviving work by Poussin to illustrate this poem. It is not surprising that Poussin preferred Tasso's *Jerusalemme Liberata* for which he made at least six paintings and a number of drawings (see Plates 43, 188-9), since it was held up by the more conservative and classical critics of his time as the model of the 'pure' epic, but what is more surprising is that the *Orlando* was very rarely chosen by his Baroque contemporaries, since it was admired for its 'episodes', which were appealed to by Roman Baroque artists such as Lanfranco and Cortona to justify their introduction of as many figures and as elaborate settings as possible in their paintings.

40. Poussin. *The Satyr and the Peasant*. Paris, Private Collection. Pen and brown ink. 135 x 112 mm. (C.R. 427).

Aesop was rarely illustrated by artists of the seventeenth century, but this particular fable was popular, though more with Flemish artists than Italian or French. Poussin's drawing is based on an engraving in the edition of the fables published in Rome in 1563.

These two drawings include a type of figure new in Poussin: an old man with a rounded head with hair and beard drawn with little curved touches, as if to pick out the curls. This type appears in other drawings which can be definitely dated to the very last years of the decade: a study for *Confirmation* (Plate 47), a drawing for the Wallace *Dance to the Music of Time* (Plate 48), and one connected with the Roccatagliata *Holy Family* of 1641-2 (Plate 49).[13]

One new category of drawings appears for the first time in the second half of the thirties: landscapes. The earliest certainly datable drawing of this type is the *View of Villeneuve-lès-Avignon* (Plate 56), made on the journey back to Rome in 1642, but several others, notably the *Five Trees* (Plate 51), the *View of*

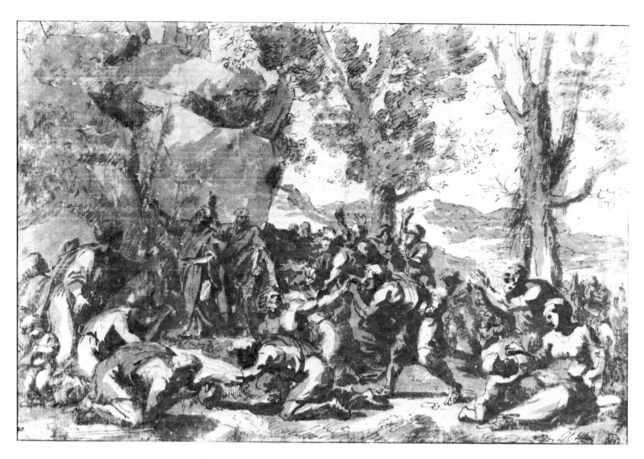

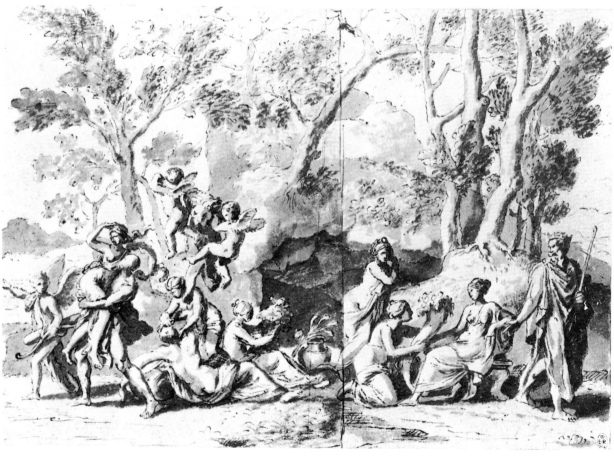

41. (upper left) Poussin.
Moses striking the Rock.
Paris, Musée du Louvre. Pen
and brown wash. 242 x 372
mm. (C.R. 23).

Study for the painting,
now in the collection of the
Duke of Sutherland (on loan
to the National Gallery of
Scotland, Edinburgh),
painted in or shortly before
1637. This is one of the first
examples of what may be
called Poussin's 'peopled
landscapes' in which the
trees are used to create a space
in which the figures move.

42. (lower left) Poussin.
*Hercules carrying off
Deianira.* Windsor Castle,
Royal Library. Pen and
brown wash. 220 x 318
mm. (C.R. 218).

An elaborate composition
in which, as in the *Moses
striking the Rock*, the land-
scape plays an active part
and the foliage of the trees is
treated with as much care —
particularly in the varying
tones of wash — as the
figures. The drawing shows
several episodes from the
story of the combat between
Hercules and the river god
Achelous over Deianira who
during the combat trans-
formed himself into a bull,
but was defeated by Hercules
who broke off one of his
horns. Poussin has drawn
a line dividing the composi-
tion into two nearly equal
parts and he seems to have
executed a painting of the
left-hand part only (now lost).

43. (upper right) Poussin.
Armida carrying off Rinaldo.
Paris, Musée du Louvre. Pen
and brown wash over chalk.
202 x 256 mm. (C.R. 144).

A study for the
painting executed in 1637
for Poussin's close friend the
painter Jacques Stella and
now in East Berlin.

44. (lower right) Poussin.
*Camillus and the
Schoolmaster of Falerii.*
Windsor Castle, Royal
Library. Pen and brown wash.
179 x 179 mm. (C.R. 123).

A study for the second
version of the subject painted
for La Vrillière in 1637 and
now in the Louvre.

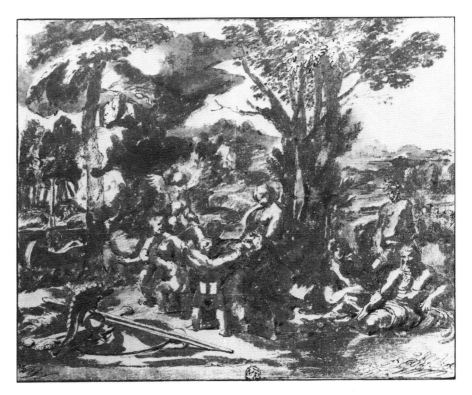

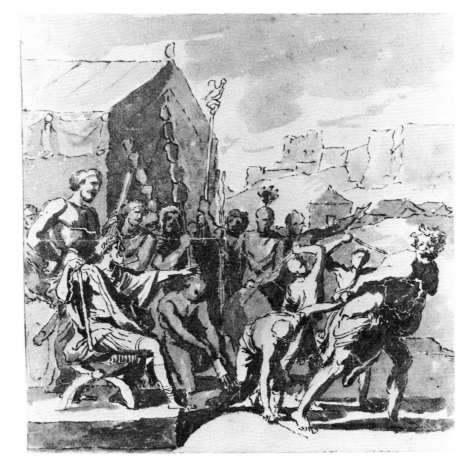

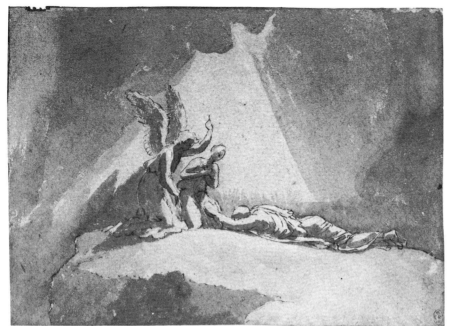

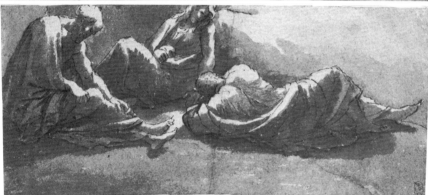

45. (left) Poussin. *The Agony in the Garden.* Windsor Castle, Royal Library. Pen and brown wash on blue paper. Overall measurements *c.* 280 x 245 mm. (C.R. 64).

At an early date this drawing was cut in two and the two pieces reached the Royal Library through different channels, the lower part with Cardinal Massimi's drawings acquired by Frederick, Prince of Wales, and the upper with the Albani Collection bought by George III. Two features of the iconography of the drawing are very unusual: Christ is shown lying prone instead of kneeling, and the angel is accompanied by a second figure, not winged, who may represent Ecclesia.

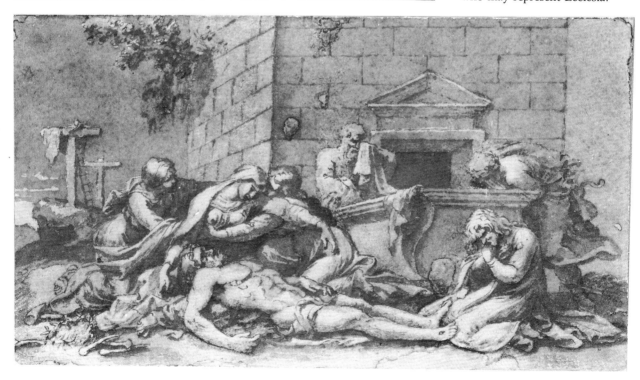

46. (lower left) Poussin. *Lamentation over the dead Christ.* Windsor Castle, Royal Library. Pen and brown wash. 140 x 255 mm. (C.R. 400).

47. (upper right) Poussin. *Confirmation.* Windsor Castle, Royal Library. Pen and brown wash. 137 x 208 mm. (C.R. 85).
 Study for the *Confirmation* in the series representing the *Seven Sacraments,* painted for Cassiano dal Pozzo between 1636 and 1641 and now in the possession of the Duke of Rutland. The drawing is typical of the careful, almost tight draughtsmanship of the years just before the journey to Paris.

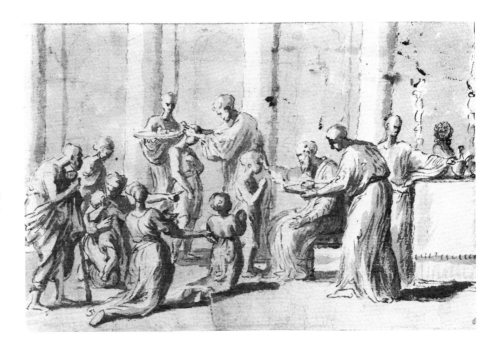

48. (lower right) Poussin. *A Dance to the Music of Time.* Lockinge, Berkshire, Christopher Loyd Collection. Pen and brown wash. 149 x 197 mm. (C.R. 149).
 A study for the painting in the Wallace Collection, commissioned in 1639 by Cardinal Giulio Rospigliosi, later Clement IX. The dancing figures represent Poverty, Industry, Riches and Pleasure (see my note in the *Burlington Magazine*, CXVIII, 1976, p. 844).

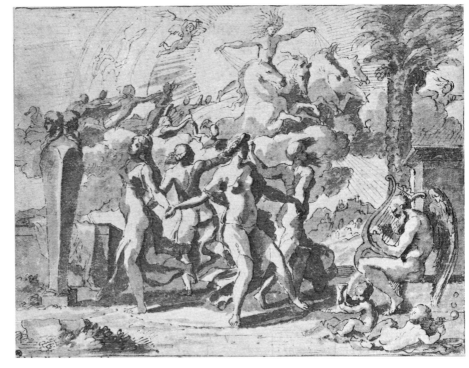

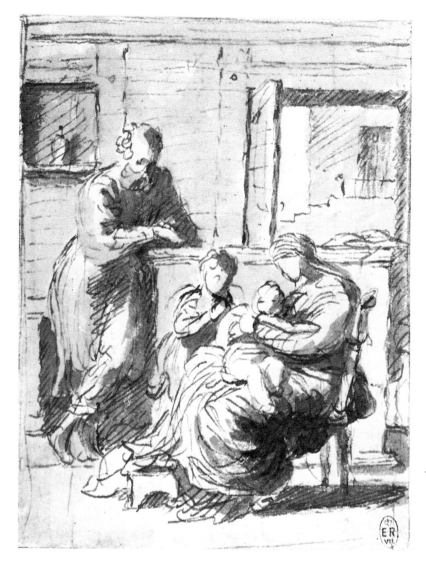

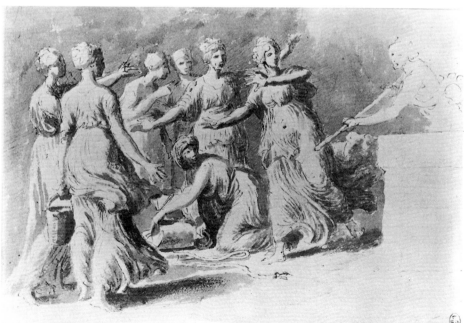

49. (upper left) Poussin. *The Holy Family.* Windsor Castle, Royal Library. Pen and brown wash. 140 x 101 mm. (C.R. 41).

A study for the *Holy Family* commissioned by the dealer Stefano Roccatagliata and painted in Paris in 1641-2.

50. (lower left) Poussin. *Moses and the Daughters of Jethro.* Windsor Castle, Royal Library. Pen and brown wash. 145 x 212 mm. (C.R. 11).

Study for a composition known from an engraving and several other drawings (C.R. 10, 12, A3). The drawing is unusual technically in that the forms are indicated by very delicate touchès with the point of the brush, without the broad washes which Poussin had used earlier.

51. (right) Poussin. *Five Trees.* Paris, Musée du Louvre Pen and brown wash. 240 x 181 mm. (C.R. 271).

One of Poussin's most spontaneous records of the landscape of the Roman Campagna, probably — if not certainly — drawn directly from nature. In drawings such as this he comes closer than in any other works to the spirit of Claude Lorraine, but even here his approach is distinguished by an interest in the actual structure and growth of the trees which he depicts.

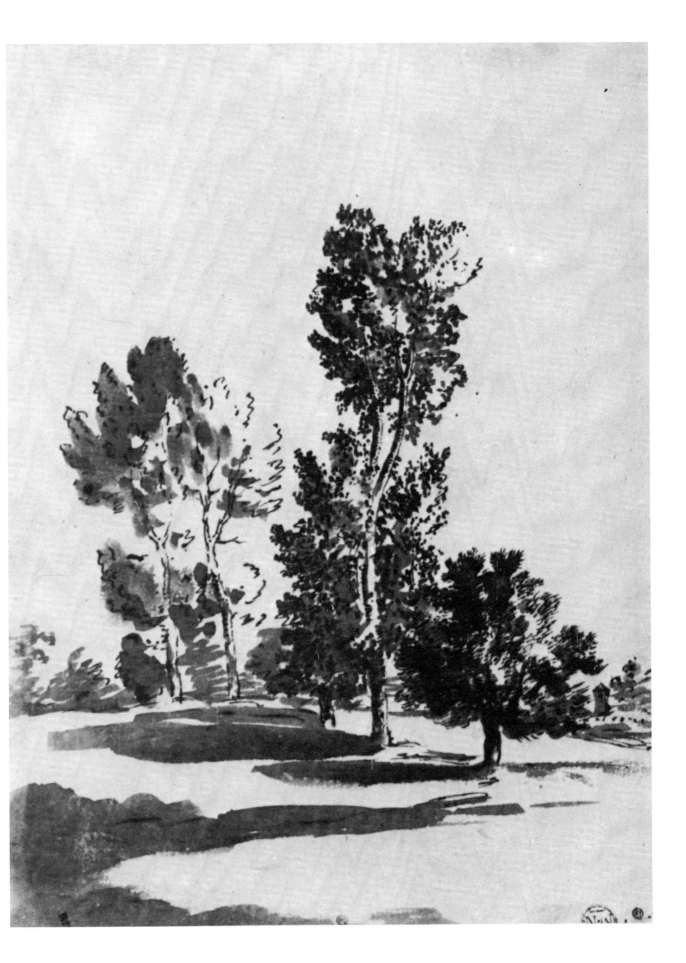

the *Tiber* (Plate 52) and the *St. Mary of Egypt and St. Zosimus* (Plate 53), must have been executed in the mid or late thirties, at the moment when landscape was beginning to play a more important part in Poussin's painting. These drawings are among the freshest that the artist ever made, recording an impression felt in front of inanimate nature with a directness that he rarely displays.

In these drawings — as well as in his earliest landscape paintings — Poussin turned for technical inspiration to a tradition with which he had completely broken since he had settled in Rome, that of Northern painting. He evidently found that the brilliant but schematic method which Annibale Carracci and Domenichino used for their landscape studies (Plate 54), while appropriate to the effects which they sought, would have been useless for the precise notation of natural effects which he sought, and he turned quite logically to the technique used by Breenbergh (Plate 55), Poelenburgh and others in their studies of the Roman Campagna.

During the unhappy time that Poussin spent in Paris between December 1640 and September 1642 he was so occupied with painting large altarpieces or allegorical paintings for the King and for Cardinal Richelieu and with planning the decoration of the Long Gallery of the Louvre that he had little time for painting or drawing according to his inclinations. In fact the drawings which date from this period are mainly by assistants and will therefore be considered in Chapter VI where the problem of Poussin's studio will be examined.

It was at about this period that Poussin began to suffer from the shakiness of the hand which affected his drawing style for the remainder of his life. There is no evidence to show what caused it, or exactly how it afflicted him. It is often assumed that it grew steadily worse as he grew older so that the shakier the hand the later the drawing, but this is certainly not the case and it seems to have come on and gone off unpredictably. He first complained of it in a letter written from Paris in June 1642, but there is little tangible evidence of it in the drawings made in Paris, though it is visible in one of the three drawings for the *Scipio Africanus* (C.R. 421), of which the other two are perfectly clear and steady. The same contrast occurs later. Most of the drawings of the late forties are steady, but in a few, such as one for the *Holy Family*

52. Poussin. *A View of the Tiber.* Montpellier, Musée Fabre. Pen and brown wash. 200 x 140 mm. (C.R. 276).
Like the *Five Trees* this drawing was probably made directly from nature, the site being a stretch of the Tiber just above the Ponte Molle, though not, as has often been suggested, the exact site shown by Poussin in his painting of *St. Matthew* in Berlin.

53. Poussin. *St. Mary of Egypt and St. Zosimus.* Windsor Castle, Royal Library. Pen and brown wash. 225 x 310 mm. (C.R. 275).
This is Poussin's earliest known experiment with 'composed' landscape, in which the figures play a minor part and the landscape is based on elements observed in nature but organised so as to make a carefully planned spatial design.

55

on the Steps of 1648 (Plate 82), the artist's hand has trembled badly. In the drawings of the 1650s the shakiness is generally more marked, sometimes producing an extraordinary effect of nervous vivacity (Plates 92, 94), but in some drawings his hand is steady. Even in his very last years he clearly had periods when the shakiness left him, and the last splendid drawing for the *Apollo and Daphne* is perfectly clear in most parts (Plate 101).

Poussin left Paris at the end of September 1642 and travelled by coach to Lyons and thence to Avignon and Marseilles, probably arriving in Rome in November.[14] While at Avignon he made a drawing of the fortifications of Villeneuve-lès-Avignon with the foreground dominated by an arch bearing the papal arms (Plate 56). The drawing is mainly treated with the broad washes typical of the thirties, but the town and hills in the background are drawn with the point of the brush in a manner which foreshadows the landscapes of the later forties. The drawing,

54. (upper left) Domenichino. *Landscape with two Boys.* Chatsworth Settlement, Derbyshire. Drawing.

55. (above) Bartholomeus Breenbergh. *View of Bomarzo.* Paris, Stichting Custodia. Drawing.

Plates 54 and 55 represent the two main styles of landscape drawing current in Rome when Poussin began to be interested in the depiction of inanimate nature. Somewhat surprisingly he borrowed little from the drawings of Domenichino, whose figure painting he much admired, but relied far more on drawings by

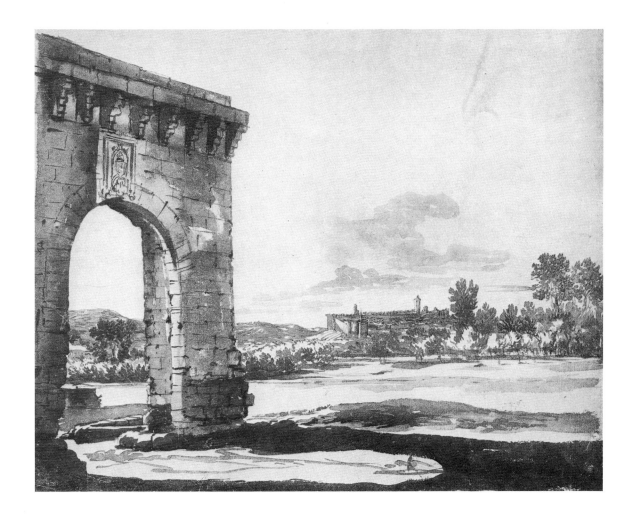

56. Poussin. *View of Ville-
neuve-lès-Avignon.* Chantilly,
Musée Condé. Pen and
brown wash. 219 x 277
mm. (C.R. 272 and V, p.
127).

One of Poussin's very few
landscape drawings repre-
senting a precisely identi-
fiable site. The drawing was
made on his journey back
from Paris to Rome in
November 1642. The arch
on the left has vanished but
the fortifications still stand
and are clearly recognizable.

———

Northern artists with whose
general aims in painting he
had little sympathy.

which is one of Poussin's most luminous creations, seems to be
his hymn of joy at once more seeing the sun of the south and a
landscape which would have reminded him of the Roman
Campagna.[15]

The years after Poussin's return to Rome at the end of 1642
were of crucial importance in the development of his art. They
saw the sudden flowering of his new classical style, manifested in
the second series of *Sacraments* (1644-8) and in a number of
other ambitious compositions, mostly of religious subjects, and
this new heroic style of painting was accompanied by a new style
of drawing.

This new manner appears suddenly in its full maturity in the
magnificent drawing for *Extreme Unction* which can be dated
precisely to the end of March or the beginning of April 1644
(Plate 57). The differences between this drawing and all
Poussin's previous works are very striking. Before this time the

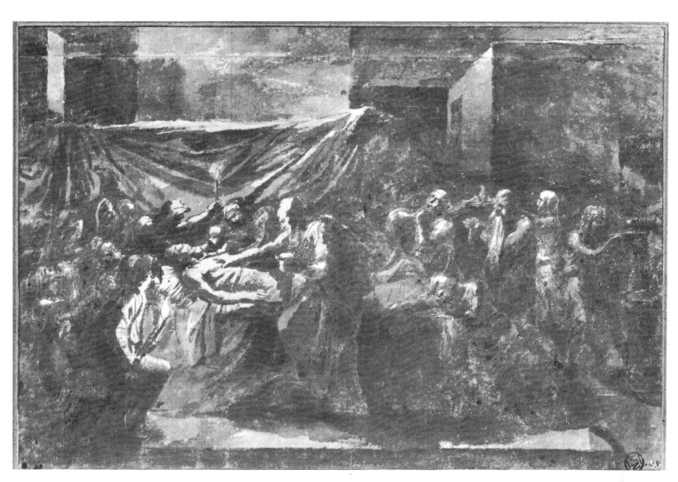
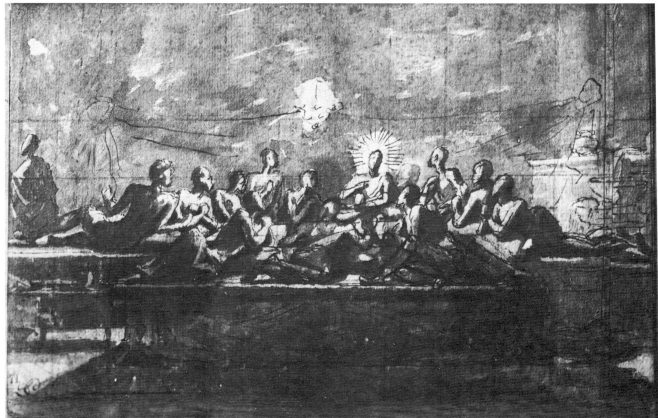

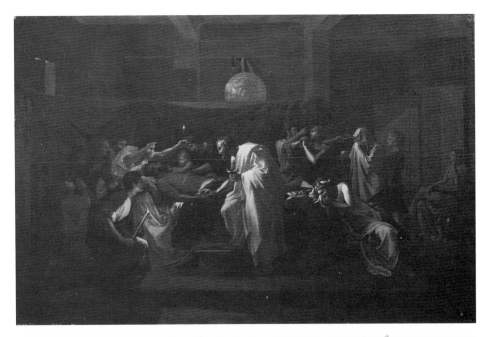

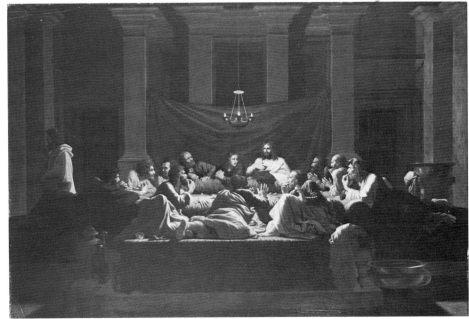

57. (upper left) Poussin. *Extreme Unction.* Paris, Musée du Louvre. Pen and brown wash. 218 x 332 mm. (C.R. 103).

58. (upper right) Poussin. *Extreme Unction.* Duke of Sutherland, on loan to the National Gallery of Scotland, Edinburgh. Painting. 117 x 178 cms.

59. (lower left) Poussin. *Eucharist.* Paris, Musée du Louvre. Pen and brown wash. 157 x 256 mm. (C.R. 100).

60. (lower right) Poussin. *Eucharist.* Duke of Sutherland, on loan to the National Gallery of Scotland, Edinburgh. Painting. 117 x 178 cms.

artist had drawn his figure groups in firm pen outlines, adding the
forms in a bold wash, sometimes worked up to give the inner
modelling, and always with the white of the paper playing a
prominent part in the whole effect. Now line plays a quite subsi-
diary part; the whole composition is built up in layers of wash,
covering all but very small parts of the paper, which is only left
white for the few highlights. The drawing is a creation in terms of
light and shade, building up to the climax in the lamp held up
over the dying man; the whole of the right half of the
composition is enveloped in shadow from which the figures
emerge in ghost-like forms. Technically the greatest difference is
in the actual use of the wash. In the thirties Poussin had always
laid on the first layer in a broad continuous area of uniform tone,
even if he later worked over it with smaller touches to give the
details of the forms; but now even the very lightest washes are
varied and broken in their effect and are covered with other

61. (left) Poussin.
Penance. Montpellier, Musée
Fabre. Pen and brown wash.
210 x 310 mm. (C.R. 99).

62. (upper right) Poussin.
Penance. Duke of
Sutherland, on loan to the
National Gallery of Scotland,
Edinburgh. Painting. 117 x
178 cms.

63. (lower right) Poussin.
Ordination. Duke of
Sutherland, on loan to the
National Gallery, Scotland.
Painting. 117 x 178 cms.

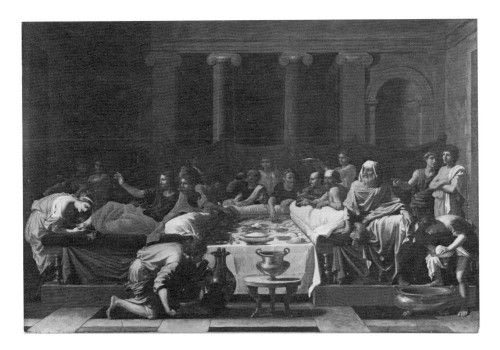

Plates 57-63 represent the
new heroic style created by
Poussin in the years after his
return from Paris at the end
of 1642, which reached its
finest expression in the
second series of *Sacraments,*
painted between 1644 and
1648. The drawings lack the
sensuous charms of the
earlier works, but as expres-
sions of human drama they
have few rivals. Plates 59
and 61 show that Poussin
sometimes employed the
method practised by
sixteenth-century Italian
artists of drawing the figures
in the nude and only adding
the draperies at the last stage
in the evolution of the
composition.

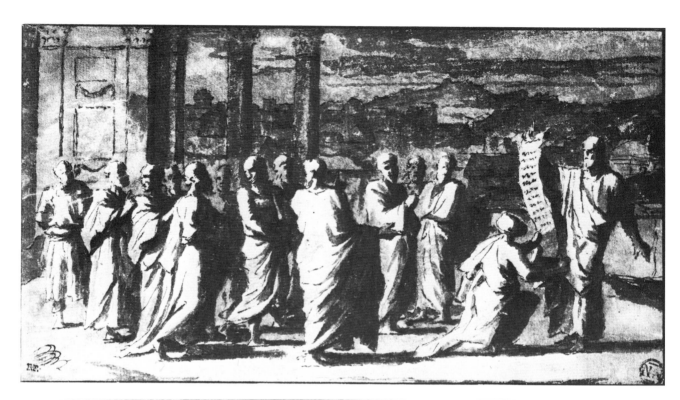

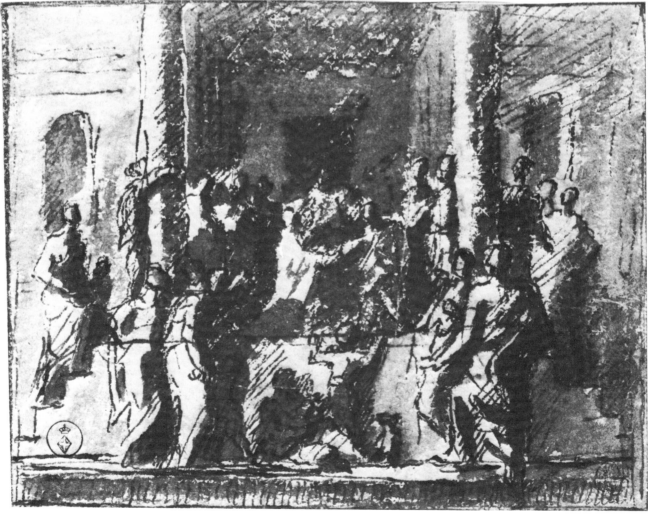

64. Poussin. *Ordination.* Paris, Musée du Louvre. Pen and brown ink. 133 x 246 mm. (C.R. 96).

This drawing must on stylistic grounds be dated to the period immediately after Poussin's return to Rome at the beginning of 1643 — particularly on account of the handling of the clouds, laid in with long strokes made with the point of the brush. It therefore probably represents a first idea for the *Ordination* which was actually painted in 1647. In this drawing Poussin has preserved the composition which he had used for the first version, painted just before the Paris visit, with the Apostles strung out almost in a straight line across the foreground.

65. Poussin. *The Marriage of the Virgin.* Turin, Biblioteca Reale. Pen and brown ink. 78 x 103 mm. (C.R. 92).

Although Poussin used this subject to represent *Marriage* in both series of the *Sacraments,* neither of the paintings bears any relation to the present drawing, which together with two others (C.R. 93-4) was probably made in connection with a quite different painting, as far as we know, never executed. The style suggests a date in the late thirties — that is to say near the first series of *Sacraments* — when Poussin was still using the broad washes of dark brown ink which have been noticed in the drawings of that period (see Plates 34-5, 44).

washes laid on apparently with a dryer brush so that they leave a ragged edge. This process seems to have been repeated several times, either with washes or, as in the drapery behind the bed, with narrower strokes made with the point of the brush to indicate the folds.

In this particular case it might be argued that the style was dictated by the subject, which suggests, even if it does not actually impose, a setting with contrasts of candlelight and deep shadows, and indeed Poussin uses the same technique with great effect for the catacomb setting of *Confirmation* (Plate 130) and for the 'Upper Room' of *Eucharist* (Plate 59), in which the impact of the light on the wall behind the figure group is brilliantly suggested by a series of dagger-like interventions of the white paper; but in fact the change is more fundamental, for Poussin applies the new style with equal effect in the studies for *Baptism, Penance* and *Marriage*, all of which take place in broad daylight, *Baptism* even in the open-air. Naturally Poussin's application of the new technique to daylight scenes is different. In *Penance* (Plate 61) the rough, drily applied wash is limited to the architectural background; in *Marriage* (C.R. 91) it is applied over the figure group as well but it does not absorb the actors into the shadows as in *Extreme Unction*. In the studies for *Baptism* the effect is more varied. The two earliest, in the Uffizi and the Hermitage (Plates 121-2), are markedly different from each other: the former is carefully constructed with pen outlines and touches with the point of the brush, whereas the latter is almost wholly conceived in roughly laid-on washes. The next drawing, in the Louvre (Plate 123) is again dominated by the rough wash, particularly in the treatment of the sky, but in the last of all the studies, also in the Louvre (Plate 124), the two techniques are combined: the basic forms are established in wash but are then redefined in terms of touches with the point of the brush.

It may seem paradoxical that, at the moment when Poussin's style in painting reached its highest point in monumental and sculptural clarity, his drawings should have become less linear and more dependent on the use of wash, but in fact this technique enabled him to give greater clarity to the three-dimensional forms of his figure groups. In the drawings of the thirties the use of a sharp outline tended to emphasise the planar quality of the composition, and to create an almost flat pattern in terms of light

63

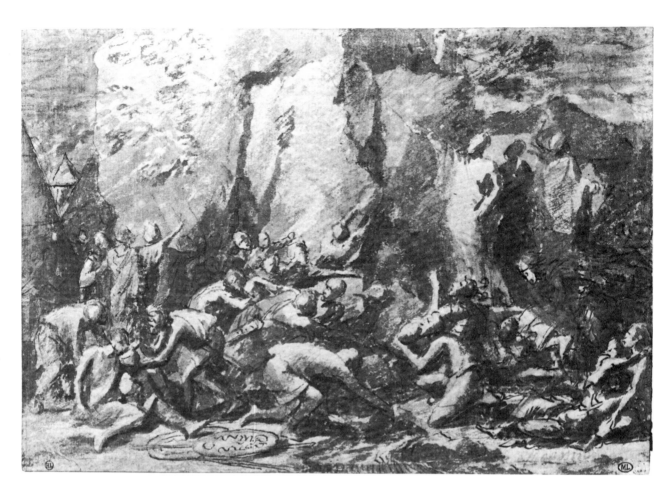

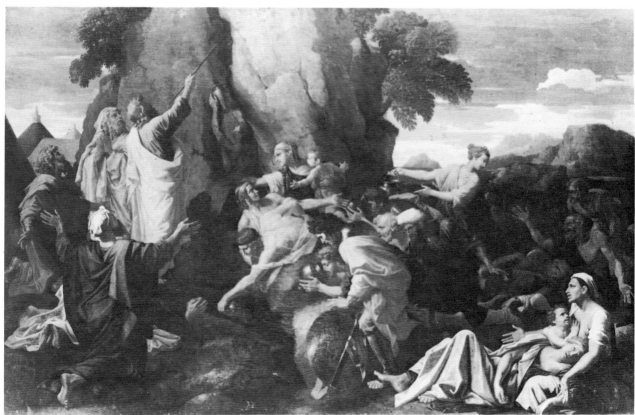

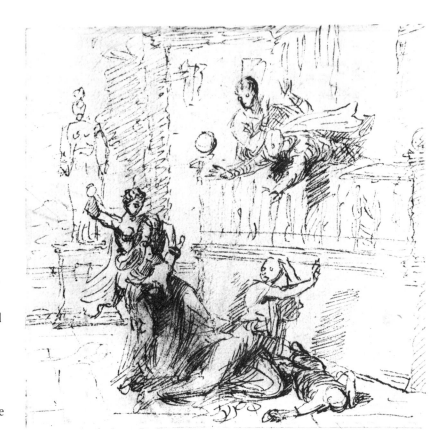

66. (left) Poussin. *Moses striking the Rock*. Paris, Musée du Louvre. Pen and brown ink. 170 x 255 mm. (C.R. 26).

67. (lower left) Poussin. *Moses striking the Rock.* Leningrad, Hermitage. Painting. 122.5 x 193 cms.

The Louvre drawing and the even more dramatic sheet in the Hermitage (C.R. 27) are typical examples of Poussin's new style of the late 1640s. It will be noticed that between the drawing and the painting the artist has made radical changes in the design and has moved the principal figures — Moses and Aaron — from the right to the left-hand side of the composition.

68. (above right) Poussin. *Medea slaying her Children.* Windsor Castle, Royal Library. Pen and brown ink. 161 x 168 mm. (C.R. 223).

This drawing, which must date from the second half of the 1640s, shows that Poussin was capable of producing dramatic effects with the use of pen alone and without the help of wash.

and shade, whereas the new technique allowed a greater subtlety of modelling.

It was also a more effective vehicle for expressing the dramatic qualities which Poussin wished to bring out in his subject. His earlier style of drawing would not have allowed him to convey the tragedy of *Extreme Unction* or of the *Last Supper* as he did in the drawings for the second series of the *Sacraments*; and he was able to apply the method to quite different themes as in *Moses striking the Rock* (Plate 66), a drawing connected with the painting of 1649 in the Hermitage, which he treats in terms of sharp contrasts of light and shade very different from the open daylight effects of the 1638 composition. In two drawings of *Rinaldo carried away from Armida* (Plates 188-9), which can be dated to 1647, the rough use of wash is complemented by an equally rough technique of drawing, which suggests the poignancy of the subject vividly. In this drawing and in the final study for the *Crucifixion* of 1645-6 (Plate 69) the faces take on an almost gro-

65

69. (upper left) Poussin. *The Crucifixion.* Leipzig, Museum der bildenden Künste. Pen and brown wash. Squared 178 x 252 mm. (C.R. 399).

This drawing corresponds in almost every detail with the painting made in 1644 for the Président de Thou (now in the Wadsworth Atheneum, Hartford, Connecticut) and is unusual in being squared for transfer to the canvas (see below, p. 96). The composition includes the figure of Adam rising from his grave at the foot of the cross, a survival from mediaeval iconography unusual in Poussin and indeed in the work of any seventeenth-century artist.

70. (upper right) Poussin. *The Crucifixion.* Paris, Musée du Louvre. Pen and brown ink. Height of each fragment *c.* 170 mm. (C.R. 66 and 68). Composite photograph made up of two fragments of drawings.

The left-hand fragment exists as a separate drawing in the Louvre, but the right-hand part has been mounted with a fragment of another drawing which is in a quite different style and does not show the walls of Jerusalem in the distance.

71. (lower left) Poussin. *The Judgment of Solomon.* Paris, Ecole des Beaux-Arts. 248 x 384 mm. Pen and brown wash over black chalk (C.R. 32).

Study for the painting executed in 1649 for Poussin's friend Pointel, now in the Louvre (Plate 72). Poussin has made one inexplicable mistake in the composition by showing the wicked mother holding her own dead baby whereas it is an essential point of the story that it should be in the hands of the good mother.

72. (lower right) Poussin. *The Judgment of Solomon.* Paris, Musée du Louvre. Painting. 101 x 150 cms.

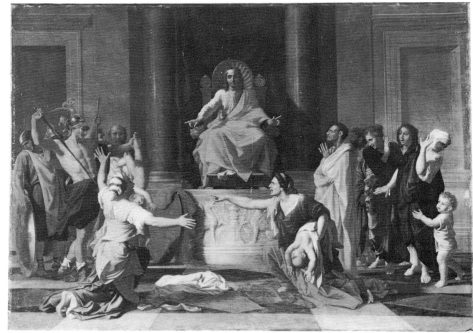

73. (left) Poussin. *The Conversion of St. Paul.* Chantilly, Musée Condé. Pen and brown wash. 186 x 280 mm. (C.R. 71).

tesque character, and are drawn like masks, with the eyes and mouths indicated by simple rounds, a practice which was to be normal with Poussin for the rest of his career. As the result of these new features of his style his drawings become less elegant and less immediately attractive to the eye, but they are also far more expressive. A similar change took place in the paintings of the period. Poussin sacrificed the sensuous charms of Venetian colour and handling in the interests of clarity and dramatic intensity, and in the same way in his drawings he abandoned the rich, transparent washes and the brilliant line of the thirties to attain a greater force of dramatic expression, but he used his new technique in many different ways and to produce very varying effects.

In the studies for the *Judgment of Solomon* (Plate 71) of 1649 the grotesque expressive element is the most obvious feature. Here it is combined with a severely classical composition, whereas in the *Conversion of St. Paul* (Plate 73), probably of 1649-50, the same features are used in a design of almost baroque movement. The same energy appears in the *Death of Hippolytus* (Plate 74), one of Poussin's most baroque inventions — almost as baroque as Rubens's treatment of the same subject — but the technique is much firmer; the broad washes are rough and broken but the foreground group is carefully modelled with hatching executed with the point of the brush. The brush domi-

74 & 75. (right) Poussin. *The Death of Hippolytus.* New York, Pierpont Morgan Library. Pen and brown wash. 225 x 330 mm. (C.R. 222).

This drawing combines the movement and vivacity of Poussin's work of the 1630s with the more careful technique of the forties characterized by the repeated touches with the point of the brush.

On the *verso* (Plate 75) is a dramatic — if slightly clumsy — sketch in pen and ink only, showing the very rarely depicted sequel to the death of Hippolytus in which Aesculapius appears, brings Hippolytus back to life and transports him to Italy, where under the name of Virbius he becomes the tutelary deity of the grove at Ariccia, near Rome, of which Egeria was one of the Votaries.

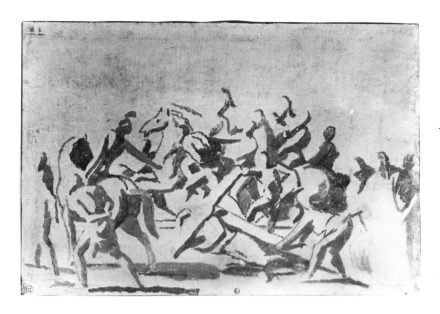

76. (upper left) Poussin. *Christ carrying the Cross.* Dijon, Musée des Beaux-Arts. Brown wash over black chalk. 160 x 250 mm. (C.R. 65 and V, p. 79).

After finishing the *Crucifixion* Poussin was asked by de Thou to paint a picture of Christ carrying the Cross, but he refused, saying in his letter: 'I am no longer gay or healthy enough to undertake these sad themes. The Crucifixion made me ill — I took great pains over it — The Carrying of the Cross would kill me.' (*Nicolas Poussin. Actes du Congrès (1958)*, Paris, 1960, II, p. 219).

77. (left) Poussin. *Studies for Moses and the Daughters of Jethro.* Paris, Musée du Louvre. Pen and brown ink. 160 x 188 mm. (C.R. 13).

This sheet of sketches for the composition reproduced as Plate 78 is on the *verso* of a study for the *Finding of Moses* of 1647. It illustrates Poussin's method of working out the details of a composition, making a fairly large study of the main group (in fact probably of the whole composition because the sheet is cut on the right), then redrawing the group of the three standing women and finally turning the sheet round and adding two — possibly even three — quick sketches of the women actually drawing water from the well.

nates the drawing of *Christ carrying the Cross* (Plate 76) of 1646 to the total exclusion of the pen; the figures are drawn with thin brush strokes, which define the forms by two sharply contrasted areas of shadows and lights. The technique is effective for the

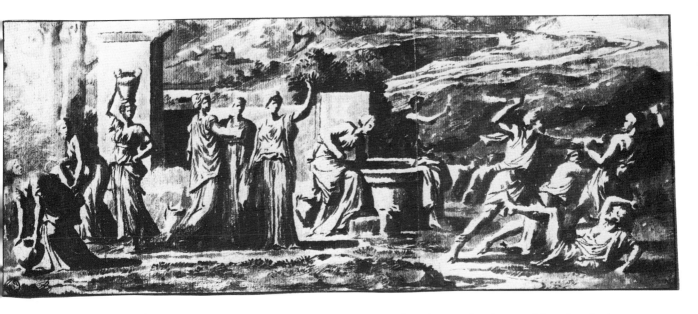

78. (above) Poussin.
Moses and the Daughters of Jethro. Paris, Musée du Louvre. Brown wash over black chalk. 173 x 434 mm. (C.R. 15).

This and *Christ carrying the Cross* are two of the rare drawings which Poussin made with the brush and without using a pen for drawing the outlines, which are only indicated in black chalk. In spite of this however the *Moses* has the utmost sharpness both in the general bas-relief composition and in the definition of the individual forms. Its size and finish suggest that it was made as a work complete in itself and not as a study for a painting. A recently discovered drawing for the same composition, now on loan to the Fogg Museum, Harvard University, suggests that the Louvre drawing may extensively be cut at the top.

rendering of a dramatic scene, but it can also be used for classical calm, as in the big drawing of *Moses and the Daughters of Jethro* (Plate 77), an exceptionally finished work probably intended to be complete in itself. Here the brush technique is applied to the landscape as well as to the statuesque figures to produce an effect of unusual grandeur.

Poussin's new style could equally well be applied to subjects with few figures, for instance the Holy Family, which he frequently painted in the last years of the forties and in the early fifties. The three drawings connected with the *Holy Family on the Steps* of 1648 (Plates 82-3 and C.R. 45) are all conceived in a curious 'cubic' style appropriate to the geometrical character of the whole composition, though in one the effect is blurred by the shakiness of the line. This drawing is however particularly dramatic in its treatment of light and shade. A drawing in Stockholm for a different composition (Plate 84) shows the 'grotesque' style at its most effective, while two others, both related in their figure group to the *Holy Family under a Tree* in the Louvre which probably dates from just after 1650 (C.R. 48-9), are much calmer in treatment, so that nothing disturbs the clear pyramid of the figure group.

The 1640s were marked in Poussin's painting by an increase in the importance of landscape and it was in 1648 that he produced the great series of landscape paintings illustrating Stoic

71

79 & 80. (upper and middle left) Poussin. *The Holy Family under a Tree.* London, British Museum. Pen and brown wash. 206 x 323 mm. (C.R. 55).

This drawing shows several interesting points about Poussin's methods of working. The sheet, which appears to have been cut on all four sides, has drawings on both sides. The *verso* (Plate 80) has a fairly finished drawing of a landscape with a flaming castle, which appears in several of Poussin's paintings of about 1648 and also in the drawing at Düsseldorf (Plate 86), and was probably drawn first. Then Poussin turned the paper over and using it as an upright sheet made a rough sketch of the Holy Family with putti, which is also related to paintings of the years 1648-50, though it is not an exact preparatory study for any one of them. Finally he turned the sheet round again and made another sketch for the principal figures of the first composition. Then, as if not interested in this sketch but anxious to preserve the first study, he drew a line across the sheet, running right through the second sketch and used the remaining blank part of the paper to make a draft of a letter. He took the trouble to leave three of the figures in the second sketch visible, but three lines of the draft cut right across the seated figure on the left. The draft of the letter is not dated, but in it Poussin refers to the despatch of a painting of the *Ecstasy of St. Paul* painted for the poet Paul Scarron and finished in 1650.

81. (lower left) Poussin. *The Holy Family on the Steps.* Washington, D.C., National Gallery. Painting. 68.9 x 96.5 cms.

Plates 82 and 83 illustrate two studies for the Washington painting, one of Poussin's most carefully conceived and worked out compositions, constructed in almost pure geometrical forms, and this feature is already visible in the drawings, particularly in Plate 83 with its emphasis on the forms of the steps, walls and piers and the indication of a simple Doric portico covering it as well as in the simplified treatment of the figures.

82. (upper right) Poussin. *The Holy Family on the Steps.* New York, Pierpont Morgan Library. Pen and brown wash. 184 x 251 mm. (C.R. 46).

83. (lower right) Poussin. *The Holy Family on the Steps.* Paris, Musée du Louvre. Pen and brown ink. 184 x 247 mm. (C.R. 47).

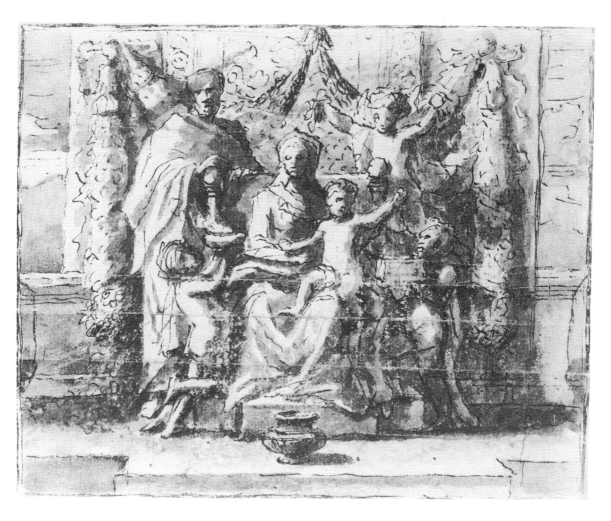

themes such as the stories of Phocion and Diogenes. In these paintings Poussin gave to nature a grandeur suitable to the heroic story for which it acts as a setting, and he sacrificed the freshness of the earlier experiments in landscape painting to attain the clarity and monumentality which he sought in his figure paintings. A similar change can be seen in the landscape drawings. Even those which represent actual sites, such as the slope of the Aventine (Plate 85), the Belvedere of the Vatican (Plate 140) or the Tiber valley (Plate 139), are much more considered that the direct studies of trees which Poussin had made in the thirties, and they are already conceived as mature spatial compositions; but the greater number were clearly made as preparations for paintings.[16] In some cases, such as the big drawing of a river valley at Düsseldorf (Plate 86) and the landscape with a blazing castle (Plate 80) on the *verso* of the *Holy Family under a Tree* in the British Museum, the paintings for which they were

85. (right) Poussin. *The Aventine.* Florence, Uffizi. Brown wash over black chalk. 134 x 312 mm. (C.R. 277).

This drawing, which is one of the very few by Poussin representing a specific site, shows a view of the Aventine, Rome, seen from the north bank of the Tiber with the buildings of the Priory of Malta on the skyline. The drawing, which may have been made directly from nature, shows the scene under the strong mid-day sun, which forms haloes of light round the trees, an example of Poussin's close observation of natural effects in his landscape drawings.

74

84. (left) Poussin. *The Madonna enthroned.* Stockholm, National Museum. Pen and brown wash. 157 x 190 mm (C.R. 52).

No painting is known of this composition which is unique in Poussin's work in showing the Virgin and Child seated on a throne in front of a brocade curtain over which hang swags of fruit. The hieratic frontal pose is consciously archaic; the curtain reminds one of the Madonnas of Giovanni Bellini and the swags are taken from Mantegna, an artist whom Poussin greatly admired. He owned a large number of engravings after Mantegna's compositions and he would almost certainly have seen the frescoes on the vault of the Ovetari Chapel in the Eremitani church at Padua — where similar swags occur — on his way from Venice to Rome in 1624.

intended can be identified; with others, such as a drawing in the Hermitage (Plate 143), this is not the case but it is clearly conceived as a complete composition, punctuated by figures and architecture. Some of these drawings which probably date from the middle of the forties are executed with the brush only, while others are mainly in pen.

The transition to the 1650s is made by an extraordinary work, the drawing of the *Rape of Europa* (Plate 87), now in Stockholm. This measures twenty-six by fifty-seven centimetres and is drawn on a sheet composed of several pieces of paper which Poussin had previously used (Plate 88). One of these contains two slighter studies for the same composition; one has a drawing for the *Moses striking the Rock* in the Hermitage; and one has the *Madonna enthroned* shown on Plate 84. The edges are made up with further pieces of paper, some blank, some with undecipherable fragments of drawings. Although Poussin has in this way sacrificed several of his drawings to make up the sheet, he has taken care to cut them in such a way that as much as possible of the actual drawings survives. For instance the sheet with the studies for *Europa* is cut so that both figure groups are included, but one edge is cut irregularly so that it covers as little as possible of the Moses drawing on which it is stuck down. All the

86. (upper left) Poussin. *Landscape with a blazing Castle and a Basilica.* Düsseldorf, Kunstmuseum. Pen and brown ink over black chalk on grey paper. 200 x 540 mm. (C.R. 286).

The largest and one of the most impressive of Poussin's landscape drawings. No painted version of the composition is known, but the drawing contains features such as the blazing castle which occurs in other drawings (Plate 80) and in the painting of *Orpheus and Eurydice* now in the Louvre. On the *verso* is a variant of the same landscape and also a sketch connected with the *Finding of Queen Zenobia* (Plate 187).

87 & 88. (middle and lower left) Poussin. *The Rape of Europa.* Stockholm, National Museum. Pen and brown wash. 263 x 572 mm. (C.R. 166).

For this exceptionally large drawing Poussin stuck together three sheets that he had already used (see Plate 88); one with a study for a *Madonna* (Plate 84); one with a drawing of *Moses striking the Rock* (C.R. 25); and one with two slight sketches for the *Europa* (C.R. 167-8). Only a fragment of the painting survives.

89. (right) Poussin. *The Rape of Europa.* Florence, Uffizi. Pen and brown ink. 180 x 260 mm. (C.R. 169).

This must be one of Poussin's first ideas for the *Europa*, since although it seems to be complete — perhaps slightly cut at the edges — it only shows the left half of the composition, without the group of Eurydice and the snake which is an important element in the final composition.

operations involved in making up this sheet must have taken place in a very short space of time, because the *Europa* was commissioned in 1649, the same year as the *Moses striking the Rock.*

The drawings on the *verso* represent the style of the late forties, but when we turn to the *recto* we are in a different world. After ten years during which he painted and drew only religious subjects or themes from ancient history Poussin has turned back to the myths of ancient Greece and Rome, not however as erotic stories but as symbols of the forces of nature. For the stories he still follows Ovid but his intention is deeper and more serious than in his earlier illustrations to the poet. His gods and even the human beings taking part in the scene have a gravity quite unlike the gay or melancholy figures which appear in the early Ovidian scenes; and, above all, nature plays a new part. The *Europa* is like a majestic group of sculpture, set in, not merely against, a landscape. Nature is here as important as man, and figures and landscape are fused into a single unity which expresses Poussin's almost pantheistic philosophy. The story of *Europa* is for him a symbol of the fertility of nature embodied in Jupiter, the bull, echoed in the herds of cattle and in the seated shepherd, who is probably Apollo guarding the herds of Admetus, and finally reflected in the grandeur of the landscape itself, in which — since Poussin is always at heart a humanist — man's works play their part in the form of a walled town around a harbour and a castle — in fact the Castel S. Angelo — from which burst threatening clouds of smoke.

The figure composition is made up of two groups: the agitated maidens round Europa and the bull on the left and the massive

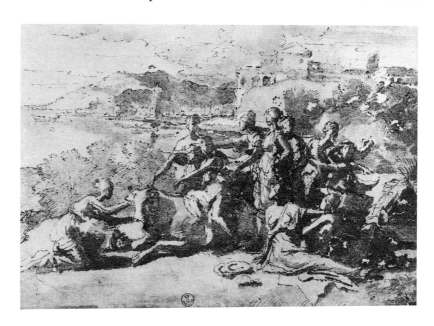

river-god and naiads on the right. The two are linked by various devices. The figure of Eurydice, springing back in fear at the sight of the snake, leads from one group to the other while above her, prominent and isolated, sits Apollo beside a little shrine. A more subtle link is formed by the network of tension created by the figures gazing at each other across the gap: Eurydice and her companion look in fear at the snake, and the river god and one naiad gaze at them unmoved. This method is used again in the left-hand group where all the maidens gaze fixedly at Europa.

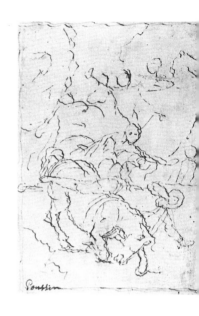

The principal group is built up like the sculpture of a Greek pediment with the left-hand maiden and Eurydice filling the corners, and this triangle is echoed on a smaller scale by the group of river god and naiads on the right. The landscape reflects the forms of the figure group: just over the head of Europa is the peak of a mountain, the mass formed by her companions is carried on into the trees behind them, and the castle forms the apex of a triangle which bridges the gap in the middle of the composition and is continued by the lines of the hill, so that the whole design takes on the form of two pediments subsumed under a single larger one, a scheme familiar in the architecture of the seventeenth century.

In the left-hand group there is a strong movement out of the composition, actual in the flying figures of Mercury and Cupid, and implied in Europa and the bull; but it is all checked by the maiden who kneels before the bull and winds a wreath of flowers round his horns. The right-hand group is static, but has a certain tension created by the contrasting actions of the figures, two of whom gaze to the left, while the third — the nymph squeezing water out of her hair — faces to the right and completes the triangle.

No other drawings of importance survive from the first years of the fifties, but the period 1655-7 is represented by a considerable group. In almost all of them the hand of the artist is very shaky; indeed some of the drawings are difficult to decipher, but even in these cases something impressive emerges; for instance in a drawing of the *Conversion of St. Paul* (Plate 90) the clumsy action of the saint falling off his horse is dramatically conveyed, and in *Achilles among the Daughters of Lycomedes* (C.R. 106) the effect of surprise is vividly expressed and is perhaps even heightened by the nervous quality of the line. In the study for the

78

Death of Sapphira (Plate 92) the effect is electric. Poussin leaves out all detail to concentrate on the charged gazes of all the figures, shooting across the surface of the composition, strengthened by the balancing gestures of St. Peter and the woman on the left. The artist seems to have found this device too obvious and in the painting the figure of the woman is turned round, so that she walks out of the composition.

The two most remarkable drawings of this period are the *Birth of Bacchus* (Plate 95) and *Venus at the Fountain* (Plate 97). The first is a study for the painting of 1657, which like the drawing is in the Fogg Museum; the second, datable to the same year, was used by an inferior artist, perhaps Antoine Bouzonnet Stella, as the basis for a painting in a French private collection.[17]

These drawings are a direct development out of the *Europa*; in both landscape plays as important a part as human beings; in the

90. Poussin. *The Conversion of St. Paul.* Leningrad, Hermitage. Pen and brown ink. 130 x 90 mm. (C.R. 69).

91. Poussin. *Mutius Scaevola.* Leningrad, Hermitage. Pen and brown ink. 132 x 140 mm. (C.R. 418).
 These are two examples of the shakiness of Poussin's hand in his last years. In the St. Paul it almost heightens the dramatic effect of the saint falling suddenly — even clumsily — from his horse, and in the *Mutius Scaevola* it does not detract from the vertical severity of the composition.

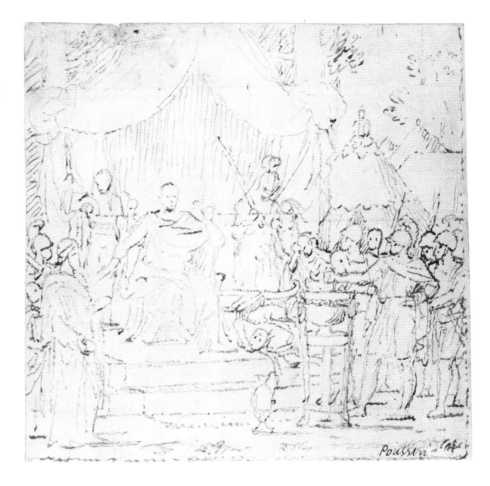

92. (upper left) Poussin. *The Death of Sapphira*. New York, Private Collection. Pen and brown ink. 195 x 302 mm. (C.R. 407).
93. (lower left) Poussin. *The Death of Sapphira*. Paris, Musée du Louvre. Painting. 122 x 199 cms.

The comparison between the drawing and the painting shows the degree to which Poussin in his later years monumentalizes in his paintings the nervous, dramatic quality of his first sketches.

94. (above) Poussin. *Hercules shooting the Stymphalian Birds*. Leningrad, Hermitage. Pen and brown ink. 129 x 165 mm. (C.R. 442).

This sketch shows how vibrant Poussin's drawing can be even when his hand was at its shakiest. It also reveals an unusual intensity of observation of animals, which do not usually play much part in his work.

Bacchus and probably in the *Venus* the theme is an allegory of fertility; and in both the richness of nature is emphasised by the thick foliage of the trees and in the *Bacchus* by the heavy fruit of the vine. They are as moving examples of Poussin's late poetic style as the paintings of the same phase, the *Bacchus* itself and the *Landscape with Orion* in the Metropolitan Museum.

During the last years of his life Poussin's activity as an artist was restricted by his increasing ill-health. His documented works after 1660 are limited to one figure painting, *Christ and the Woman of Samaria*, the landscapes representing the four Seasons, and the *Apollo and Daphne* in the Louvre (Plate 98), which he abandoned unfinished in 1664, the year before his death. No drawings survive for the paintings of the Seasons[18] but surprisingly a whole series is known connected directly or indirectly with the *Apollo and Daphne*.

These drawings, which culminate in the magnificent sheet in the Louvre, show that Poussin's methods had changed again, this

95. (upper left) Poussin. *The Birth of Bacchus.* Cambridge, Mass., Fogg Art Museum. Pen and brown wash. 228 x 375 mm. (C.R. 433).

96. (lower left) Poussin. *The Birth of Bacchus.* Cambridge, Mass., Fogg Art Museum. Painting. 114.5 x 167.5 cms.

The drawing shows Apollo in his chariot over the grotto, whereas in the painting he is replaced by the rays of the rising sun.

97. (right) Poussin. *Venus at the Fountain.* Paris, Musée du Louvre. Pen and brown wash. 250 x 230 mm. (C.R. 212).

In this magnificent late drawing Poussin's hand is shaky but he established the main features of his composition — and even the architectural details — with absolute security. The drawing was used by another artist as the basis for a painting (see p. 174).

98. (upper left) Poussin. *Apollo and Daphne.* Paris, Musée du Louvre. Painting. 155 x 200 cms.

99. (upper right) Poussin. *Apollo guarding the Herds of Admetus.* Turin, Royal Library. Pen and brown ink. 290 x 423 mm. (C.R. 179).

100. (lower left) Poussin. *Apollo and Daphne.* Leningrad, Hermitage. Pen and brown ink. 127 x 152 mm. (C.R. 175).

101. (lower right) Poussin. *Apollo and Daphne.* Paris, Musée du Louvre. Pen and brown wash with alterations in black chalk. 310 x 430 mm. (C.R. 174).

Plates 99, 100 and 101 reproduce drawings made by Poussin in connection with the painting of *Apollo and Daphne* now in the Louvre (Plate 98), his last work, which he gave to his friend Cardinal Camillo Massimi in an unfinished state in 1664 when he realised that he was too ill to complete it. The drawings show that he was playing with various different themes connected with Apollo, some of which he eventually discarded to concentrate on the theme of the god's frustrated love for Daphne, represented — with many allegorical allusions — in the painting and in the Louvre drawing which corresponds to it in all essentials.

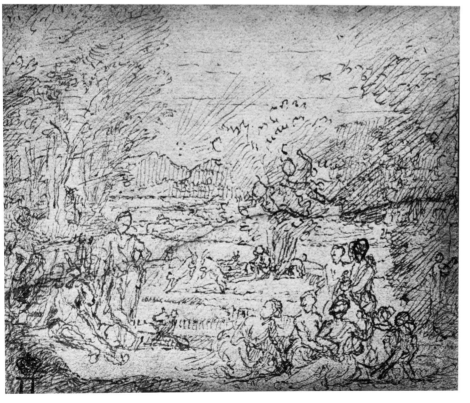

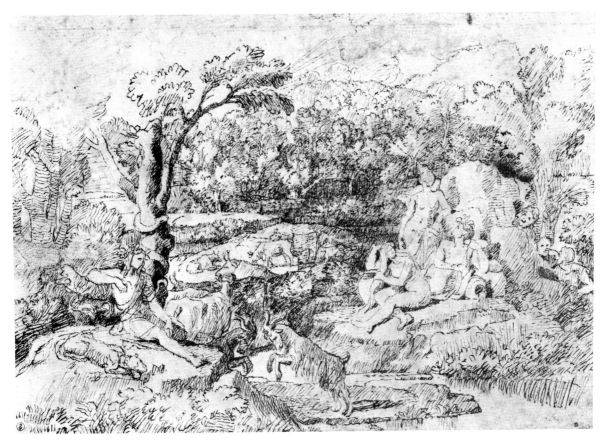

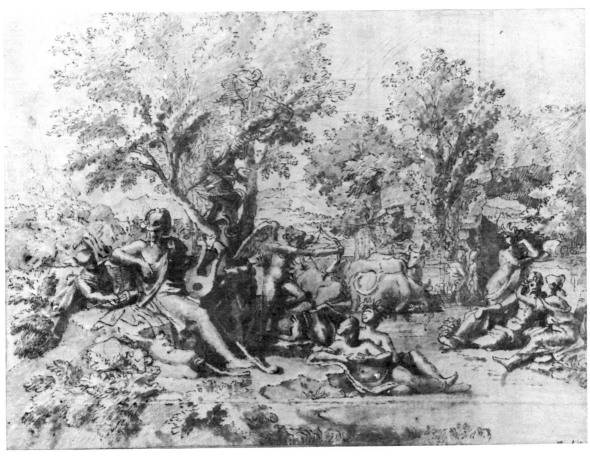

time in a more fundamental way. The drawings surviving from his earlier years show that he generally followed a more or less straight path from his first idea, jotted down in a rough sketch, to a composition which corresponded accurately with what he was actually to paint on the canvas. He sometimes dropped a motif and then took it up again, but there was never any hesitation about the principal theme of the composition or about the general conception which he had in mind.[19]

In the case of the *Apollo and Daphne* he seems to have played with a number of different themes, all related to Apollo but differing from each other in quite essential features. The central motif is the story of Apollo and Daphne, but one drawing in Turin (Plate 99) shows Apollo guarding the herds of Admetus, while another, known only from a copy in the Louvre, represents him shooting an arrow at a lizard (C.R. 177), an episode recorded by Pliny as the subject of a statue by Praxiteles. This drawing also includes the theme — not apparently otherwise treated in seventeenth-century painting — of Mercury stealing an arrow from the quiver of Apollo. another drawing, in the Uffizi (C.R. A 46), shows the story of Apollo and Daphne in the foreground, while in the distance Jupiter appears handing over Io, transformed into a heifer, to Argus. Yet another (Plate 100) represents Apollo with his sheepdog, presumably therefore in the role of shepherd to Admetus, but it must also represent the story of Apollo and Daphne, because on the right one can just decipher the figure of Cupid aiming his arrow at Apollo. Next to him is a group of girls, one of whom looks round at the god in surprise and appears to be hiding something from him. This part of the composition is related to two other drawings where the figures are seated in melancholy poses as if in mourning (C.R. 175, 176; cf. also V, p. 90).

In the final drawing (Plate 101) and in the painting Poussin has dropped many of the motifs which appear in the earlier studies, and has concentrated on the central theme of Apollo and Daphne, though he still includes the mysterious episode of Mercury stealing an arrow from the quiver of Apollo.

As drawings many of these studies are slight and confused but the final version has real magic. The artist's hand is surprisingly steady and conveys his intention with perfect clarity. Figures, herds, trees and distant landscape are each treated in the manner

102. Poussin. *Self-Portrait.* London, British Museum Red chalk. 375 x 250 mm. (C.R. 379).

The inscription under this drawing, which dates from the late seventeenth century, states that it was made when Poussin was ill in about 1630. It shows an astonishing frankness of approach combined with brilliant control of the medium of red chalk.

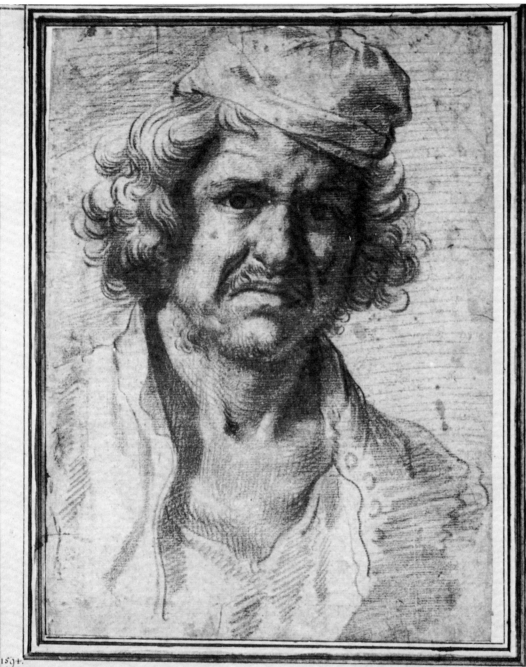

1594. 1665.

Ritratto Originale simigliantissimo di Mons.' Niccolò POSSINO fatto nello specchio di pro
pria mano circa l'anno 1630. nella convalescenza della sua grave malattia, e lo donò al Cardinale
de Massimi allora che andava da lui ad imparare il Disegno. Notisi che và in stampa nella sua
vita il Ritratto ch'ei dipinse per il Sig. Chatelou l'anno 1650. quando non aveva che anni 56. Fù
buon Geometra, e prospettivo, e studioso d'Istorie. A Niccolò Possino è obbligata l'Italia, e massi=
me la Scuola Romana d'avergli fatto vedere praticato lo stile di Raffaello, e nell'antico da lui com
preso nel suo fondo sostanziale imbevuto ne i suoi primi anni, poichè nacque nobile nel Conta=
do di Soison di Piccardia in Andelò l'anno 1594. Andò à Parigi, dove dal Matematico Regio
gl'erano imprestate le stampe di Raffaello, e di Giulio Romano, sulle quali indefessamente, e di
tutto suo genio s'affaticò su quello stile di disegnare ad imitazione, e di colorire à proprio talen
to. Fù trattenuto à Parigi per alcuni quadri ordinatili l'anno 1625. per la Canonizazione di
S. Ignazio, e S. Francesco Xaverio. Nell'Ospedale studio d'Anatomia in Roma venuto quà
nel 1624. per il Naturale all'Accademia del Disegno.

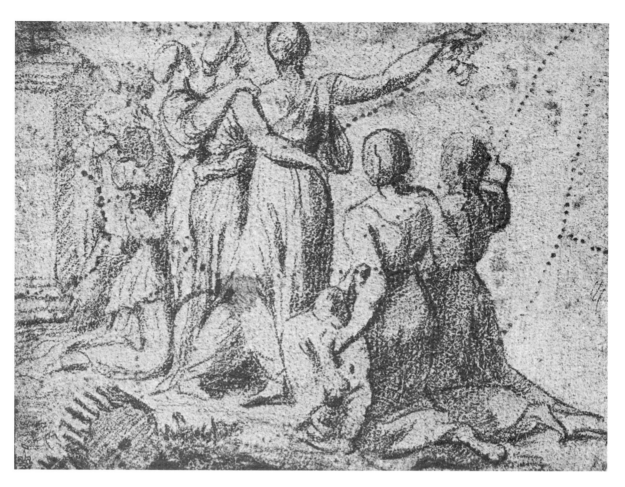
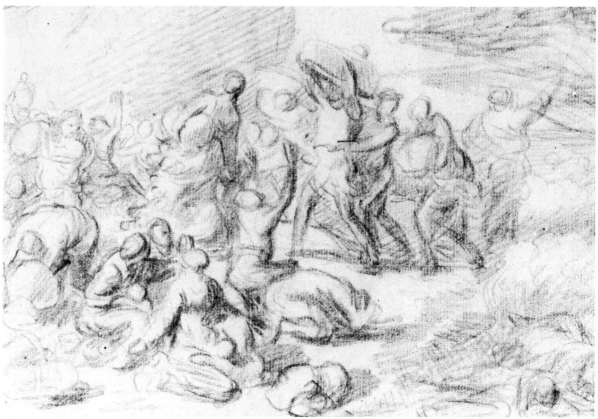

appropriate to them: the figures are firm and sculptural, the cattle square and heavy, the trees rich and bushy, the mountains sharp and angular; and the whole composition is brought together by the wash, which is here used with a subtlety not often found in Poussin's drawings after the 1640s. As Poussin himself would have said, the head that guided the hand was as clear as ever, but rarely at this time was the servant to fulfil the commands of its master so brilliantly.

* * *

Generally speaking Poussin was remarkably consistent in the technique of his drawings, which were almost always executed in pen and rather pale bistre wash, quite different from the rich dark colour, near to sepia, used by Claude, but on occasion he deviated from his normal practice and used different media.

One of the most interesting of these 'eccentric' groups is composed of drawings in which Poussin used red chalk only, without any strengthening with pen or wash. This technique was common in Rome in the early seventeenth century and was widely used by the Carracci and their followers, both for studies from the posed model and for compositional sketches. Poussin probably used it in his lost drawings from the posed model, since this was almost universal practice, but the surviving examples are of a different kind, and in them he seems to have used a common sixteenth-century technique, rather than that of his immediate predecessors in Rome.

The most spectacular of these red chalk drawings is the self-portrait in the British Museum (Plate 102).[20] It is a drawing of exceptional vigour and reveals in Poussin a power of observation and a frank naturalism which do not normally come to the surface in his paintings or his drawings, though his contemporaries tell us that he was a constant observer of men and their actions and it is this basis in the direct study of nature that gives life even to his most abstract conceptions.

In his early drawings Poussin quite often used red chalk for the first blocking in of the composition but he then generally went over the drawing with heavy pen and ink strokes so that the chalk hardly remains visible.[21] In some cases however he worked the drawing up to a finished state in chalk only. Examples of this are the studies for the *Triumph of David* at Dulwich (Plate 103), the

103. Poussin. *Triumph of David*. Chantilly, Musée Condé. Red chalk. 120 x 165 mm. (C.R. 29).
Study for the painting at Dulwich, probably executed *c*.1627-30. The drawing is unusual for Poussin in being entirely executed in red chalk. The lines pricked across it form part of a cartoon made to transfer the group of women shown in the drawing from one position in the canvas to another (see pp. 96-7).

104. Poussin. *The Crossing of the Red Sea*. London, Sir Anthony Blunt Collection. Red chalk. 152 x 225 mm. (C.R. 386).
Most of the preparatory drawings for the *Crossing of the Red Sea*, now in Melbourne, are executed in Poussin's normal technique of pen and brown wash (see Plates 27-8), but at a relatively late stage in the evolution of the composition he made this unusual one in red chalk. The drawing of the seated women in the foreground is reminiscent of the study for the *Triumph of David* (Plate 103), but the whole drawing is bolder in its handling of the chalk.

Crossing of the Red Sea (Plate 104) and the *Nymph and Satyr* at Kassel (Plate 105). The study for the *Triumph of David* is connected with the early stages of the composition and therefore probably dates from about 1627. The handling of the chalk is competent but staid, and in the *Crossing of the Red Sea* Poussin seems much more at home with the medium. The drawing is so different in character from the painting that one would at first surmise that it represented an early experiment with the composition, but in certain details, such as the group on the extreme right, the chalk drawing is closer than the pen and wash studies to the final design, and it seems that, at a quite advanced stage in developing the design, Poussin turned aside to make a study of certain groups in this unusual medium.

The *Nymph and Satyr* is nearer to being a final study for the painting to which it corresponds than are the two drawings just discussed. The group of the nymph riding on the shoulders of the satyr and the putto on the left are almost exactly as in the painting, but in the drawing Poussin has not yet introduced the youth carrying the basket of fruit on his head who in the painting fills the right-hand half of the composition.

The study for the *Ascension* at Windsor (Plate 106) is also from Poussin's own hand, though no painting connected with it is known. It is difficult to date, but was probably made in the late 1630s.[22]

The only other known red chalk drawings by Poussin are sketches for details of the *Massacre of the Innocents* and the *Kingdom of Flora* (C.R. 394-5a), both of which date from about 1627-30, and it seems fairly clear that Poussin did not continue to use the medium in his later life. By the time of the Paris journey he seems to have abandoned it in favour of the more austere technique of black chalk.

Before the Paris journey he had often used black chalk to indicate the general outlines of his figure groups, but in all except a very few cases he went over the drawings with pen and ink.[23] The earliest drawings in which Poussin used black chalk only, apparently as a complete statement, are three of the *Birth of Venus* (Plate 107, C.R. 203-4) which can probably be dated to about 1636 on account of their connection with the Philadelphia *Triumph of Neptune*.

Even in these drawings Poussin handles the black chalk much

105. (right) Poussin. *Nymph and Satyr.* London, British Museum. Red chalk. 185 x 169 mm. (C.R. 229).
This drawing, made as a preparation for a painting at Kassel, shows how freely Poussin could use red chalk when he wished to do so; indeed the style almost suggests the virtuosity of French eighteenth-century draughtsmen, such as Fragonard.

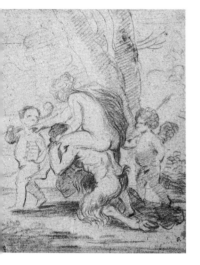

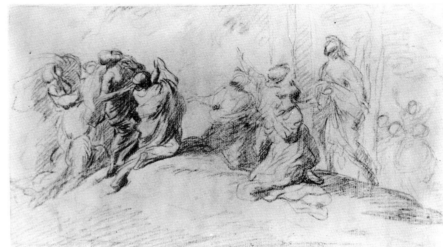

106. (above right) Poussin. *The Ascension.* Windsor Castle, Royal Library. Red chalk. 145 x 265 mm (C.R. 403).

This drawing, which is another of the rare examples of Poussin's use of red chalk, is cut at the top and probably only represents the lower half of the composition which must have included the figure of Christ himself ascending to heaven.

more roughly than he had used the red chalk in his studies of the same period, and the figures — particularly in the heads — take on something of the grotesque character which marks the later black chalk drawings. This is more clearly apparent in another slightly later drawing of the same subject differently conceived with the three Graces greeting the goddess (Plate 181), and in a study for the *Scipio and the Pirates* of 1640-2 (C.R. 421). The black chalk style only reaches its full development however in the 1650s in the studies for the 1651 *Finding of Moses* (C.R. 6-8) and the *Three Marys at the Sepulchre* (Plate 193) in which a single thick but shaky line is made the vehicle to express an enigmatically moving vision of the subject.

Poussin occasionally used the medium for mythological subjects as in two very late drawings of *Children playing* (Plate 108) in which he takes up a theme that he had treated in the *Children's Bacchanals*, now in the Galleria Nazionale d'Arte Antica, Rome.[24] The austerity of the black chalk medium serves to intensify the mood of remote contemplation which distinguishes Poussin's late mythological fantasies from his playful experiments with similar subjects in the 1620s.

We have already seen that in some drawings dating from the late forties — such as the *Christ carrying the Cross* and *Moses and the Daughters of Jethro* (Plates 76-7) — Poussin uses bistre wash without any pen work, but there is another group in which the same technique is used in a very different manner. In these

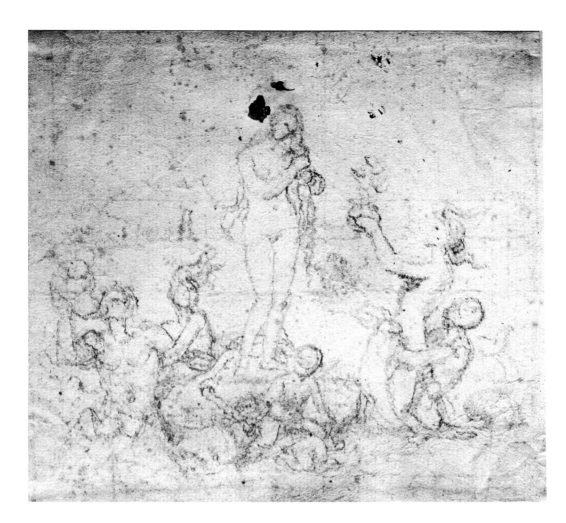

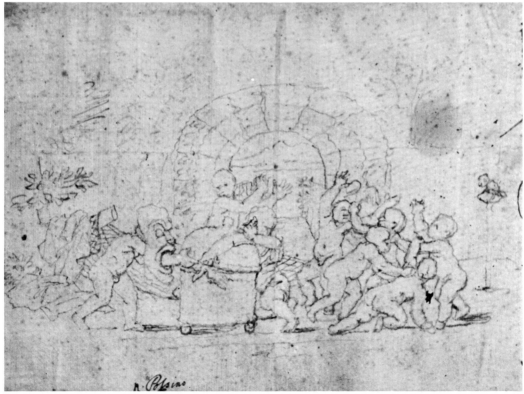

the wash is laid on much more boldly, making a broad pattern of light and shade which establishes the main forms without showing the details of the modelling. None of these drawings is directly related to any known painting by Poussin, but they must be earlier than the group just discussed, since the use of wash is comparable to drawings of the mid or late thirties in which pen is used. The borderline between Poussin's own drawings in this medium and those of contemporary artists such as Jacques Blanchard or Pier Francesco Mola is not easy to establish, but generally speaking Poussin arrives at a clearer statement of the forms than his imitators. Typical examples of his use of this technique are the *Adoration of the Shepherds* (C.R. 36) and the *Galatea* or *Birth of Venus* (Plate 109), and to those should almost certainly be added the *Shepherds presenting Offerings* at Chantilly (C.R. B 26 and V, p. 117).

These excursions into unusual techniques were rare with Poussin and generally speaking his manner of drawing, like his style in painting, developed steadily and consistently, gaining in expressive power what it lost in elegance and charm, and culminating in an elliptical manner designed to express the poetical and philosophical mood of his last compositions.

107. (upper left) Poussin. *The Birth of Venus.* Rome, Gabinetto Nazionale delle Stampe. Black chalk. 132 x 153 mm. (C.R. 202).

This drawing, which might represent either Venus or Galatea is one of the few examples of sketches made by Poussin solely with black chalk.

108. (lower left) Poussin. *Children playing.* Rome, Gabinetto Nazionale delle Stampe. Black chalk. 182 x 259 mm. (C.R. 237).

As in many other late works, Poussin returns here to a theme which he had treated in his first years in Rome, but both the spirit and the technique are different. Poussin's primary interest is now in the symbolical meaning of Bacchic themes of this type which he renders in an expressive line, somewhat clumsy owing to his shaky hand. For a painting by a French follower of Poussin based on this drawing, see Plate 195.

109. (right) Poussin. *Galatea* or *Birth of Venus.* Stockholm, National Museum. Brown wash over black chalk. 141 x 200 mm. (C.R. 216).

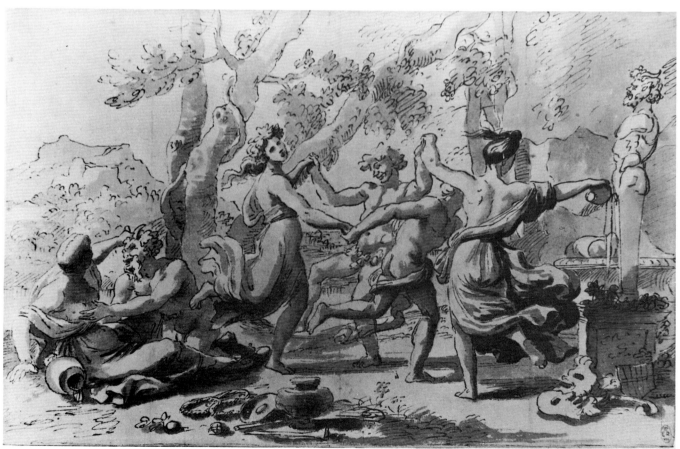

The Purpose of the Drawings

110. Poussin. *Study of a seated Woman.* Windsor Castle, Royal Library. Pen and brown ink. 114 x 77 mm. (C.R. 374).

This is probably the only drawing by Poussin known to us which was made directly from nature in the sketchbook which, according to his biographers, he always carried with him when he walked round Rome.

111. Poussin. *Dance before a Herm of Pan.* Windsor Castle, Royal Library. Pen and brown wash. 208 x 328 mm. (C.R. 196).

By far the greater number of Poussin's drawings were made as preparations for paintings, but they are limited to projects for the whole composition or for sections of it, and there are no drawings for individual figures. This is partly accounted for by Poussin's method of work. His biographers tell us[1] that when he began to plan a composition he first read all that was relevant to the subject, whether in the Bible or in Plutarch or in Ovid, so as to be able to visualize the story. At this stage he made a rough sketch to record his first idea of how it might be represented. He developed his conception in further sketches, and he would then proceed to the next step which was much more unusual. He made little wax figures, about nine inches high, representing the individual characters taking part in the action, and for these he made draperies in fine linen, and then arranged them on a miniature stage, the floor of which was squared like a chessboard and which was equipped with means of controlling the lighting and a slot at the back for a drawing to supply the landscape or architectural background. He would then make a drawing of the group as it appeared on the stage, and, if he was not satisfied with the result, would move the wax figures about, changing the lighting and the backcloth as necessary, till he felt that he had arrived at a disposition which satisfied him as a lucid representation of the story, a clear construction in space and a harmonious pattern on the flat surface of the drawing.[2]

According to Bellori he then made bigger models for individual figures, or parts of them, in order to study the fall of drapery on a larger scale, and of these too he presumably made drawings. It is clear from these accounts that he did not draw from a posed model at any stage in the preparation of a painting, but it must be supposed that he used the drawings which he had made while working in the studios of Domenichino and Sacchi. His biographers, however, say that if he found himself unable to discover the appropriate form or gesture for his figures, he would go out into the street and observe passers-by till he saw what he needed.

He made notes of what he observed in this way, but they must of necessity have been quick sketches and not large-scale detail drawings. One drawing at Windsor (Plate 110) may come from such a sketchbook. Its directness and vividness make one feel that Poussin suddenly saw this somewhat formidable figure sitting at her door one evening, and noted the pose in this sketch.

The steps by which Poussin moved from his small sketches to work on the canvas are not at all clear. There are a few squared drawings, some of which must have been made at a relatively early stage in the evolution of a composition, since they do not correspond at all closely to the paintings themselves. For instance the squared drawing in the Uffizi for the *Apollo and Daphne* (C.R. A 46) includes two episodes — the pursuit of Daphne, and Jupiter, Argus and Io — which were left out in the final version, and it must therefore have been made in order to transfer the design to another sheet of paper. On the other hand one for the *Confirmation* for the second series of *Sacraments* (C.R. A 20) and one for the *Crucifixion* (Plate 69) correspond almost exactly to the paintings and can only have been made at the very last stage, for actual transfer to the canvas. Another drawing in the same category is that for the *Dance before a Herm of Pan* in the British Museum (Plate 112) which is on a bigger scale than those just mentioned and would therefore have been more easily transferred to the canvas.

This drawing throws some light on a problem which arises in connection with Poussin's method of work: did he use full-size cartoons, to be pricked through direct on to the canvas?

A fragment of one such cartoon survives, but there are reasons for thinking that it was made in exceptional circumstances and cannot be used to prove that Poussin normally used this method. This fragment is to be found on the Chantilly drawing for the Dulwich *Triumph of David* (Plate 103). The sheet shows a series of lines, visible even in a reproduction, which have been pricked through and which correspond exactly in outline and in scale with the arm of one of the women in the left foreground of the painting and the waist and belt of another. The sheet must clearly have been joined by the artist to others in order to make a full-scale cartoon, and at first sight it would be natural to assume that the Chantilly drawing is a fragment of a cartoon of the whole painting; but this is probably not the case. Examination of the

picture by x-rays shows that Poussin altered the left-hand side of the composition, and did so in a very unusual manner.[3] He moved the group of three women a few inches to the left, without altering their poses, and, in order to carry out this for him surprisingly mechanical modification, he would almost certainly have traced the outlines of the figures so as to be able to transfer them easily to their new positions. It is therefore likely that the existing fragment formed part of this tracing and not of a cartoon in the ordinary sense of the word.

The making of full-size cartoons was almost universal in the seventeenth century for frescoes or large altarpieces, and the artists responsible for such works normally had a team of studio assistants who transferred the cartoon to the plaster or canvas; but it seems to have been less generally employed for canvases of the size used by Poussin, that is to say roughly between three and six feet in length, which were then regarded as small and as suitable for private rooms rather than churches. One reason for thinking that Poussin used full-size cartoons is the fact that, as examination by x-rays shows, in his mature years he made extraordinarily few changes once he had started work on the canvas. This can on the other hand be accounted for by the very careful preparations which he carried out in the form of small preliminary drawings, so that, when he embarked on the actual painting, he knew exactly what he wanted to do. With his extraordinarily meticulous way of working Poussin would have been able to enlarge the final drawing — with his own hands, not those of assistants — and establish it on the canvas with such finality that little alteration would later have been necessary.

It is not known at what period Poussin began to use his model stage, but it is described by Sandrart, who left Rome in 1635, so that the artist must have adopted the practice at a period quite early in his career. Moreover there seem to be traces of its use in certain early paintings. For instance, of the various studies known for the *Massacre of the Innocents* which dates from about 1628-9, two (Plate 19 and *Master Drawings*, XII, 1974, Plate 4) show the baby in a pose almost exactly that of the painting but seen from different angles. It looks as though Poussin had made a model of the child, and then turned it about on his stage, making slight adjustments to the positions of the legs. The use of wax models would also explain the fact that the whole composition in

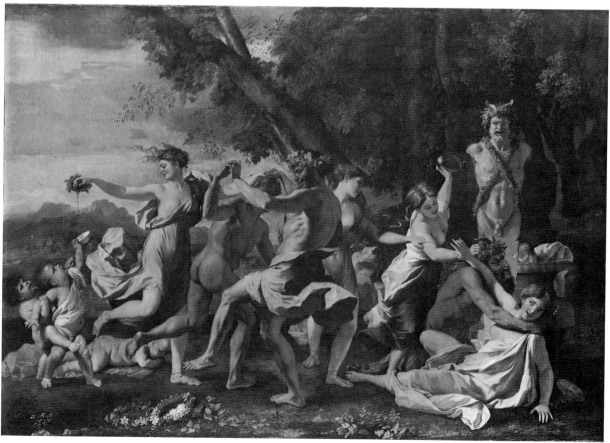

the painting of the *Massacre* seems to be conceived as a closed group of sculpture, and the same characteristic marks certain other paintings of this period, particularly the Dulwich *Rinaldo and Armida* and the National Gallery *Nurture of Bacchus*.

In two cases enough drawings for a single composition survive to enable us to study its evolution in detail, and to watch Poussin moving his wax figures on the squared board almost as if it were a chessboard.

The earlier of these is the *Triumph of Pan* (Plate 120), painted in 1635-6 for Cardinal Richelieu. It was to be set with its pair, the *Triumph of Bacchus* (Plate 117) and a third composition of slightly different format representing the *Triumph of Silenus* in the frieze of a room at the Château de Richelieu, *en suite* with the compositions by Mantegna and others painted for the studio of Isabella d'Este in Mantua, which had been presented to the Cardinal by the Gonzagas shortly before, probably in an attempt to win his support in the dispute over the inheritance of the Duchy of Mantua.

This was Poussin's first commission from the French court, and he evidently realized that it was an opportunity for him to produce something impressive which would make him known in his native country. The trouble that he took in the preparation of the canvases is evidence of this determination.

There are no surviving drawings for the *Silenus* as it was finally painted, but there are a few slight sketches illustrating different stories about him which are on the same sheet as studies for the *Triumph of Pan*. These drawings represent the occasion when Silenus was found drunk and asleep by a group of shepherds who tied him up with garlands and sprayed his face with mulberry juice. This story was no doubt thought to be unedifying and the more generalized scene of the National Gallery picture was preferred.

For the *Triumph of Bacchus* there are five drawings, three of which are fragments showing various studies for the centaurs drawing the chariot of Bacchus (C.R. 435-5a, 437). The two drawings for the complete composition (Plates 115-16) show that Poussin originally intended to depict the procession advancing diagonally across the foreground and then abandoned this project in favour of a more classical arrangement with the figures spread out parallel to the plane of the picture, as if in a bas-relief. The

112. Poussin. *Dance before a Herm of Pan.* London, British Museum. Brown and red wash over black chalk, squared with red chalk. 234 x 341 mm. (C.R. 198).

113. Poussin. *Dance before a Herm of Pan.* London, National Gallery. Painting. 100 x 142 cm.
Plate 111 illustrates a preliminary study for the composition shown in the National Gallery painting, though it differs from it in many features and was probably made some years before it; its style suggests the late twenties whereas the painting must date from the mid-thirties. Plate 112 shows a drawing, which is only a fragment, cut on all sides except the bottom, but which is the nearest thing that we have to a drawn cartoon by Poussin. The figure group conforms in every detail to the painting and is on about one quarter of its scale. Poussin transferred it directly to the canvas and only altered parts of the background, adding a tree on the left.

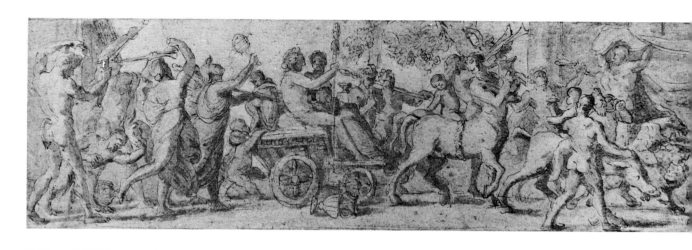

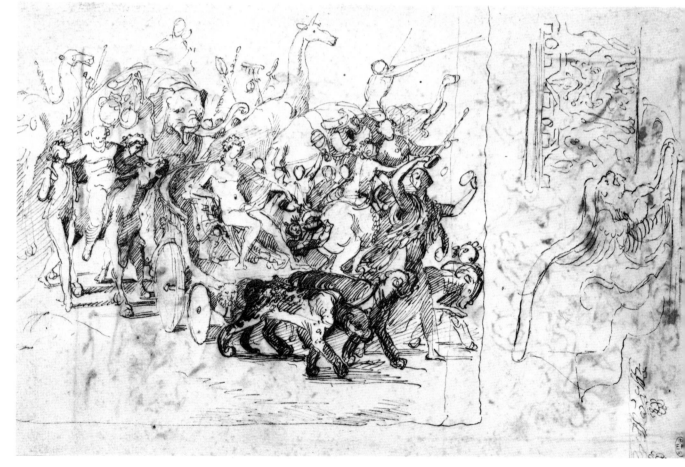

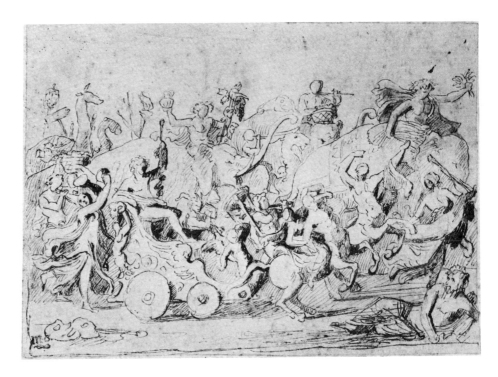

114. (upper left) Poussin.
*The Triumph of Bacchus
and Ariadne.* Windsor
Castle, Royal Library. Pen
and grey wash over red
chalk. 126 x 425 mm. (C.R.
183).
 This is probably Poussin's
first study for a composition
which eventually developed
into the *Triumph of Bacchus*
(Plate 117). Here however
the subject is the *Triumph
of Bacchus and Ariadne* and
not, as in the painting, the
Indian Triumph of Bacchus.

115. (lower left) Poussin.
The Triumph of Bacchus.
Windsor Castle, Royal
Library. Pen and brown ink.
195 x 291 mm. (C.R. 185).

116. (upper right) Poussin.
The Triumph of Bacchus.
Kansas City, Missouri,
Nelson Gallery and Atkins
Museum. Pen and brown
ink. 159 x 229 mm. (C.R.
436).

117. (lower right) Poussin
(copy after?). *The Triumph
of Bacchus.* Kansas City,
Missouri, Nelson Gallery
and Atkins Museum.
Painting. 128 x 151 cms.
 In the first study (Plate
115) Poussin intended to
make the procession more on
a diagonal leading from the
left background to the right
foreground. He presumably
found the composition too
baroque and returned to the
frieze-like arrangement of
Plate 114. In the painting he
also left out the more exotic
animals, such as elephants,
camels and giraffes. On the
right of Plate 115 is a separate
study of the chariot, based
on an ancient marble throne.

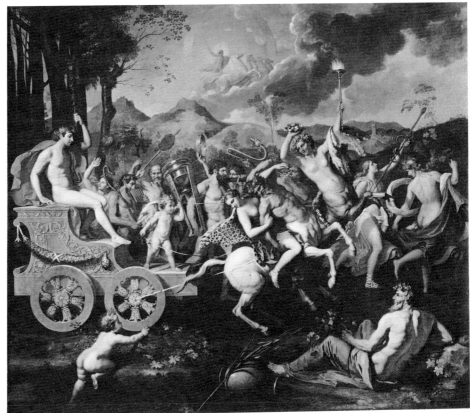

Windsor drawing has a detail study for the chariot, the main lines of which are certainly taken from an ancient throne.

For the *Triumph of Pan* there are ten sheets of drawings, several of them containing more than one sketch, so that we can here study Poussin's method of work in some detail (Plates 37, 118-19 and C.R. 186-93, 437a, 438).

Poussin seems to have made wax models both of single figures and of groups. Among the single figures are two Bacchantes, one of whom rushes into the composition, waving a Thyrsus and squeezing the juice out of a bunch of grapes into her mouth, while the other carries the carcase of a sacrificed goat over her shoulder; there are also two naked youths, one of whom squeezes grapes into a cup held up to him by a child, while the other blows a trumpet; and finally there are putti and attendants who play minor parts in the ceremony. The groups are more varied. The most complex is one showing a man supporting a woman on the back of a goat, while she turns round to take fruit from a basket held up to her by another man who kneels beside her. Then there is a smaller group of a Bacchante attacking a drunken satyr, and yet another in which a drunken satyr is carried off by his companions. One almost grotesque group showing a paunchy little Silenus strutting on to the scene only appears once and was dropped, no doubt as being unsuitably frivolous like the episode with the mulberry juice. These are the main protagonists in the Bacchic feast, but they are all conceived in relation to the principal feature, the herm of Pan which is being decorated with garlands by a Bacchante. In most of the drawings the herm is placed, as in the painting, in the middle of the composition, but in one or two of the sketches Poussin tried it on the extreme right, in profile facing into the picture. For this variant he made two particularly vivid little sketches (Plate 37), in one of which the nymph is assisted by two putti, while in the other she half-kneels on a goat which appears in some of the centrally placed herm-groups and also in the painting.

Having equipped himself with this wax *corps-de-ballet* Poussin proceeds to move them about on his stage. In four drawings the group with the woman seated on a goat and taking fruit appears on the left of the composition, in one it is on the right and in one it does not appear at all. In the painting Poussin brings it back to the left-hand side of the composition, but turns it round so that it

118. Poussin. *The Triumph of Pan*. Windsor Castle, Royal Library. Pen and brown ink. 195 x 291 mm. (C.R. 189).
On this sheet Poussin first made the study for the *Triumph of Bacchus* (Plate 115) which covered the whole paper. He then turned it over and drew a line across the middle of the sheet dividing it into two unequal parts. On these he made two studies showing quite different compositions for a scene showing votaries of Bacchus crowning a herm of Pan. At a later stage he combined elements from both of these into a single composition in the painting in the Morrison Collection (Plate 120).

forms a closing element on this side of the design. The maenad with the grapes is to be found in one drawing and then disappears, though in one sketch she is replaced by the other maenad carrying the sacrificed goat. In one drawing the man blowing the trumpet rushes in from the right, in another he turns his back on the spectator and blows into the composition creating an awkward break in the carefully planar construction of the whole. But Poussin does not only move his wax groups, he modifies them to suit their new context. Wax being a soft, easily malleable material this would not have been difficult. The figures making up the group with the woman taking fruit remain little changed through their migration from one part of the composition to another, but that with the Bacchante and the drunken satyr is completely transformed. In the drawing shown on Plate 118 the figures form a closed circular pattern in a single plane and the action is relatively gentle, but in the finished revision (Plate 119) and the painting she tears at his hair and he turns over on his side in a desperate attempt to escape, thus breaking the closed circle of the earlier composition. In fact it almost looks as though Poussin made a new wax figure for the satyr in this group and adapted the old one to appear as the drunken satyr who is helped by his two companions in the right hand corner of Plate 119. To do this it would only have been necessary to bend the body further forward in relation to the legs and to alter the pose of the arms.

In two of the drawings for the *Triumph of Pan* (Plate 118 and C.R. 437) Poussin uses a very curious device. He has divided the sheet into two not quite equal parts, made one drawing, then turned the sheet over and made a second one for a different composition. The reason for this curious arrangement is probably to be found in the fact that in the case of both drawings there is a larger drawing on the *verso*, covering the whole sheet, which, if it was done before Poussin used the *recto*, would have prevented him from cutting the sheet in two.

I referred to the wax figures for the *Triumph of Pan* as the *corps-de-ballet* and though the term may seem a little frivolous it is not, I feel, inappropriate to figures which hurl themselves about on the stage with such violence and such frenzy, and, after all, the votaries of Bacchus are often quoted as the originators of the dance in its modern sense. But when we come to consider the drawings for the later religious works the appropriate term is

119. Poussin. *The Triumph of Pan.* Windsor Castle, Royal Library. Pen and brown wash. 228 x 335 mm. (C.R. 192).

This highly finished drawing was probably made after the painting as a sort of pastiche of an ancient bas-relief. Poussin replaced the wooded landscape against which the scene takes place in the painting by a dark wash like the ground for a relief, and closed the top of the composition by a kind of vine-trellis which is to be found on many ancient vases, including one by the Hellenistic artist Salpion, now in the Naples Museum, which Poussin is known to have admired.

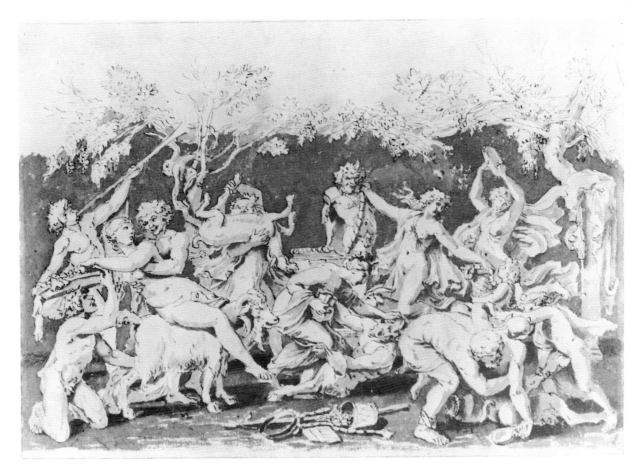

120. (right) Poussin. *The Triumph of Pan.* Executors of Simon Morrison. Painting. 134 x 145 cms.

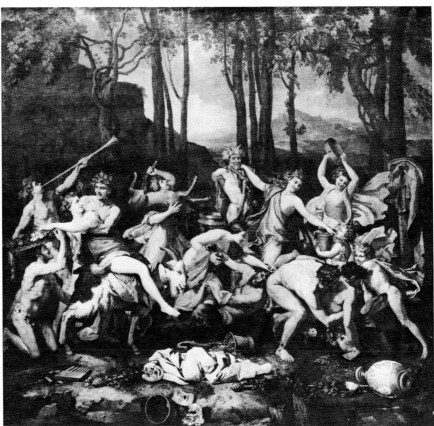

121. (upper left) Poussin. *Baptism.* Florence, Uffizi. Pen and brown wash. 123 x 191 mm. (C.R. 77).

122. (lower left) Poussin. *Baptism*. Leningrad, Hermitage. Pen and brown wash. 164 x 255 mm. (C.R. 78).

123. (upper right) Poussin. *Baptism*. Paris, Musée du Louvre. Pen and brown wash. 157 x 255 mm. (C.R. 81).

124. (lower right) Poussin. *Baptism.* Paris, Musée du Louvre. Pen and brown wash. 165 x 254 mm. (C.R. 83).

These four drawings illustrate the way in which Poussin evolved his figure compositions during the later part of his life (see p. 108).

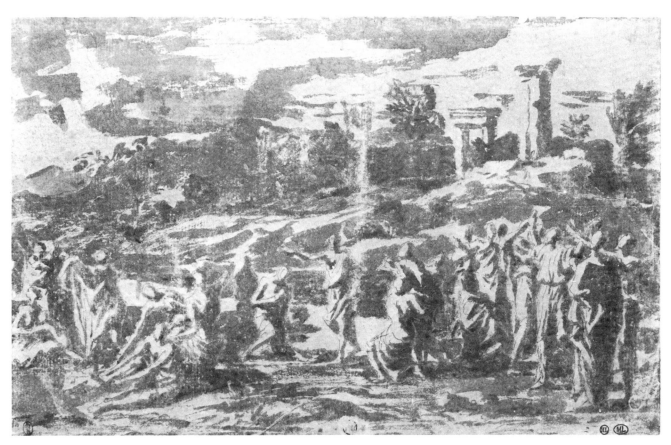

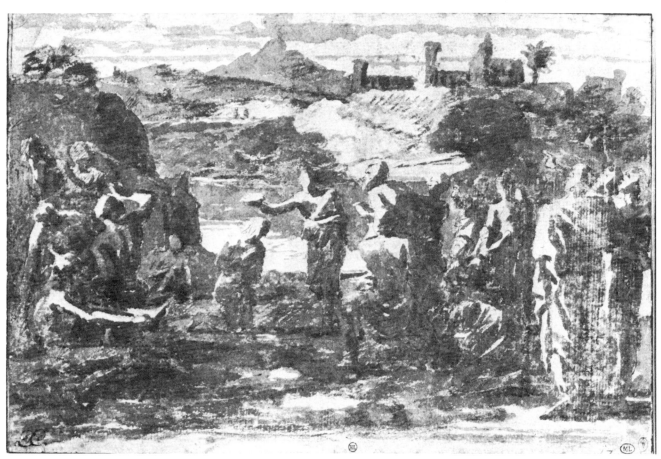

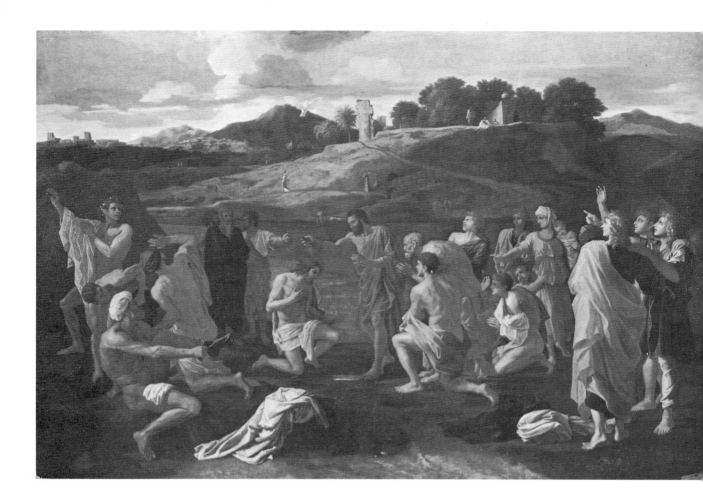

clearly the *dramatis personae*. There is no physical movement in
the *Sacraments* and they must be among the most totally static
compositions ever conceived. At most there is a flutter in a
corner — two youths pouring out wine in *Penance*, a maid-
servant leaving the death chamber with medicaments, Judas
slinking out at the back of *Eucharist* — but the principal figures
are as motionless as rocks, and even for the gay subject of
Marriage Poussin has chosen an instant where all movement is
stopped while the priest joins the hands of the bride and bride-
groom.

The clearest demonstration of Poussin's use of wax models and
stage in this series is to be seen in the drawings for *Baptism*, of
which there are six studies for the whole composition and a
number for groups in it, covering a long evolution of the design.
The two earliest (Plates 121-2) are similar in their general
disposition and show the figures arranged in two rather loosely
organised groups round the central protagonists, Christ and the

Baptist, but the landscape backgrounds are different, and one can see that Poussin has changed the drawing which he put in the slot at the back of his stage. The two drawings also differ in a more fundamental way in that the Uffizi study is essentially a study in light and shade, whereas in the Hermitage drawing Poussin's main objective has evidently been to establish the positions of the figures in space. The group on the left contains several quotations, the man pulling on his shirt which goes back to the Quattrocento, but which Poussin is more likely to have known through Raphael's *Loggie* composition, and the man sitting and pulling on his stocking from Michelangelo's Cascina cartoon; but between these figures and those representing the actual Baptism is a quite different group showing an old man, stripped to the waist and led up for baptism by his sons, one of whom kneels beside him and supports him. Behind are three spectators, who take no part in the action. On the right are other figures, some watching, some asking for baptism. In the third drawing, in the Louvre (Plate 123), Poussin opens out the composition, enlarging both side groups, and he moves the group with the old man supported by his sons from the left to the right-hand side of the composition. In this way he has clarified the functions of the different groups, placing all those awaiting baptism on the right and those dressing after it on the left. He also gives more explicit gestures to the spectators. In the final drawing, also in the Louvre (Plate 124), which corresponds almost exactly to the painting in its figure grouping, he closes the composition on the left by turning the man pulling on his stocking and making him face towards the centre of the picture. At the same time he further defines the gestures of the spectators, so that those at the back on the left clearly express scepticism, whereas those in the foreground on the right acclaim the miracle.

In this complicated evolution of the design the individual figures change far less than in the drawings for the *Triumph of Pan*. For instance the figures dressing reappear in almost identical poses from one drawing to another, and although new figures are added to the spectators on the right those that appear in the first Uffizi study hardly undergo any change. The group of the old man and his two sons had necessarily to be altered when it was moved from one side to the other and Poussin interchanged

125. Poussin. *Baptism*. Duke of Sutherland, on loan to the National Gallery of Scotland, Edinburgh. Painting. 117 x 178 cms.

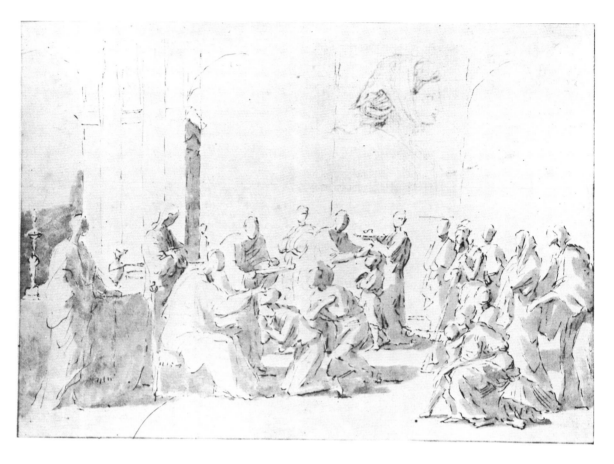

the figures of the two sons so that the kneeling one should always appear in front of his father and so not entirely obscure him.

The only point where steady changes are to be observed is the central group of Christ and the Baptist. In the Uffizi drawing the Baptist stands upright, and Christ nearly so, with slightly bowed head, but gradually he bends lower and lower and in the final version actually kneels, while the Baptist stretches out his arm horizontally to pour the water over him. One can almost see Poussin remodelling the two wax figures at each stage.

It is clear from some of the drawings for the *Sacraments* (Plates 59, 61) and from a drawing at Windsor for the *Holy Family in the Temple* (Plate 132) that Poussin occasionally followed the practice, common with Raphael and his followers, of drawing the figures in the nude to study the poses under the draperies. Poussin's method does, however, differ in one essential feature from that of the sixteenth century. Raphael and his followers

126. (above) Poussin. *Confirmation*. Windsor Castle, Royal Library. Pen and brown wash. 182 x 256 mm. (C.R. 86).

127. (upper right) Poussin. *Confirmation*. Paris, Musée du Louvre. Pen and brown wash. 124 x 246 mm. (C.R. 87).

128. (middle right) Poussin. *Confirmation*. Paris, Musée du Louvre. Pen and brown wash. 131 x 254 mm. (C.R. 88).

129. (lower right) Poussin. *Confirmation*. Paris, Musée du Louvre. Pen and brown wash. 126 x 254 mm. (C.R. 89).

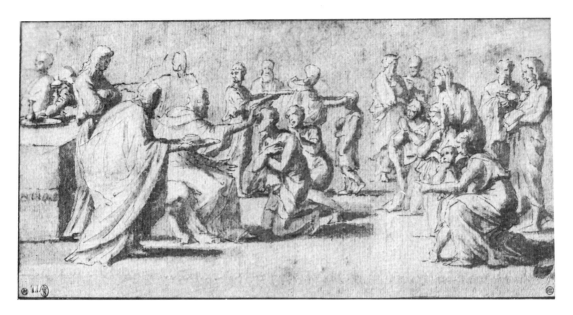

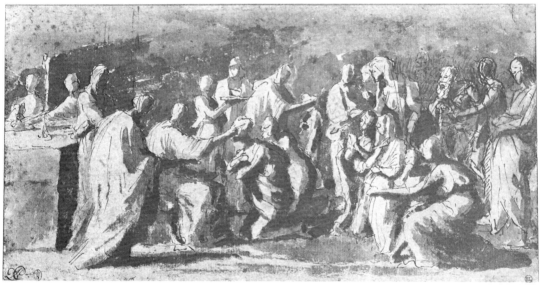

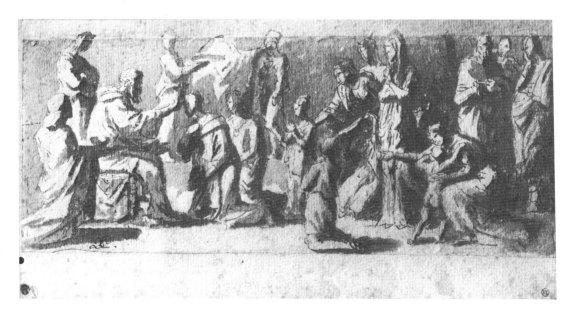

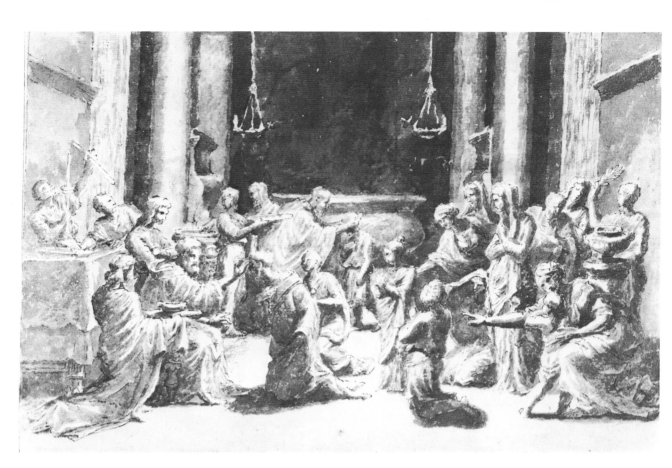

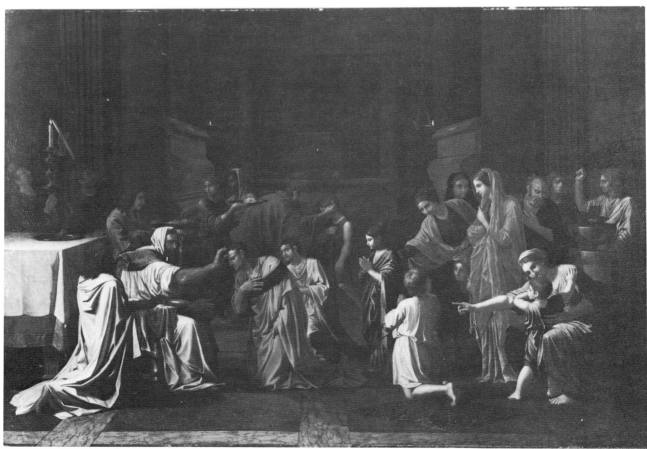

130. Poussin. *Confirmation*. Windsor Castle, Royal Library. Pen and brown wash. 186 x 287 mm. (C.R. A 20).

131. Poussin. *Confirmation*. Duke of Sutherland, on loan to the National Gallery of Scotland, Edinburgh. Painting. 117 x 178 cms.

In these drawings (Plates 126-30) we can watch Poussin evolving his composition as in the case of the *Baptism*, trying out different arrangements to make the story clearer and the design more harmonious. The basic elements remain the same: the two priests, one seated accompanied by two (or in the first drawing three) servers and administering the chrism, the second standing further back and tying the fillet round the forehead of a child who has already received the chrism; on the right a group of the faithful watching or awaiting Confirmation themselves.

It is interesting to notice that the liturgically and historically most unusual features were only introduced at relatively late stages. The unusual toga with a broad folded edge worn by the man actually receiving Confirmation only appears in one of the preliminary sketches (Plate 129); the catacomb setting is not introduced till the finished study (Plate 130). (In the first sketch Poussin indicates the setting like the interior of a sixteenth-century Roman church which he had used in the first version of the subject painted for Cassiano dal Pozzo); and the youth holding the branch of hyssop on the extreme right also only appears at the same stage.

In the first volume of the *Catalogue Raisonné* the drawing on Plate 130 was wrongly described as a studio work. The woman's head visible at the top of Plate 126 is in fact showing through from the other side of the paper.

made drawings of this kind from actual models posed in the nude and they generally consist of a single figure or a small group of three or four figures, the artist's purpose being to establish precisely the pose of each figure in accordance with the recently expanded knowledge of human anatomy and of the movements of the human body. Poussin's drawings with figures in the nude are all of complete compositions and belong to the same category as those showing the figures already draped. The poses of the individual figures must have been fixed while the artist was making the wax models, and the anatomy worked out in the larger models of individual parts which Poussin also made, according to Bellori.[4]

* * *

Although, as has been said above, most of Poussin's drawings were made as steps in working out the composition of his paintings there are a certain number which appear to have been made for their own sake and not for some ulterior purpose. In one case, a small roughly sketched drawing at Windsor representing the *Death of Cato* (Plate 133), I believe that Poussin made it simply as a note of what he had visualized when he read the account of the scene in Plutarch. Cato's suicide to avoid submitting to the tyranny of Caesar was always held up as a model of Stoical fortitude, and was certainly of great significance to Poussin. It is of course possible that Poussin intended to develop the sketch into a painting, but it has such a personal quality that I am inclined to think that it was made simply as a direct record of a strong emotional reaction to a heroic story.

A few drawings seem to have been made as *modelli* to show a patron how the finished work would appear, but they are rare and Poussin seems to have been averse to the usual Seicento practice of making such *modelli*; only one is known in oils, namely the sketch, now in Ottawa, for the *Martyrdom of St. Erasmus*, for the St. Peter's altarpiece which was a commission of exceptional importance for Poussin. However two drawings seem to have been made for the same purpose: the *Death of the Virgin* (Plate 8), which seems to have been a *modello* for the painting commissioned for Notre-Dame by the newly created Cardinal-Archbishop of Paris in 1623, and the *Camillus and the School-*

113

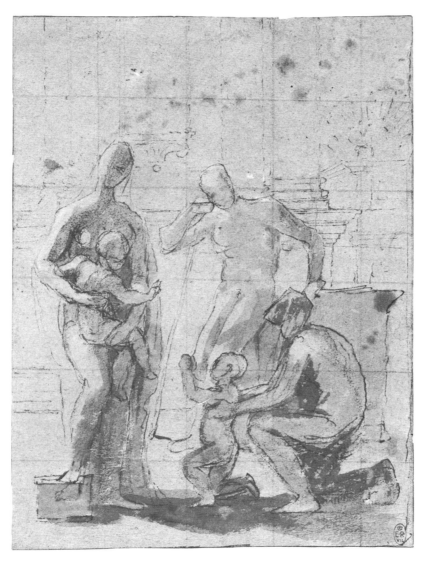

132. Poussin. *The Holy Family in the Temple.* Windsor Castle, Royal Library. Pen and brown wash over black chalk on bluish paper. 213 x 164 mm. (C.R. 43).

Study for a composition known in several versions of which the one at Chantilly is probably the original. The composition is iconographically unusual in that Joseph leans on a measuring rod and in the painting there is added a T-square on the low wall beside him — allusions to the idea that he was a man of learning and to the masonic traditions associated with the Temple of Solomon. In the right background of the drawing is a detail which Poussin did not include in the painting and which appears to represent a figure standing or kneeling on a massive structure which may possibly be an allusion to the Ark of the Covenant.

The drawing has an unusually luminous quality, due to the fact that it is on pale bluish paper which the artist has left uncovered in the light areas and allowed to shine through the washes of varying darkness in the shadows. It is also unusual in that it shows the figures in the nude (but see Plates 59, 61) and that it is squared for transfer.

master of Falerii in the British Museum (Plate 26), which is so much more highly finished than most of Poussin's drawings that some special distinction seems to be implied.

These are however as far as I know the only examples of Poussin's using what was a regular practice in his day, but it is characteristic of his method of work and of his relations with his patrons that *modelli* should not have been necessary. He was painting relatively small canvases, the idea of which could be conveyed in a rough pen and wash sketch, and his patrons were so close to him and shared so many of his ideas both on art and on

religion and philosophy that they could form a clear idea of what he planned from very slight indications.

One group of drawings were probably designed with the conscious intention that they should be engraved, namely those made for Marino in Paris in 1623 (Plates 4-7) which have already been discussed. They are more summary than most of the drawings made for engravings by the Flemish and Dutch artists whom Poussin seems to have been imitating, such as Goltzius or Martin de Vos, but they conform to what had become an almost standard formula for such illustrative engravings, and Poussin would have been able himself to guide the hand of the engraver and fill in any details that were lacking.

Apart from the Marino drawings the remaining large finished

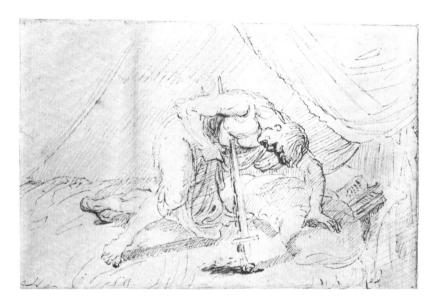

133. Poussin. *The Death of Cato.* Windsor Castle, Royal Library. Pen and brown ink. 96 x 149 mm. (C.R. 124).

134. Poussin. *The Testament of Eudamidas.* Hamburg, Kunsthalle. Pen and brown wash. 128 x 193 mm. (C.R. 417b).

These two drawings represent heroic moral themes which were very close to Poussin's heart.

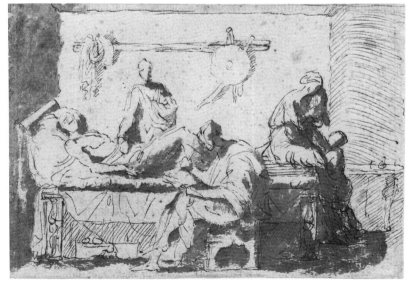

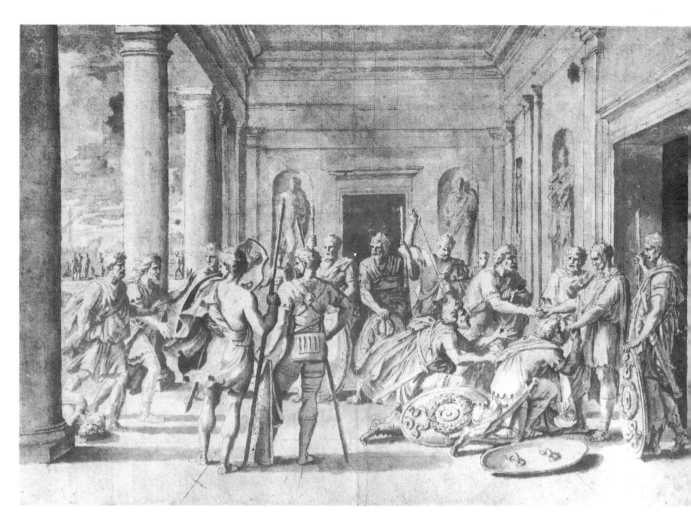

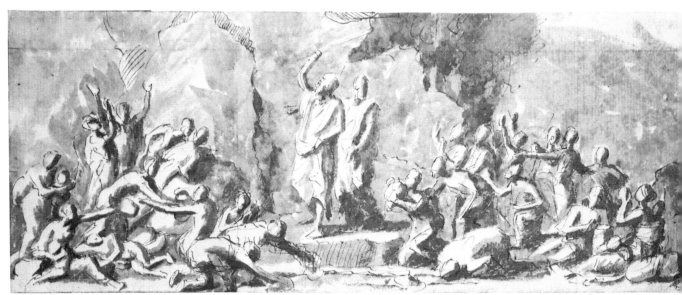

drawings by Poussin do not seem to be either *modelli* or preparations for engravings and must have been made for other specific purposes. One, representing *Scipio Africanus and the Pirates* (Plate 135), was made for Cardinal Francesco Barberini while Poussin was in Paris between 1640 and 1642. It does not seem to have been the intention of either patron or artist that the design should have been executed on canvas, but we cannot assert this categorically because the Barberini fell from power less than two years after Poussin's return to Rome and no doubt many projects were left unfinished — including one for a set of four paintings of the Evangelists in landscapes, of which only two were painted and only one delivered.

Two drawings — the *Victory of Godfrey de Bouillon* of *c*.1628-30 (C.R. 147) and *Moses striking the Rock* of *c*.1645-56 (Plate 136), both at Windsor — are difficult to assign to any category. They are certainly not for engravings and they are not finished enough to have been intended as "Presentation drawings", like Michelangelo's elaborate chalk drawings for Tommaso dei Cavalieri.

There are however three drawings which have enough features in common to suggest that they were all produced for the same purpose: the *Triumph of Pan* (Plate 119) and *Three Youths dancing on a Wine-Skin* (Plate 137) dating from the mid-1630s and both at Windsor, and *Aaron's Rod turned into a Serpent* (Plate 138) dating from the later forties and in the Louvre. The first feature that strikes one as unusual is that, whereas Poussin's drawings are almost always placed in an architectural or landscape setting, in these the space is completely and firmly closed by a flat wash of dark bistre. The result is to produce the effect of a bas-relief and this may indeed have been Poussin's intention. Mantegna had painted imitation reliefs on canvas in grey against a porphyry coloured ground and the followers of Raphael, particularly Polidoro da Caravaggio, whom Poussin greatly admired, had made a speciality of Triumphs in imitation relief on the façades of Roman palaces. The *Three Youths* is based on an ancient gem, so the idea of a relief — though probably an intaglio rather than a cameo — must have been present in Poussin's mind from the beginning. In the *Triumph of Pan* he closed the top of the composition with a trellis of vine, no doubt an echo of the Hellenistic marble vase signed by Salpion, now in Naples,

135. Assistant of Poussin. *Scipio Africanus and the Pirates.* Windsor Castle, Royal Library. Pen and brown wash. 331 x 465 mm (C.R. A 32).

An unusually large and finished drawing, probably by a studio assistant, made while Poussin was in Paris in 1642 and sent to Cardinal Francesco Barberini in Rome.

136. Poussin. *Moses striking the Rock.* Windsor Castle, Royal Library. Pen and bistre wash. 143 x 364 mm. (C.R. 28).

This drawing combines features from Poussin's two painted versions of the subject, one executed in or just before 1637 (see Plate 41), the other, now in the Hermitage, twelve years later, but it is not an exact preparatory drawing for either. On stylistic grounds it is safe to date it to the mid or late 1640s. Its unusual size and relatively high finish of execution suggest that it may have been made as a *modello* to show a client, and the fact that it is squared — very lightly — seems to indicate that Poussin intended to transfer it to canvas; but no painting is known or mentioned in the sources which corresponds to this composition.

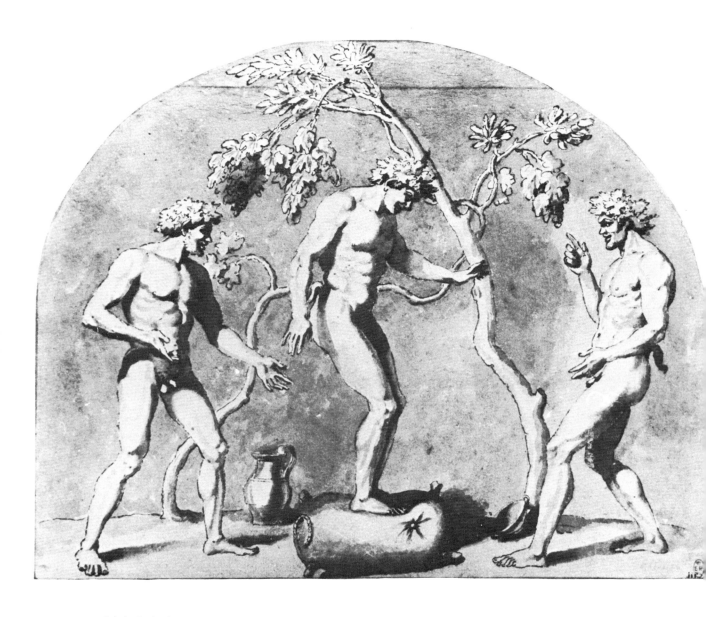

which it is known Poussin admired when it was serving as the font in the cathedral of Gaeta.

In the case of the *Aaron's Staff* drawing, the connection with a bas-relief is not so clearly demonstrable, and it could be argued that the dark background was intended simpy to indicate the gloom of Pharaoh's palace, but the explanation is not convincing because the drawings for the pendant, *The Infant Moses trampling on Pharaoh's Crown* (C.R. 9, A2), are in Poussin's usual light style, with the architectural background clearly lit up.

118

137. (above) Poussin. *Three Youths dancing on a Wine-Skin*. Windsor Castle, Royal Library. Pen and brown wash over black chalk. 247 x 318 mm. (C.R. A 68 and V, p. 116).

The drawing illustrates a game described by Virgil in the *Georgics* in which shepherds danced on a goat-skin covered with oil. The drawing is based on an ancient gem and like that reproduced on Plate 119 is intended to be an imitation of a bas-relief.

* * *

Poussin's landscape studies include some of his most immediately attractive drawings, with a sparkle of light rarely to be found in his figure studies. His very subtle understanding of light has often been overlooked, partly because we have come to overstate the contrast between Claude, the painter of light, and Poussin the painter of massive motionless trees set in an evenly lit almost unatmospheric space. This is unfair because in his early landscapes, such as the *Manna*, or the two now in the National Gallery, or even as late as 1648 when he painted the *Man killed by a Snake*, also in the National Gallery, London, his treatment of light is of extraordinary beauty and subtlety. The difference between him and Claude is that the latter preferred the changing lights and the extremes of sunrise and sunset or unusual effects, with the sun actually visible in the sky, and reflected in water, whereas Poussin preferred the even light of noon, strong but moderate. But this does not prove that his interest in light was

138. (below) Poussin. *Aaron's Rod changed into a Serpent.* Paris, Musée du Louvre. Pen and brown wash. 156 x 260 mm. (C.R. 16).

purely secondary; when he painted the *Self-Portrait* now in Berlin he chose to depict himself leaning on a book the title of which reads: *De lumine et colore*, and we are justified in concluding that this was a work which he would have liked to write himself.

The second interest of the landscape drawings is that they have an important bearing on the problem of Poussin's relation to Nature. We have seen that none of his surviving figure drawings were made directly from nature, and although with the landscapes the question of how far he actually made them in front of *le motif* is a delicate one, some of them undoubtedly show him face to face with nature in a way not to be seen in any of the other types of drawing.

There are only two drawings of precisely identifiable sites: the view of Villeneuve-lès-Avignon (Plate 56), made in September 1642 on the journey back to Rome, and one of the Aventine, probably dating from about 1645 (Plate 85), but the two drawings at Montpellier (Plate 52) and Holkham (Plate 139) almost certainly represent specific reaches of the Tiber valley, though the exact sites have not been traced, and two others repre-sent clumps of trees in the Campagna (Plate 51 and C.R. 270). A drawing at Chantilly which shows the exterior of the buildings surrounding the Cortile di Belvedere (Plate 140) is a borderline case, because, though it is clearly based on the actual site, it is inaccurate in the left half of the composition, and further it was used by Poussin in the background of his painting of Diogenes. There may have been another drawing, made on the spot, on which it was based.

Even in the case of the drawings which represent specific sites it is not at all certain that Poussin actually made the drawings on the spot. They are so deliberately composed and so carefully executed that it seems more likely that they were executed in the studio on the basis of a rapid sketch made in front of nature. At first sight it may seem almost incredible that Poussin should have been able to carry the effect of light in his mind so precisely as to be able to render so vividly the brilliance of the Provençal land-scape or the *contre-jour* effect of the Roman sun streaming through the trees on the slope of the Aventine, but in the case of Claude we know that he was capable of doing so and it is not impossible that Poussin may have had the same gift. A similar problem arises over the two drawings which show groups of trees

121

standing in the Campagna, though here the execution is more direct and it is possible that they may have been done in front of nature; but the matter must remain unsettled.

External evidence does not provide much help in solving the problem, because although we know from Sandrart that Poussin and Claude accompanied him on excursions on which they drew — and even painted — from nature, this evidence applies only to Poussin's early years and most of his surviving landscape drawings date from after this period. Sandrart's account could however apply to the two drawings of trees and to that of the bend on the Tiber, which probably all date from 1633-5. These drawings with their brilliant observation of the structure and character of individual trees were the raw material from which Poussin built up paintings like the *St. Jerome* in the Prado in which an arborologist can identify a large number of specific types of trees, rendered with almost scientific accuracy.

Two of the obviously composed landscape drawings — the *St. Mary of Egypt* at Windsor (Plate 53) and the landscape in the Beurdeley collection (C.R. 274) — appear to date from the years just before the Paris journey, and correspond in their lucid spacing with the new conception of landscape which appears in the paintings of the time, such as the Louvre *St. John baptising*, the Sutherland *Moses striking the Rock*, the Berlin *Armida carrying off Rinaldo* or the *Ordination* from the first *Sacraments*, in all of which the composition is punctuated by carefully placed trees, often almost bare of foliage, which define the spatial recession. In the drawings dating from the years after the return to Rome this method is abandoned and the space is constructed in terms of planes and masses as in the view of the Aventine, the Holkham *Tiber Valley* and a drawing in the Hermitage which may be connected with the painting of *St. John on Patmos* (Plate 143). The same method is to be found in the landscape paintings of the period and in compositions such as the *Baptism* from the second series of *Sacraments* in which landscape plays an important part.

The next group of landscape drawings is related to painted compositions dating from the years 1648-50. Three were evidently made as preparations for the National Gallery *Landscape with a Man killed by a Snake* (Plate 142 and C.R. 281, 283), but some contain motifs which occur not only in this

141. Poussin. *Landscape with a Man killed by a Snake*. London, National Gallery. Painting. 119.5 x 198.5 cms.

142. Poussin. *Landscape Study*. Dijon, Musée des Beaux-Arts. Pen and brown ink with brown and grey wash. 260 x 388 mm. (C.R. 282).

In the general lay-out of the landscape this drawing corresponds closely to the *Landscape with a Man killed by a Snake* in the National Gallery, London (Plate 141), but the town in the distance is a generalized ancient city and not the fairly accurate view of Fondi shown in the painting, and instead of the figures in the painting who enact a drama of fear there is a single fisherman carrying his net. This illustrates the fact that Poussin sometimes worked out landscape compositions before he decided what theme they were going to include.

painting (Plate 141) but also in others of the same period, such as the *Orpheus and Eurydice* in the Louvre and the Plymouth *Phocion*. This seems to indicate that Poussin worked on landscape themes without having any specific human subject in mind and later adapted them to the historical or mythological subjects which he wanted to depict. This view is confirmed by the fact that even those drawings which are demonstrably connected with the Snake landscape include figures which have no relation to this theme and were apparently added almost as an afterthought, probably to give a scale to the landscape itself.

One magnificent drawing, formerly in the library of Uppsala University (Plate 144), may possibly be connected with the Snake landscape, but it stands on its own as one of Poussin's most remarkable inventions. It depicts a group of trees standing round a pond which bears some resemblance to that in the middle distance on the right of the painting; but the drawing seems to have been intended as a composition in its own right and suggests rather a representation of the Philosophers' Grove, a theme treated by Salvator Rosa at about the same time. The mood is that of Poussin's most meditative landscape paintings of the late 1640s, and though no specific subject can be associated with it we may justifiably imagine that Poussin was planning another painting of the same type. If he had painted it, it might have been his foreshadowing of Cézanne's *Les Grands Arbres*.

143. (above) Poussin. *Classical Landscape with Figures.* Leningrad, Hermitage. 148 x 387 mm. Black chalk and brown wash. (C.R. 279).

144. (right) Poussin. *A Group of Trees.* Formerly Uppsala, University Library. Pen and brown ink over black chalk. 254 x 300 mm (C.R. 457).

The grandest of the landscape drawings dating from Poussin's late years. It may possibly have been conceived as the Grove of the Philosophers, a theme in accordance with his contemplative mood at the time.

Bassin

Drawings after the Antique and after other Masters

Poussin clearly attached great importance to his drawings after the Antique. Out of the three hundred and seventy drawings listed in the inventory of his studio made in 1678, referred to above, a hundred and sixty were contained in a volume described as follows: 'A book of drawings made by monsieur Poussin from the Antique, after Raphael, Giulio Romano and others, for his own use, containing 160 sheets, some drawn on both sides.'

Appreciation of Poussin's drawings after the Antique has been confused by the fact that in this field more than any other his name has been indiscriminately applied to drawings of very poor quality which bear little resemblance to his style.[1]

The practice of making drawings after ancient sculpture and architecture goes back as far as the fifteenth century, and in the first half of the sixteenth century it was widely practised by Raphael and his pupils and associates Giulio Romano, Polidoro da Caravaggio, and Baldassare Peruzzi, as well as by a number of anonymous artists whose sketchbooks survive today. In the later sixteenth century the practice was extended and was taken up by certain artists, such as Pirro Ligorio, who were almost more interested in archaeology than in architecture and who in fact built very little. Some specialists, like Fulvio Orsini, the librarian to the Farnese, made large collections of archaeological drawings, many of them by competent draughtsmen of no great individual merit.

This type of collection reached its highest point in that formed in the early seventeenth century by Poussin's friend and patron, Cassiano dal Pozzo, who brought together more than a thousand drawings of this kind to make what he called his *museo cartaceo*, his 'paper museum'. These drawings are now in the Royal Library at Windsor Castle, to which they came after passing through the collections of Clement XI and Cardinal Alessandro Albani, whose librarian was the great archaeologist Winckelmann. Pozzo acquired a few drawings made in the

145. Poussin. *Marble Group of two Athletes.* Chantilly, Musée Condé. Pen and brown wash. 246 x 171 mm. (C.R. 293).

This drawing is after a famous Roman marble group, now in the Prado, representing two athletes — often but without foundation called 'Castor and Pollux' — which Poussin would have seen in the garden of the Villa Ludovisi. In the drawing Poussin has emphasised the effect of sunlight on the marble.

sixteenth century, but by far the greater part were specially made for him by Pietro Testa who seems to have been almost exclusively employed by him for several years when a young man.[2]

It is often said — and I have said it myself — that Poussin was one of the artists involved in the making of this archaeological collection, but this is almost certainly not the case. The early biographers do not mention him among those who worked in this way for Pozzo, and he described himself as *scolare* of the *museo cartaceo* which implies that he learnt from it rather than that he helped to create it. Further, Pozzo's archaeological drawings are numbered in a hand which is easily recognizable and these numbers only appear on one drawing which can be reasonably ascribed to Poussin.[3]

Internal evidence moreover confirms that Poussin's drawings were not made for Pozzo's museum. They are entirely different in character from those of Testa and his colleagues which are intended as records and fulfilled the function which would nowadays be served by good photographs. It is a curious fact however that none of the drawings has any measurements as one would expect in a series so positively collected in an archaeological spirit. Such measured drawings were certainly made at the time and Poussin himself made a series which are recorded by Bellori at the end of his life of Poussin.[4] The drawings are lost and those that survive are of a quite different type. They are quick notations of the salient features of a statue or a relief and they convey the general character rather than the detail. Proportions are often changed and individual features moved from one point to another so that they would be almost useless from the archaeological point of view. The key to the problem is given by the phrase *fatti...per suo studio* used by the author of the 1678 inventory. These were drawings made by Poussin for himself, for his own special purposes; and it is no doubt for this reason that he treasured them so carefully. In fact Poussin was following the example of Raphael and his school rather than that of Fulvio Orsini or Pozzo.

The most immediately striking of these drawings represent a single statue or relief. They differ among themselves in style, but they have in common a brilliantly rapid line and a bold use of brown ink, usually applied in broad washes which give the effect of sunlight on marble with extraordinary vividness. This is

146. Poussin. *Sacrifice of an Ox.* Bayonne, Musée Bonnat. Black chalk and bistre wash. 142 x 211 mm. (C.R. 297).
After a famous relief now in the Uffizi which in Poussin's time was in the Villa Medici, Rome.

particularly evident in the drawing of the S. Ildefonso group (Plate 145), which is now in the Prado but in Poussin's day was in Rome in the Villa Ludovisi. This drawing was almost certainly made from the original, but Poussin has made certain alterations in the left leg of the left-hand athlete, which in the drawing is bent so that the knee is resting on the altar at his feet. At first sight this alteration seems to have been carried out hastily, and the line of the leg below the knee does not seem to join up with the foot and the lower part of the shin. This is however due to the rather careless placing of the touch of wash, and the pen outline leads correctly to the lower part of the leg. The splendidly luminous drawings after the *Sacrifice* (Plate 146) and the *Triumph* from under the Arch of Titus (Plate 147) are probably also made from the originals, but the *Phaedra* (Plate 148) is almost certainly taken from the plate in the *Galleria Giustiniani*, the fine series of engravings of works of art in the Giustiniani collection of

which the first volume was published before the death of the Marchese Vincenzo Giustiniani in 1638 and the second a few years later.

The engravings in the *Galleria* were certainly the source of most of the drawings which Poussin made after works of art in the Giustiniani collection. The drawings of altars correspond closely to the engravings, and in one case (Plate 149), a drawing showing a circular altar, it can be demonstrated that Poussin used the engraving as his model, first because the drawing shows precisely the same view as the engravings, and secondly because the engraver has misunderstood one detail in the original — the column with a fire burning on it is in fact an altar — and Poussin has copied his mistake. A comparison of the drawing with the engraving reveals how Poussin has given life and light to a model which was dead and mechanical.

This drawing illustrates a danger which confronts the student of Poussin's drawings after the Antique. In the same solander in the Musée Bonnat is another drawing (Plate 150) almost identical with the first. It is inscribed, apparently in an eighteenth-century hand, *copie d'un dessin du Poussin*, but if it did not bear this note and if we did not have the first drawing for comparison the second might well have passed as an original. Put side by side with the first drawing its weaknesses are apparent but it is a sufficiently good imitation to act as a warning; and it may well be that one or two of the drawings now accepted as originals may turn out to be copies in the same category, but till finer versions are discovered they will probably continue to hold their present status.

The *Galleria Giustiniani* was not the only source which Poussin used as a short-cut in making his drawings after the Antique. The *Marcus Aurelius* at Chantilly (C.R. 295) is almost identical with the engraving in François Perrier's *Icones*, published in 1638, but it is in reverse. In this case Poussin may have used either Perrier's original drawing or an offset of the etching. In any case he was right to use a model in the opposite sense to the etching, because the latter is reversed in comparison with the statue itself, which therefore comes out the right way round in Poussin's drawing. In the case of the drawings after Trajan's column he relied on the sixteenth-century engravings by Francesco Villamena in Chacon's publication of 1576, the

147. Poussin. *The Triumph of Titus*. Stockholm, National Museum. Pen and brown wash. 151 x 277 mm. (C.R. 299).
After one of the reliefs under the Arch of Titus, Rome. Poussin has accurately recorded the state of the relief in the seventeenth century and has not made any attempt to complete it.

148. Poussin. *Phaedra*. Formerly Paris, Maurice Gobin. Pen and brown wash. 198 x 268 mm. (C.R. 298).
This intensely alive drawing was made not from the original marble in the Giustiniani Collection but from an engraving in the illustrated catalogue of the collection published in the 1630s.

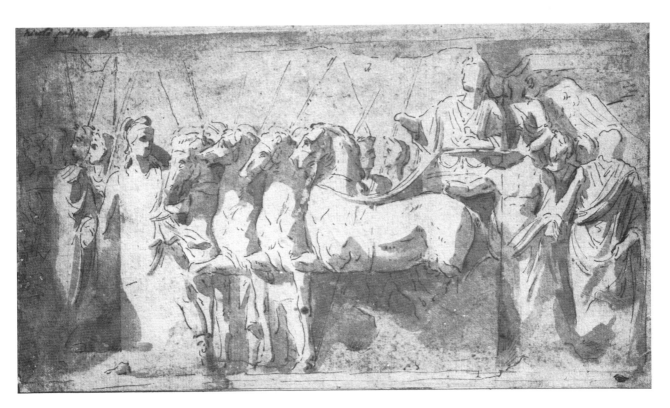

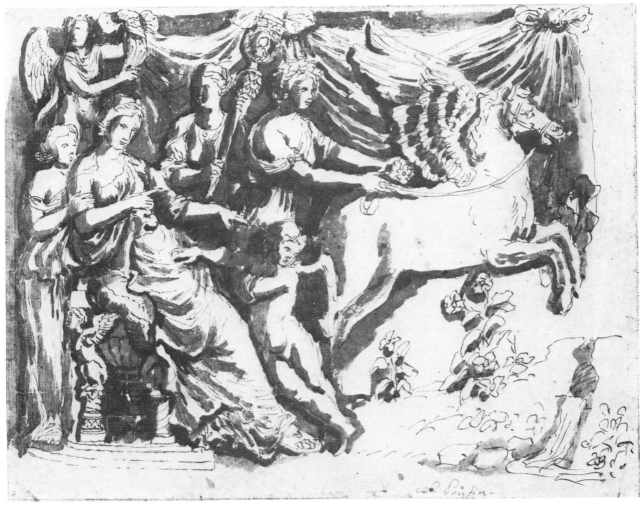

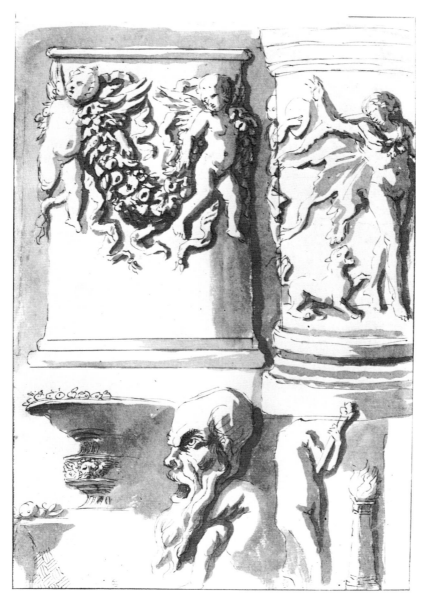

149. Poussin. *Altars.*
Bayonne, Musée Bonnat.
Pen and brown wash. 248 x
181 mm (C.R. 326).

The altars shown in this
drawing were all in the
Giustiniani Collection and
the drawing was based on
the engravings in the
catalogue. Poussin used the
motif of the putto hiding
inside the huge satyr's mask
in an early painting, now in
the Galleria Nazionale d'Arte
Antica, Rome, and in a
late drawing reproduced on
Plate 108.

only available engraved source in his day, and many individual
drawings after ancient statues or reliefs were certainly made not
from the originals but from drawings in the Pozzo collection, the
corrections and omissions of which they follow exactly.

The drawings after Trajan's column and from the *Galleria
Giustiniani* are different in kind from those after single statues or
reliefs. They form a sort of anthology of motifs selected by
Poussin from a particular set of models. In some cases the

132

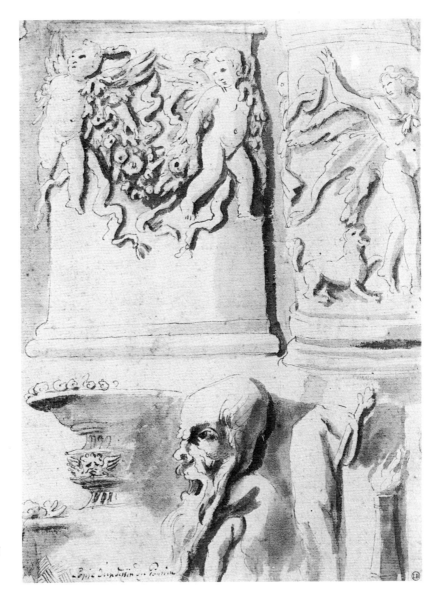

150. Copy after Poussin. *Altars.* Bayonne, Musée Bonnat. Pen and brown wash. 248 x 181 mm. (C.R. A 145).

A deceptively good copy of the original drawing shown on Plate 149.

principle of selection is obvious, particularly in the case of the drawings after Trajan's column where Poussin brings together on a single sheet details from many different parts of the reliefs bearing on a single theme: Roman ships (C.R. 334-5), standards (C.R. 333), soldiers on the march (C.R. 330), a triumphal procession with Dacian captives (Plate 151) and so on. Sometimes it is clear how he made his selection, though not why he made it. In several cases he has obviously been turning the pages of the

Galleria and has noted down details of altars or sarcophagi on adjacent engravings. For instance, Plate 152 shows a variety of details, all from engravings in the *Galleria*. Surprisingly Poussin has left out the two figures which fill the roundel supported by flying putti, shown in the top drawing and in one of the engravings, but below he has carefully drawn another similar couple from an engraving in the same volume.

This plan for making an anthology of motifs from ancient sculpture is even more clearly evident in other drawings after the Antique. Plate 153 shows a series of instruments connected with Roman sacrifices, based on a famous relief found in the Forum and now in the Capitoline Museum. Poussin has in fact taken his drawing from the engraving after the relief by Beatrizet, whose inscriptions he has also copied. Here his archaeological interest

has clearly predominated and he has been intent on collecting information about the habits of the ancient Romans rather than in recording the appearance of a work of art.

Even more revealing of Poussin's archaeological enthusiasm are two sheets, evidently successive pages from a sketchbook, which contain small drawings interspersed with writing. The studies on the upper half of the first page (Plate 154) are taken from hunting sarcophagi and show spears, horses' heads and two men carrying a net to catch wild animals. The remainder of the drawings and notes on these pages come from a quite different source. They are taken from a book on ancient religion, *De la religion des anciens Romains*, by a Frenchman called Guillaume du Choul. It appeared first in French in 1556, but Poussin has used the Italian edition of 1559 and has either copied the text exactly or given abridged versions of passages from it.

In many of these 'anthological' drawings it is hard to say how Poussin has selected the items which he has chosen to bring together on a single sheet. One drawing (C.R. 341), for instance, includes an Athena figure from a famous tripod in the Vatican, an incomplete figure of a charioteer or gladiator and three studies of sandalled feet. Another (C.R. 344) illustrates a sacrificial tripod, a patera, an altar, the torso of a man wearing several torques, the bust of a boy wearing a *bulla*, and a sandalled foot. Plate 155 remains for the moment a puzzle as regards the sources on which Poussin drew, but it is one of his most impressive drawings in the category which we are considering. The top left-hand group with Cerberus and the Furies does not at first sight look as though it was based on an ancient model, but it is not unlike the Scylla shown on Plate 158 which is taken from a roundel generally accepted as ancient, and we may therefore suppose that a similar model existed for the Cerberus. The palms, chariot and battering ram in the top right-hand corner are no doubt also taken from a Roman relief, but the menacing snake at the bottom has an almost Aztec character and is unlike any image known in classical sculpture. It may be an invention by Poussin himself, who was much obsessed by snakes in his later years, or it may have been inspired by a sarcophagus representing the story of Proserpine on which the serpents pulling the chariot of Ceres often form a figure of eight like the snake in Poussin's drawing.[5]

151. (far left) Poussin. *Reliefs from Trajan's Column.* Chantilly, Musée Condé. Pen and brown wash. 316 x 216 mm (C.R. 329).
The drawings in the upper row show figures connected with a sacrifice except for the one on the extreme right which, like those below, represents prisoners made during Trajan's Dacian campaigns. The drawing, which is particularly fresh and well preserved, was made after sixteenth-century engravings and not after the original column of which all but the lowest reliefs are too far away to be conveniently copied.

152. (left) Poussin. *Details of Altars and Tombs.* Bayonne, Musée Bonnat. Pen and brown wash. 256 x 148 mm. (C.R. 339).
Studies after details of ancient sculpture in the Giustiniani collection, based on engravings.

The drawing illustrated on Plate 157 shows a peculiar device which Poussin sometimes uses in his 'anthological' sheets. The study on the left is a straightforward drawing after an altar now lost, but the right-hand half of the sheet is more curious. It shows Hercules attempting to carry off the tripod from the sanctuary of Apollo at Delphi. All the known reliefs representing this subject show Apollo himself on the right, holding back Hercules by gripping his shoulder with his right hand. Poussin does not copy this part of the relief, but he does not altogether ignore it, for he records its existence and a short inscription: *Apollon luy tire par derriere*.

There are other instances of this habit. On the sheet illustrating hunting scenes (Plate 154) the word *cane* is written below the sketch of the two men carrying the net, and in fact the relief which Poussin copied shows a dog led by the foremost of the huntsmen. The same method is employed in the drawing shown in Plate 158, one of the most striking of Poussin's anthology sheets. The two figures in the top left-hand corner are from a group of Niobid reliefs now in the Hermitage, but recorded in Rome from the early sixteenth century; and the scene below with Ulysses and Scylla is from an ancient roundel, now lost, but recorded in a drawing from Pozzo's collection. The most interesting sketch however is that on the right showing a priestess standing before an altar on which is a small cult statue and over which curves a tree impaling a human head. Beside the priestess is written the word *temple* and below to the right is a longer inscription: *Sacrifice d'hommes. Les hommes seront menes nuds et enchynes par des hommes armes et vetus a lantique*. At first sight this seems to have no connection with the scene depicted, but actually the drawing represents the left-hand section of a sarcophagus which shows Orestes and Pylades brought before Iphigenia when she was the priestess of Artemis on the island of Tauris, where her duty was to sacrifice any stranger who landed on the island.[6] The right-hand section shows the two friends led up to the priestess bound, and, if not actually naked, very lightly clad. Once again, therefore, Poussin has recorded in words the part of the relief which he has not copied in the drawing.

One of the most striking features of these 'anthology' drawings is the beauty of their *mise-en-page*. Poussin may bring

153. (right) Poussin. *Sacrificial Instruments*. Paris, Ecole des Beaux-Arts. Pen and brown wash. 348 x 228 mm. (C.R. 352).

These drawings represent details of a famous ancient Roman frieze from the Temple of Neptune, now in the Capitoline Museum, but Poussin actually made them after a sixteenth-century engraving by Beatrizet.

154. (far right) Poussin. *Drawings after Ancient Sculpture and Du Choul's 'De la religion des anciens Romains'*. Chantilly, Musée Condé. Pen and brown ink. 412 x 273 mm. (C.R. 354).

This sheet illustrates Poussin's interest in archaeology. The drawings in the upper rows are after details from ancient sarcophagi, but the lower ones are after illustrations to a sixteenth-century treatise on ancient Roman religion from which the text is also copied.

together on a single sheet the most disparate objects from widely scattered sources, but he combines them brilliantly so that they form a satisfying whole.[7] From the fact that he took so much trouble over the disposition of these drawings we may conclude that he must have had some special purpose in making them. If they were only intended as factual notes he would have been less solicitous about composition, and more systematic in his selection. He was apparently trying to do something more personal, perhaps to build up a corpus of what he himself found particularly interesting or beautiful in Roman sculpture, to make his own personal *florilegium* of ancient motifs. But he may have had a

further idea in view. The fact that the drawings were brought together in a volume and were carefully kept after his death seems to suggest that he intended them to be preserved for posterity. If so, did he hope that they would be engraved? He had great contempt for the few engravers who copied his paintings during his lifetime, but in this context they would have served a useful purpose: to make known to artists and lovers of art his personal conception of ancient art. Such a scheme would have been in keeping with his admiration for antiquity and his desire to set it up as the one true standard for artists to follow.

155. (left) Poussin. *Sheet of Sketches.* Bayonne, Musée Bonnat. Pen and brown ink. 257 x 189 mm. (C.R. 345).

No exact models have been found for any of the objects shown in this drawing. Those in the top row are almost certainly after the Antique, but nothing in ancient sculpture is comparable to the magnificent snake, coiled in a figure of eight, which is almost pre-Columbian in character.

156. (right) Poussin. *A Snake.* Paris, Musée du Louvre. Pen and brown wash. 268 x 196 mm. (*Master Drawings*, XII, 1974, p. 243).

Poussin was much obsessed by snakes in his later years and often introduced them into his landscapes (e.g. the *Man killed by a Snake* in the National Gallery, London (Plate 141); the *Orpheus and Eurydice* in the Louvre, and the *Europa* (Plate 87)). The present drawing was probably made after an ancient bronze or gem.

apollo lus
tiro
par dorio

157. (left) Poussin. *Two Reliefs.* Bayonne, Musée Bonnat. Pen and brown wash. 244 x 178 mm. (C.R. 325).

The drawing on the left shows a typical Roman altar, but that on the right represents part only of a relief representing Hercules attempting to steal the tripod of Delphi, the figure of Apollo being omitted.

158. (right) Poussin. *Drawings after the Antique.* Present whereabouts unknown. Pen and brown wash. 313 x 230 mm. (C.R. 340).

Almost all the drawings on this sheet can be traced to ancient models, but the group in the middle on the right represents part only of a sarcophagus on which is shown Iphigenia on Tauris, the missing part being described by Poussin in the note beside the drawing.

Poussin was deeply interested in ancient architecture, as we can deduce from the settings which he created in his paintings and it is surprising that only one drawing after an ancient monument survives (Plate 159). This drawing, of great force, particularly in its rendering of light and shade, represents the Arcus Argentariorum , near the Cloaca Maxima in Rome. It was probably made from life, since no earlier engravings are known to

141

which it corresponds exactly, and it shows the arch as it was in the seventeenth century, with part of the right-hand pier built into the wall of S. Giorgio in Velabro. Poussin did not use this drawing in any of his paintings; in general he represented more important monuments which he generally based on the reconstructions of Palladio, the most archaeologically accurate versions available at his time.[8]

Poussin's interest in the art of the past was not confined to classical antiquity. A few drawings survive which show that he also copied early Christian works of art. In one (C.R. 364) recording details from sarcophagi, the lower drawing, which shows Christ handing the Rotulus to St. Peter, is after part of a sarcophagus in the Lateran which Poussin used in the *Ordination* from the second series of *Sacraments*, and the remainder of the drawing is from the lid of a similar sarcophagus, showing the three children of Israel refusing to bow down to the brazen image. The other three drawings show funeral feasts (Plate 160) and are based on catacomb frescoes, and in these Poussin has followed the method which he used in his drawings of ancient sculpture. All the drawings are taken from engravings in Bosio's *Roma sotterranea*, published in 1632,[9] but those after the paintings combine elements from various frescoes. The cylinder containing scrolls in C.R. 363 comes from a different fresco from the main feast scene. The cross in Plate 160 is obviously not connected with the main scene and is taken from another fresco, but what is more curious is that Poussin has taken the attendant on the right of the couch from one fresco and has added him to the feast shown in another.

The drawings so far considered in this chapter have all been after works of either ancient Roman or early Christian art, which for the seventeenth century was a continuation of antiquity and could claim equal, if somewhat different, authority; but in his study of the ancient world Poussin also used what may be called secondary sources. One drawing (Plate 161) shows in its upper half a throne and an altar which are certainly after ancient models, though the actual originals have not been identified, but the lower half is filled with elephants copied from an engraving after Mantegna's *Triumph of Caesar*. It is known that Poussin owned a large number of engravings by or after Mantegna and he evidently — and quite rightly — regarded him as one of the

159. (above) Poussin. *The Arcus Argentariorum, Rome*. Windsor Castle, Royal Library. Pen and brown ink. 358 x 277 mm. (C.R. 292).
 This is the only known drawing by Poussin after ancient architecture. The way the entablature is treated in lines touched in with the point of the brush is to be paralleled in drawings of the early and middle 1640s (cf. Plate 85).

160. (above) Poussin. *A Funeral Feast.* Paris, Pierre Rosenberg Collection. Pen and brown ink. 122 x 295 mm. (C.R. 361).

One of Poussin's few drawings of early Christian antiquities, made after an engraving in Bosio's *Roma sotterranea,* first published in 1632.

161. (right) Poussin. *Drawings after the Antique and after Mantegna.* Paris, Private Collection. 267 x 204 mm. Pen and brown ink. (C.R. 347).

The upper drawings are after the Antique, but the elephants are drawn from an engraving after Mantegna's *Triumph of Caesar.*

artists of the Renaissance who had the most profound under-
standing of ancient Roman art.

But this is by no means an isolated instance. Of the drawings
which Poussin made illustrating ancient ships several are taken
from Trajan's column (Plate 162); others however are clearly
not based on such models and are not consistent with any
recorded form of ancient fighting vessel (Plate 163). In fact most
of them are copied exactly from a large engraving by Giovanni
Battista Ghisi after Giulio Romano, representing a sea-fight

between Greeks and Trojans (Plate 164). In copying this engraving Poussin has used the method which he employed in copying ancient reliefs: he has selected a number of individual ships or groups of ships, but he has recombined them in a new arrangement. Even the shield at the bottom of drawing C.R. 338 comes from Ghisi's engraving, but there it is held up by a fighting soldier. Poussin has detached it, left out the arm which supports it, and attached it to a ship with which in the engraving it has no connection. Once again, Poussin has not limited his sources to a single model, for the two ships at the bottom of Plate 163 come, not from Giulio Romano's composition, but from an engraving after one of Polidoro's sea fights.

Poussin however did not only copy ships from the engraving by Ghisi. A drawing in the Ecole des Beaux-Arts (C.R. 350) shows a medley of helmeted heads, sea-horses, dolphins, a trident, a piece of drapery and the head and shoulders of a man, lying down and covering the back of his neck with his hands. All these details are extracted from the engraving, but their disposition on the page bears no relation to the order in which they appear on it.

That Poussin should have copied works by followers of Raphael is not surprising, but it is interesting that he should have turned to them, as he did to Mantegna, as sources of information about antiquity, and have selected from them exactly as he did from his ancient models.

Two other drawings after such models survive, both connected with the *Adoration of the Magi* from the Scuola Nuova tapestry compositions designed by members of Raphael's studio after his death. One from the tapestry itself (C.R. 349) shows heads of various animals in strange forms of harness and is entirely in the spirit of the 'anthology' drawings after the Antique. The other (C.R. 351) probably after a lost cartoon is much less detailed and shows a whole group, including one of the kneeling kings accompanied by attendants and animals. In this case Poussin's intention seems to have been to record a part of the composition, not to note the archaeological information which it contained. In view of his admiration for Raphael it is surprising that only two drawings by him after the master's own compositions survive. One (C.R. 365) is a rough note after two heads in the *Healing of the lame Man;* the other — a copy after the *Parnassus* in the

164. G.B. Ghisi. *Sea-fight between Greeks and Trojans.* Engraving after Giulio Romano.

146

Stanza della Segnatura (Plate 165) — shows how faithful he could
be to the original. It only differs in one detail: Poussin miscalcu-
lated the size of his sheet and found that he had not left room for
the last Muse on the right of the composition and was compelled
to transfer her to the left side of the sheet, where she appears
above the poet next to the blind Homer.[10]

The dating of Poussin's drawings after the Antique is difficult,
because his style seems to have been conditioned and made
almost uniform by the unusual nature of the task, and the
variations are relatively small. A few (C.R. 302, 330-1) have the
short-hand technique characteristic of the years before 1630 and
may date from that period, but the bulk seem to have been pro-

duced in the thirties and forties. The brilliant drawings of single
statues and reliefs (Plates 145, 147) have the strong line and
broad wash of the figure drawings of the thirties, and the same
characteristics are to be seen in most of the studies after ancient
altars.[11] The copies of groups from Trajan's column are more
minute in technique, but the inscriptions on them are in the firm
handwriting which is characteristic of the thirties, and the same
is true of the 'anthology' drawings and the pages copied from Du
Choul. A few drawings however can be fairly certainly assigned
to the forties. The *Arcus Argentariorum* (Plate 159) and the
Sacrifice of an Ox (Plate 146) must be dated to this period because
the artist has used the point of the brush instead of a pen to define
the forms, and a few, notably the *Phaedra* (Plate 148) and the
drawings after reliefs on the Arch of Constantine (C.R. 307-10),
have the scribbled drawing that appears in studies of about 1648
such as the *Madonna enthroned* in Stockholm (Plate 84). The
drawings after early Christian frescoes and sarcophagi also appear
to date from this period. There do not appear to be any drawings
of this category dating from the last fifteen years of Poussin's life,
and it is quite likely that by this time he had accumulated what he

148

needed in the way of records of ancient art, and that, unless some statue of exceptional importance had been discovered, he would not have felt the need to go on making such drawings.

Rubens, on his visit to Rome, twenty years before Poussin arrived there, had also made drawings after the Antique and a comparison between the work of the two men leads to some curious results. Poussin's drawings have a quickness of touch and a brilliance of light which are unusual in him, but which might be expected in Rubens; whereas Rubens's studies after the Antique are carefully, almost minutely drawn, and record faithfully details of damage and so on, in a manner more to be expected from a self-declared classical artist like Poussin, than from one of the founders of the Baroque. A practical explanation is that Rubens made his drawings to take with him back to Flanders when they would be his main 'source-book' for ancient sculpture, whereas Poussin had it all around him, and could refresh his mind on the originals at any moment; but the contrast still remains strange.

In one feature however the resemblance is more striking than the contrast. Rubens added inscriptions to many of his drawings, often lengthy notes with quotations from the same type of sixteenth-century archaeologists as those quoted by Poussin. In fact it seems likely that he too was planning a work on ancient art, certainly with notes and perhaps with some kind of continuous text. What a loss it is for us that neither of these two great artists should have achieved his aim! To have had a full-dress statement of their views on ancient art would have been the best possible evidence for clarifying that problem which more and more teases students of the seventeenth century: to define the attitude towards antiquity of the two tendencies which they supremely represent, the Baroque and the Classical movements.

CHAPTER VI

Poussin's 'Studio'

Terms such as 'studio work', 'pupil's work', 'work of a follower' or 'of an imitator' are often used in discussing drawings by Poussin, but it is necessary to examine the assumptions which underlie the use of these terms.

Poussin never had a studio in the sense of the word current in the seventeenth century, that is to say an establishment composed of young painters who were apprenticed to the master, helping him in the more mechanical processes connected with his art — the grinding of colours, the preparation of canvases or panels, the enlargement of drawings to cartoons, the transfer of cartoons to the wall and the execution of minor parts of the finished pictures — while at the same time receiving instruction in their art from the master and drawing from the models which he provided. Characteristically Poussin preferred to carry through the whole execution of a painting himself, from the first rough sketch to the finished work, without the intervention of assistants. This was one of the reasons why he liked to paint on a small scale and avoided the big commissions, whether for frescoes or altarpieces, in which his Baroque contemporaries excelled. He even disliked having anyone else in his studio while he worked, and Félibien records proudly that he was allowed not merely to be with Poussin when he was painting but even to set up his own easel in the studio.[1]

The very pride with which Félibien records this fact proves how rare the privilege was, and the exceptions to the rule were, as far as we can judge, very few. Gaspard Dughet worked under his brother-in-law for some years in the 1630s, learning the art of landscape painting, but he was not an assistant in the ordinary sense, and although tradition has it that he collaborated with Nicolas no example of their collaboration appears to have survived.[2] Jacques Stella was an intimate friend of Poussin, certainly from his earliest days in Rome and probably before that in Lyons, and no doubt had the freedom of the studio; but though he imitated Poussin in his later works he was never, as far as we know, in any sense a studio assistant. In 1657 his nephew

166. Assistant of Poussin. *Hercules and the Centaurs at Pholoe.* Windsor Castle, Royal Library. Pen and brown wash over black chalk, heightened with white, on blue-green paper. Diameter 262 mm. (C.R. A 92).

151

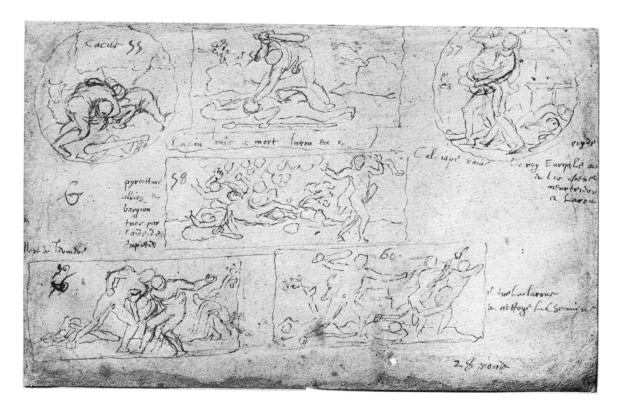

Antoine Bouzonnet, who called himself Bouzonnet-Stella, came to Rome just after his uncle's death, and was kindly received by Poussin and allowed to work in his studio,[3] but at this date Poussin was certainly not making any use of assistants.

The two brothers Pierre and Jean Lemaire have a better claim to being members of Poussin's studio, and there is an old tradition that Jean executed the architecture in some of Poussin's paintings, notably the Chantilly *Theseus* of 1636-7.[4] Whether or not this is so, both brothers were certainly closely involved in Poussin's activities during his visit to Paris in 1640-2. This is the one period in Poussin's life when he is known to have employed assistants on a considerable scale. He was forced to do so — evidently against his will — by the nature of the work which Louis XIII and Cardinal Richelieu demanded of him: large altarpieces, ceiling paintings or overmantels, designs for frontispieces for books published by the royal printing press and above all the decoration of the Long Gallery.[5]

There is no external evidence to show how Poussin's studio in Paris was organised, but certain conclusions can be deduced from the letters and from the drawings for the decoration of the Long Gallery. Two sheets of very rough sketches (Plate 167 and C.R. 242) show Poussin's first ideas for some twenty of the panels

152

illustrating the life and deeds of Hercules. One more finished drawing (Plate 168) showing Hercules and Theseus fighting the Amazons is also certainly from his own hand, and it is reasonable to assume that other drawings of the same type existed; but the bulk of the surviving drawings are of a quite different kind: finished studies, sometimes squared, evidently made as preparations for transfer to the full-scale work. These vary greatly in quality. Some (e.g. Plate 169) are so vigorous that they might almost be by Poussin himself; others (e.g. Plate 166) are evidently studio works.[6]

In one of his letters written during this period Poussin says that he is making small and large cartoons for the panels of the Gallery.[7] The smaller are probably the finished drawings just mentioned, but the larger have not survived, having no doubt perished in the process of being transferred to the ceiling. We have no evidence to show how the panels were actually carried

167. Poussin. *The Labours of Hercules.* Bayonne, Musée Bonnat. Pen and brown ink. 187 x 302 mm. (C.R. 241).

A sheet of rough sketches recording Poussin's first ideas for the decoration of the Long Gallery of the Louvre. It has recently been shown that he based the scheme on the *Mythologia* by Natale Conti (Natalis Comes).

168. Poussin. *Hercules and Theseus fighting the Amazons.* Windsor Castle, Royal Library. Pen and brown wash. 132 x 136 mm. (C.R. 243).

This drawing, from Poussin's own hand, represents the second stage in the evolution of the designs for the Long Gallery. There were no doubt many drawings of this type made by the artist to be handed over to assistants who made the finished versions.

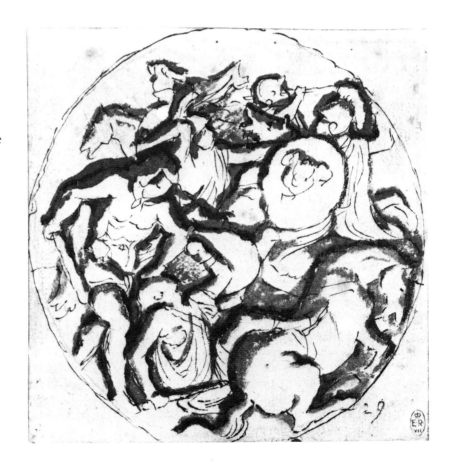

out. They may have been painted on canvas and applied to the ceiling, but given the curve of the vault this would not have been easy, and Poussin would probably have preferred the traditional Roman technique of having them painted directly on the plaster. On the other hand he would almost certainly have accepted the fact that true fresco was not suitable for the French climate and, like most decorative painters working in Paris in the seventeenth century, would have caused them to be executed in oils. It is clear from other passages in the letters that Poussin took the utmost pains to guide the hands of the executants. Not only did he make the full-size cartoons for the painters but he made full-scale drawings and even wax models for those executing the stuccowork.[8] In spite of all these precautions however Poussin was clearly unhappy about the way in which the work was being carried out, and became steadily more despondent as time went on.

When he escaped back to Rome he returned immediately to his old habits. His scrupulousness — as well as his suspicions about the abilities of other painters — are clearly revealed in the succeeding years by his correspondence with Chantelou who wanted copies made of the *Sacraments* which Poussin had painted for Cassiano dal Pozzo in the later 1630s. Poussin's horror of allowing anyone to copy his paintings — let alone collaborate

169. Assistant of Poussin. *Hercules learning to play the Lyre.* Paris, Musée du Louvre. Pen and brown wash heightened with white chalk. 180 x 423 mm. (C.R. A 79).

This represents the type of drawing made in Poussin's studio as models to be copied directly on the vault of the Long Gallery. Most of them are clearly by studio assistants, but a few — of which this is one — are so skilful that they have often been ascribed to the master himself.

154

170. Poussin. *Study for the Decoration of a Ceiling.* Chatsworth, Duke of Devonshire. Pen and brown wash. 124 x 84 mm. (C.R. 452).

In spite of the inscription on the mount, *apresso l'antico,* this drawing is certainly not after the Antique. Its exact purpose is not known but it must represent the type of drawing which Poussin made for the decorative features of the Long Gallery ceiling.

in their execution — comes out in every complaint about the impossibility of finding an adequate copyist, then in his despairing decision to do the copies himself, and finally in his offer — accepted by Chantelou with delight — to make a completely new set of compositions. With an aesthetic conscience as tender as this Poussin could never have run an organised studio in the normal *Seicento* sense of the word.

The problem of the 'studio' is raised in a slightly different form by the drawings illustrating Leonardo's *Trattato della Pittura*. It is generally agreed that the drawings in the Ambrosiana (see Plate 171) are the original set made for Cassiano dal Pozzo, but three other sets exist which are of good quality and very close indeed to Poussin in style. The finest of these, now in the Hermitage (Plate 172), was, according to the inscription in the volume, made for Chantelou when he went to Rome to fetch Poussin in 1640; the second series, contained in the manuscript in the collection of the late marquis de Ganay, is also of very early date, though not of quite the same quality as the Hermitage series; and finally an incomplete set, consisting of sixteen drawings, not attached to a manuscript of the *Trattato*, is in the Royal Library at Windsor and is at least as near to Poussin in style as the Ganay set.[9]

It is conceivable that, owing to the importance of the patron to him, Poussin should have made a set of copies specially for Chantelou, but it is not at all likely, as he was at the time overwhelmed with commissions which he was trying to finish before leaving for Paris, and it is much more probable that the job was carried out by another artist. If so, we must conclude that by 1640 Poussin had trained an assistant to imitate his style of drawing so well that, but for the existence of the better set in the Ambrosiana, his versions would — and actually did till recently — pass as originals by Poussin himself.

There is one group of drawings dating from the late thirties and early forties which seem to be by a single hand and which may tentatively be connected with one of Poussin's known assistants. They are extremely close to Poussin in style but they have a certain mannered prettiness which distinguishes them from his own drawings. They are characterized by a thin line, apparently drawn with a fine quill pen, coupled with what is almost a caricature of the type of rounded head with carefully drawn curls which Poussin uses in some of the drawings of the late thirties. Many of

155

them have skies and landscape backgrounds of hills drawn in a hesitant manner with a line which wavers slightly, but without the abrupt changes of direction which characterize Poussin's own 'shaky' style. One of the drawings, *Armida carrying off Rinaldo* (C.R. A 39), is based on Poussin's painting of 1637, and several others, such as *The Magdalen carried up to Heaven* (C.R. A 18) and *Alexander handing over the dead body of Darius to Sysigambis* (Plate 173), are in conformity with the style of the same years. In fact if these were the only drawings in this style it would be possible to argue that they were originals by Poussin in a rather uninspired moment, but there are others which are related to compositions of a considerably later date, when Poussin had abandoned this style of drawing. The most accomplished of the whole series is the finished version of *Scipio and the Pirates* which is probably the drawing sent to Cardinal Francesco Barberini from Paris in 1642. Of this there are two versions, one at Windsor (Plate 135) and the other in the museum at Orléans (C.R. A 175), and, although the Windsor version is slightly the

171. (below left) Poussin. *Illustration to Leonardo da Vinci's 'Trattato della Pittura'.* Milan, Ambrosiana Library. Pen and brown wash. 114 x 118 mm. (C.R. 267).

172. (below) Assistant of Poussin. *Illustration to Leonardo da Vinci's 'Trattato della Pittura'.* Leningrad, Hermitage. Pen and brown wash. 291 x 208 mm.

Plate 171 illustrates one of the set of drawings made for Cassiano dal Pozzo to illustrate Leonardo's *Trattato*; Plate 172 is from the set made for Fréart de Chantelou by an extremely skilful assistant.

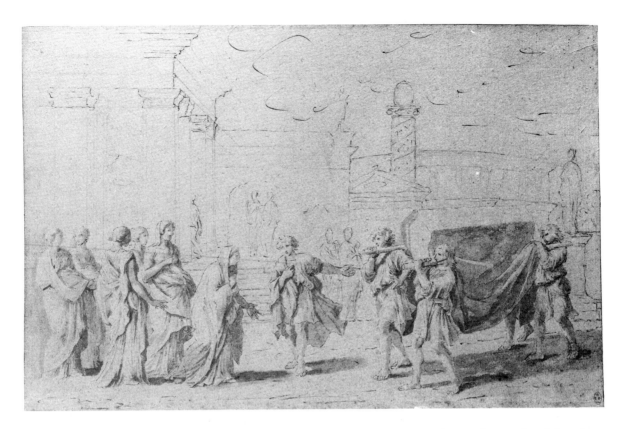

173. Assistant of Poussin (?Pierre Lemaire). *Alexander handing over the dead body of Darius to Sysigambis. (The Clemency of Alexander).* Windsor Castle, Royal Library. Pen and bistre wash over black chalk on blue paper. 259 x 410 mm. (C.R. A 29).

One of a group of drawings which may be tentatively ascribed to Poussin's assistant Pierre Lemaire. No original drawing or painting of this composition by Poussin himself is known.

more vigorous, they are so close in quality and in style of drawing that it is almost impossible to doubt that they are by the same hand.[10] It is inconceivable that Poussin himself should have made two versions so close to each other — particularly at a moment when he was hard-driven by the demands of Louis XIII and Richelieu — and, in spite of the fact that in a letter of 27 June 1642[11] to Pozzo, Poussin promised to make the fair copy, we must suppose that his other occupations prevented him from doing so and that he employed a very skilful assistant.

The same assistant seems to have executed several other drawings connected with Poussin's commissions in Paris. The two preparatory drawings for the *Burning Bush* (C.R. A 4, A 5), the large drawing for the *Institution of the Eucharist* (C.R. I, p. 49) and the preparation for the title page to Virgil.(C.R. A 42) have all the characteristics of his style.[12]

There are two drawings in the same manner connected with paintings executed after Poussin's return to Rome, one for the Chantelou *Ecstasy of St. Paul* of 1643 (C.R. A 17), the other for the *Ordination* of 1647 (Plate 174). However, by this time Poussin's own style of drawing had changed radically, and it is

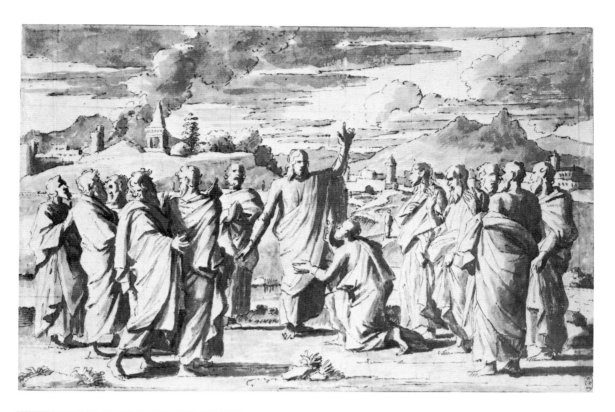

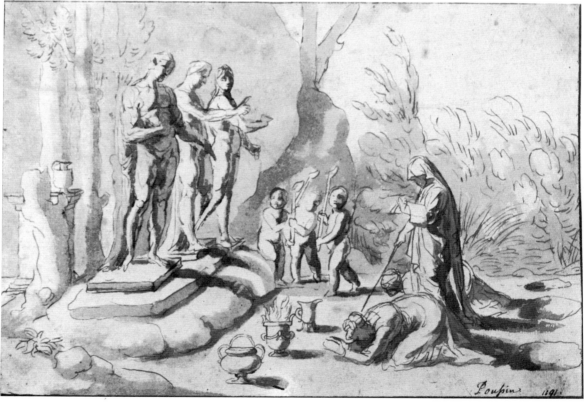

impossible to imagine that he could have had a kind of throwback in these drawings. Two other drawings which have many characteristics in common with this group seem also to be based on designs by Poussin dating from after the Paris visit: the *Medea* (C.R. A 64) and the *Alphaeus and Arethusa* (C.R. A 55). In the first case Poussin's own drawing is preserved and from its violently dramatic tone must belong to the forties.

The characteristics which mark all these drawings are also to be found — if allowance is made for the difference in scale and in type of drawing — in many of the studio drawings for the decoration of the Long Gallery and in the set of drawings illustrating Leonardo's *Trattato* in the Hermitage.[13]

If all these drawings are in fact by a single hand the author of them would have to be an artist who was close to Poussin in Rome in the late thirties, who collaborated with him in Paris in 1641-2, and who was back in Rome with him in the years after his return in 1642; who was, in short, Poussin's principal assistant roughly over the years 1637 to 1647.

Now there is one artist who fulfils these conditions, namely Pierre Lemaire. He was born about 1612, was in Rome in the years 1636-7 and went back to Paris soon after. He was with Poussin in Paris during the latter's visit and was almost certainly involved in the decoration of the Long Gallery, which was left in the hands of his brother Jean when Poussin returned to Rome.

174. (upper left) Assistant of Poussin. (?Pierre Lemaire). *Ordination*. Windsor Castle, Royal Library. Pen and bistre wash. 198 x 327 mm. (C.R. A 21).

A study made in connection with the painting of 1647, probably by Pierre Lemaire.

175. (lower left) Poussin. *Scene of Incantation.* Munich, Staatliche Graphische Sammlung. Pen and brown ink with grey wash. 187 x 267 mm. (C.R. 447).

176. (right) French imitator of Poussin. *Scene of Incantation.* Cambridge, Fitzwilliam Museum. Black chalk and brown wash. 157 x 254 mm. (C.R. A 184).

The Munich drawing is an original by Poussin made before he left Paris in 1624. The drawing may have remained in Paris, and if so this would explain how it came to the knowledge of the unknown French artist who used it as a basis for the Cambridge drawing which was evidently intended for the decoration of a wall over an arcade.

Pierre accompanied him on this occasion and is frequently mentioned in his letters of the forties. In 1665 he was a witness to Poussin's will.[14] Unfortunately no works certainly by Pierre Lemaire are known,[15] so there is no means of confirming or disproving on stylistic grounds the suggestion that these drawings are by him; but it is perhaps worth leaving the idea as a hypothesis in the hope that in due course other evidence may turn up which will make the matter clearer, one way or the other.

One curious fact about the functioning of Poussin's 'studio' is that in a number of cases he seems to have allowed other artists to make use of his drawings as the basis for their own paintings — or at any rate other artists used his drawings in this way with or without his permission.

An unexpected feature of this phenomenon is that the drawings in question cover the whole of Poussin's career and that most of the copies or variants seem to have been made during his lifetime and by a number of different artists, few of whom can be identified.

The first instance concerns a drawing almost certainly dating from the early Paris period. In the Fitzwilliam Museum, Cambridge, is a drawing (Plate 176), apparently by a French artist of the mid seventeenth century influenced by Le Sueur, showing a scene of magic or incantation. The three principal figures in this composition are copied fairly precisely from a drawing in Munich (Plate 175) which is close in style to the Marino series and probably forms part of a set illustrating an unidentified poem, executed before Poussin left Paris in 1624, of which another is in Budapest (C.R. 446). The Fitzwilliam drawing was evidently a design for a decoration to fit over an arcade, two arches of which are visible in the lower corners of the sheet, and another drawing evidently by the same hand and for the same series of decorations is in the museum at Besançon.[16] This cannot be connected with any known composition by Poussin, though it may be based on a lost drawing from the same series as the Munich drawing. The conclusion seems to be that Poussin must have left drawings of this kind in Paris when he went to Rome and that they became available to another artist perhaps twenty-five or thirty years later.

Two other cases of borrowing concern drawings of the 1620s known in the original. The first is the *Adoration of the Golden*

177. Assistant of Poussin. (?Pierre Lemaire). *The Origin of Coral.* Windsor Castle, Royal Library. Pen and brown wash. 352 x 514 mm. (C.R. A 66).
A fair copy of Poussin's original drawing made in the later 1620s (Plate 13), this and the *Kingdom of Flora* (C.R. A 58) form a series with the *Venus and Adonis hunting* (C.R. A 51) and may all be by Pierre Lemaire.

178. Sébastien Bourdon. *Perseus and Andromeda (The Origin of Coral).* Munich, Alte Pinakothek. Painting.
Based on Poussin's composition shown in the drawings reproduced on Plates 13 and 177.

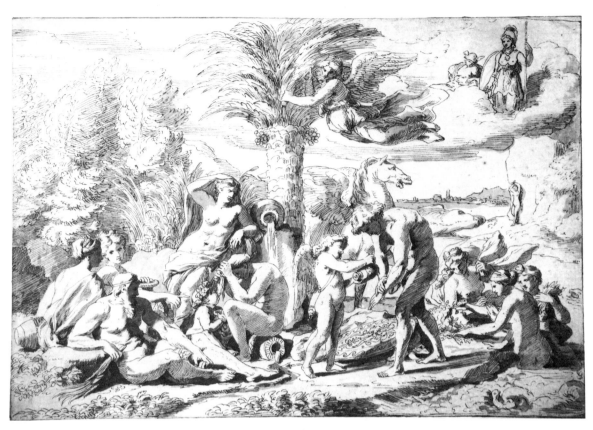

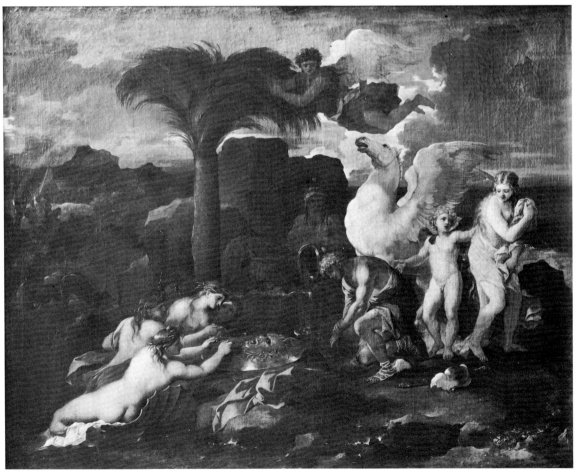

Calf, of which the painting in the W.H. de Young Museum, San Francisco, is based on a black chalk drawing at Windsor, too faint to reproduce (C.R. 22). The drawing is on the *verso* of a sheet on the *recto* of which is a *Victory of the Israelites over the Midianites* certainly by Poussin himself (C.R. 387). The San Francisco painting has generally been accepted as by Poussin because it bears the initials N.P. with a date which has been variously read as 1626 and 1629, and because it was engraved by J.B. de Poilly. The date and the initials however were almost certainly later additions and have now almost disappeared and the authenticity of the painting has recently been challenged by Pierre Rosenberg, in my opinion rightly.[17] In general design the painting follows the drawing closely, except that the two trees to the left of the calf and the child seated on the ground below it have been left out, but the painter has transformed the figures into types which are not to be found in Poussin and the handling of the head and draperies is quite different from his manner of painting in the twenties or indeed at any period. It is not possible at present to suggest a name for the author of this painting, but he seems to have been influenced as much by Castiglione as by Poussin, and the painting may date from considerably later than the drawing.

The next case concerns the composition of Perseus washing the blood from his hands after killing the monster to whom Andromeda was beng offered. The original drawing, now at Windsor (Plate 13), comes from the Massimi collection in the catalogue of which it is called *La Tintura del Corallo*. Another drawing of the same composition is also at Windsor (Plate 177), and the theme was repeated by Sébastien Bourdon in a painting now in the Alte Pinakothek, Munich (Plate 178).[19] It is not clear which of the two drawings Bourdon knew, because he has treated his model very freely, and the only feature which he takes over exactly is the palm-tree with a Victory flying beside it and plucking a leaf to give to Perseus, and these details are identical in both drawings. Bourdon has left out the figures of Minerva and Mercury which in the drawings appear on a cloud in the top right-hand corner and has moved Andromeda from the distant rock to the foreground. Pegasus has been reversed and the three naiads with the shield have been moved from the right to the left side. In spite of these differences however there can be no

question that Bourdon knew one of the drawings or possibly another for the same composition now lost. He could no doubt have seen his source when he was in Rome in the years 1634-7, but it is not clear how he gained access to it. It is often affirmed that he was in touch with Poussin during these years, but there does not seem to be any evidence to support this view,[18] and indeed what evidence we have points to the opposite conclusion. While in Rome Bourdon consorted with and imitated the style of the *bamboccianti*, the followers of Pieter van Laer who specialised in the painting of 'low' subjects, of which Poussin strongly disapproved, and if we accept as true — which we must do with caution — the only story recorded about his behaviour at this time, to the effect that he maliciously made a copy from memory of a landscape by Claude and passed it off as an original, it would certainly not have endeared him to Poussin. Given the differences which exist between his painted version and both drawings, it is permissible to wonder whether he saw one of the latter and committed to memory the idea of it in general and certain parts — such as the palm-tree — in great detail.

There is, moreover, reason to think that in his early years in Rome Poussin kept certain drawings in his studio for a considerable time and showed them to visitors, perhaps as specimens of his wares. For instance, the original drawing for the *Kingdom of Flora* (Plate 12) — which was incidentally a pair to the *Tintura del Corallo* — must have been made about 1625-7, but the painting was not executed till 1631 when it was ordered by the Sicilian diamond-merchant Valguarnera. Perhaps the same habit enabled Bourdon to see the *Corallo*, and perhaps — if we may continue to speculate — if Valguarnera had not been arrested a few months later and died in prison, he would have commissioned a pendant of the *Corallo*, in which case, we may presume, Bourdon would never have ventured to paint his version.

The next artist who can be shown to have made use of drawings by Poussin is Charles-Alphonse Dufresnoy, who spent the years 1633-53 in Rome and was almost certainly in contact with Poussin.[20] The connection with Poussin's drawings is to be found in two paintings, formerly in the Neues Palais, Potsdam, destroyed in the Second World War but luckily recorded in photographs. One, representing *Venus landing on Cythera* (Plate 179), is based very closely on a black chalk drawing by Poussin at

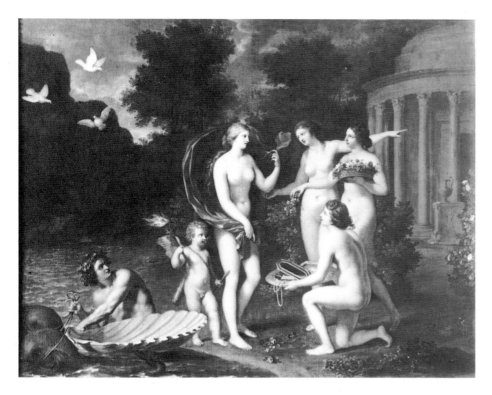

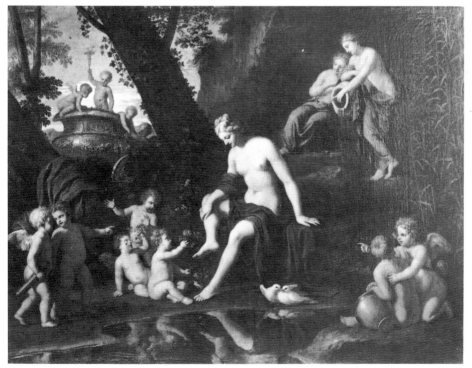

179. (upper left) Charles-Alphonse Dufresnoy. *Venus landing on Cythera.* Painting.

180. (lower left) Charles-Alphonse Dufresnoy. *The Toilet of Venus (La Tintura della Rosa).* Painting.
 Both formerly in the Neues Palais, Potsdam, and destroyed in 1945.

181. (upper right) Poussin. *Venus landing on Cythera.* Bayonne, Musée Bonnat. Black chalk. 163 x 230 mm. (C.R. 205).

182. (lower right) Poussin (copy after?). *The Toilet of Venus.* Paris, Musée du Louvre. Pen and brown wash. 184 x 239 mm. (C.R. B 24).
 Dufresnoy, who was in Rome from 1633 to 1656, evidently used two drawings by Poussin as the basis for his two paintings, which are signed and dated 1647. In the *Cythera* he has followed Poussin very exactly, but the *Toilet of Venus* differs considerably in the placing of the figures. It is possible that Dufresnoy was not using this drawing — or the original of it, if it is a copy — but a variant made by Poussin himself and now lost. What is curious is that the two drawings appear to have been made at an interval of some twenty years, the *Toilet* in the late twenties, the *Cythera* in the late forties.

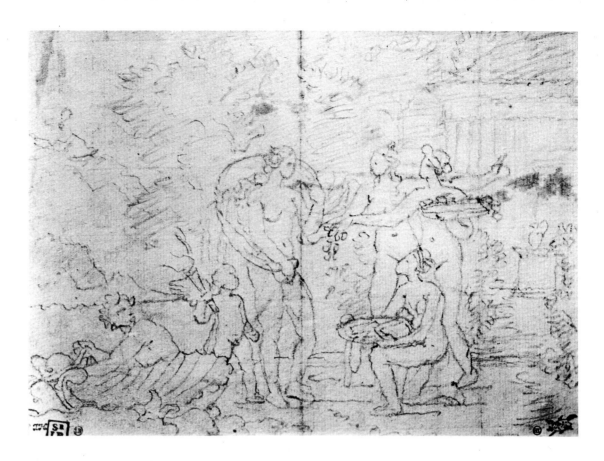

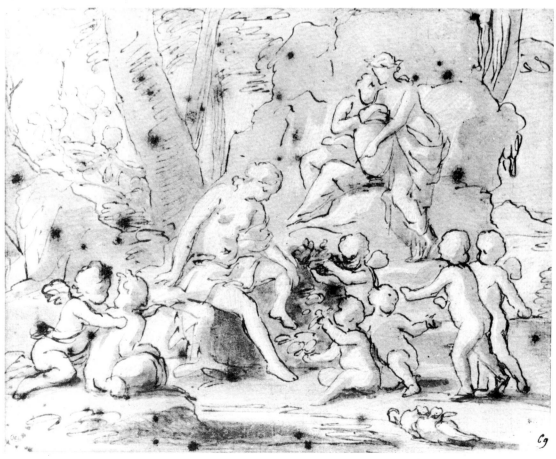

Bayonne (Plate 181), so closely indeed that the only variation is in the temple in the right background which in the painting has a specifically Palladian character. The painting is signed and dated 1647 and the drawing appears on style to date from this period. The painting however is quite different in character from what Poussin was producing at this time. In spirit it is close to Poussin's mythological paintings of the thirties, but the predominant influence is that of Albani.

The second painting, also signed and dated 1647, represents another subject familiar in the *oeuvre* of Poussin, *La Tintura della Rosa* (Plate 180). It is not however based on the composition — known in the studio drawing at Windsor, which is a pair to the *Corallo*, but on another recorded in a drawing in the Louvre (Plate 182).[21] Whereas in the *Venus landing on Cythera* Dufresnoy followed Poussin's drawing very closely, here the differences are considerable. The principal group of Venus herself attended by putti is almost the same in the drawing and the painting, but in reverse, and the pairs of putti in the foreground are also nearly identical, but moved from one side of the composition to the other. The landscape setting, the nymphs with a water-pot on the right and the chariot of Venus in the background on the left are taken over exactly from the drawing.

The processes involved in the production of these two 'copies' are curious. In one Dufresnoy appears to have used a drawing made by Poussin quite recently, and he followed it exactly; in the other his model was a drawing dating from nearly twenty years earlier, and the variations are considerable. It might be argued that Dufresnoy based his painting on another drawing by Poussin now lost, in which the artist had modified the composition, but the process of simply inverting certain elements in a composition is one which seems foreign to Poussin. One must suppose that Dufresnoy made what he could of the material available to him — and it must be admitted that his two compositions do not make a happy pair and would probably not have been accepted as pendants if they had not both been signed and dated and had a common provenance.

Dufresnoy is also involved in another more complicated case of borrowing. A number of drawings certainly from Poussin's hand, exist which illustrate the rarely depicted story of Queen Zenobia, wife of Rhadamistus, King of Armenia, which is also

183. Attributed to Charles-Alphonse Dufresnoy. *The Finding of Queen Zenobia.* Leningrad, Hermitage. Painting.

184. Poussin. *The Finding of Queen Zenobia.* Windsor Castle, Royal Library. Pen and brown wash. 158 x 200 mm. (C.R. 132).

166

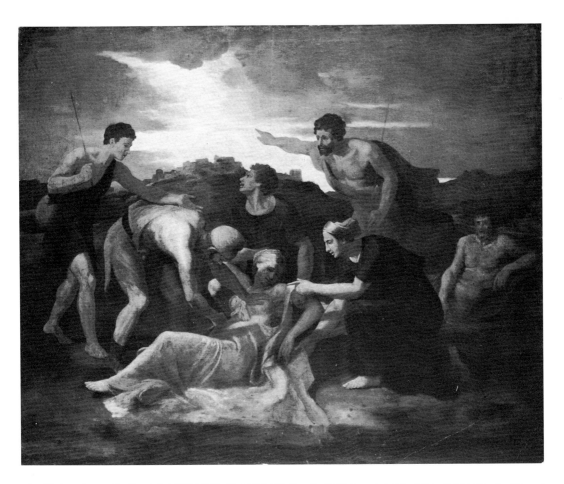

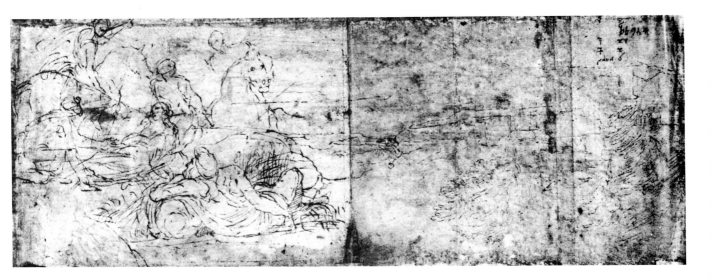

185. (upper left) Poussin. *The Finding of Queen Zenobia.* Springfield, Rhode Island, Winslow Ames Collection. Pen and brown ink. 111 x 216 mm. (C.R. A 35, wrongly described as probably a copy).

186. (left) Attributed to Charles-Alphonse Dufresnoy. *The Finding of Queen Zenobia.* Stockholm, National Museum. Pen and brown ink. 113 x 193 mm. (C.R. 133, wrongly described as an original by Poussin).

187. (above) Poussin. *The Finding of Queen Zenobia.* Düsseldorf, Kunstmuseum. Black chalk, pen and brown ink on grey paper. 200 x 540 mm. (C.R. 286). *Verso* of drawing shown on Plate 86.

the theme of two paintings directly connected with the drawings. The version in the Hermitage (Plate 183) is traditionally, but in my opinion wrongly, attributed to Poussin, but the other, the present whereabouts of which is not known, appeared in the Dufourny sale of 1819 under the name of Dufresnoy.[22] This attribution is perfectly convincing, and I believe that the Hermitage picture may be by the same hand. The problem here is different from the cases so far considered because the paintings are only connected in rather general terms with Poussin's drawings. The drawing at Windsor (Plate 184), the inscriptions on which give the clue to the subject, shows the principal figures in roughly the same grouping as in the painting, but in quite different poses; and the setting with the town of Artaxata on a hill in the distance is clearly indicated. In two other drawings (Plates 185, 187) the pose of the Queen is much closer to the painting and the figure pointing into the distance appears in one of them (Plate 187), but the men in the group are mainly on horseback. A drawing exists however at Stockholm (Plate 186), certainly not by Poussin, in which the figure group corresponds almost exactly to the painting, for which it must be a direct preparation. In this case therefore it seems that Dufresnoy knew Poussin's drawings of the subject but made his own free variant of them, first in a drawing and then in two paintings. The problem of dating is difficult. Three of the drawings by Poussin (Plates 184-5 and C.R. 131) appear to date from the late thirties or the early forties,

169

a fourth (C.R. A 34) appears to be a copy of a lost original of the same period, but the one at Düsseldorf (Plate 187) is on a sheet which contains two studies connected with the *Landscape with a Man killed by a Snake* of 1648 and must presumably date from about the same time. The Hermitage picture is however in a style related to Poussin's work of the thirties and it is unthinkable that he should have painted in this manner in the last years of the 1640s. Further it is unfinished and it would have been quite contrary to the artist's principles to have left a canvas unfinished at that date (if he had been dissatisfied with it, he would have destroyed it). If, on the other hand, it is by Dufresnoy, its condition could be explained by the fact that the artist left Rome to return to Paris in 1656, which would suggest a dating consistent with the date of the latest drawing by Poussin for the composition.

A somewhat similar problem arises in connection with a composition representing *Rinaldo carried away from Armida by his Companions*, known from two paintings, one belonging to the Earl of Lichfield at Shugborough and attributed to Lebrun (Plate 192) and the other in the collection of M. Jacques Lacombe in Paris, ascribed to Verdier. Five drawings are known connected with this composition. Two of them (Plates 188-9) are certainly by Poussin and appear to date from the late forties (one has studies for the second series of *Sacraments* on the *verso*). A rough pen drawing in a private collection is on the *verso* of another so strongly drawn that it comes through and obscures the *verso* to such extent that it is impossible to reproduce. Two further drawings, almost identical in composition and both squared, one in pen and wash, the other in wash only, are in the Philadelphia Museum, and the Dahlem Museum, Berlin, respectively (Plates 190-1). A further factor to be taken into account is that the figure of Armida in all the versions, is very close to one in a composition of the same subject by Vouet.[23]

The pen drawing, which is the least close to the painted version in that it shows the fainting Armida attended by four women, whereas in all the others she is accompanied only by a winged putto, is certainly not by Poussin and bears some relation to the Stockholm drawings for the Zenobia. The two squared drawings are close to the two originals by Poussin; in fact they combine features from both: the general composition is like Plate 188, but the group of Rinaldo and his companions is taken from Plate 189.

188. Poussin. *Rinaldo carried away from Armida by his Companions*. Paris, Musée du Louvre. Pen and brown wash. 184 x 254 mm. (C.R. 146).

189. Poussin. *Rinaldo carried away from Armida by his Companions*. Paris, Musée du Louvre. Pen and brown wash. 90 x 130 mm. (C.R. 145).
The drawing shown on Plate 188 has on the *verso* studies for *Eucharist* and *Penance* from the second series of *Sacraments* dating from 1646-7, but the drawing itself suggests a later date in the early fifties. The palace of Armida, visible on the hill in the background, is based on the Temple of Jupiter above Terracina which Poussin would have seen on his journey to Gaeta, probably made about 1630. He may have visited the district again in 1647 and he used a scene from near Terracina in his *Landscape with a Man killed by a Snake* in the National Gallery, London, painted for his friend Pointel (Plate 141).

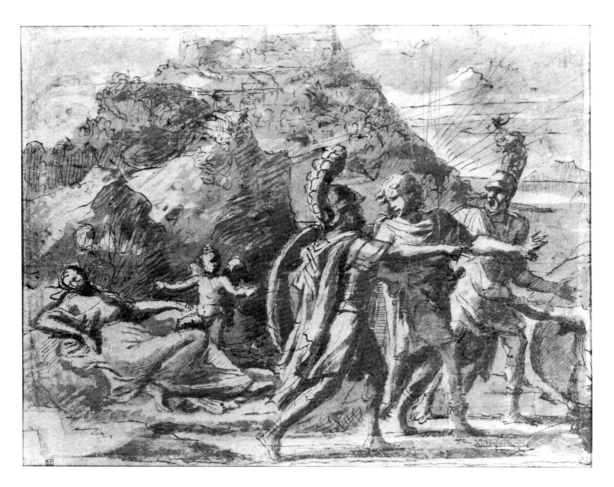

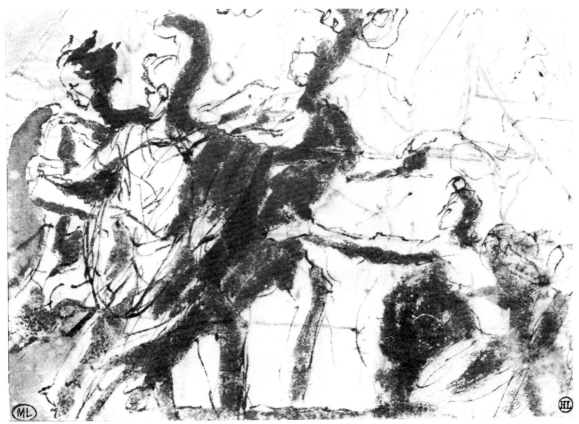

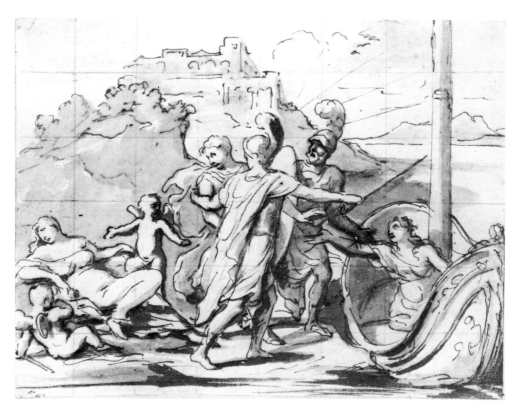

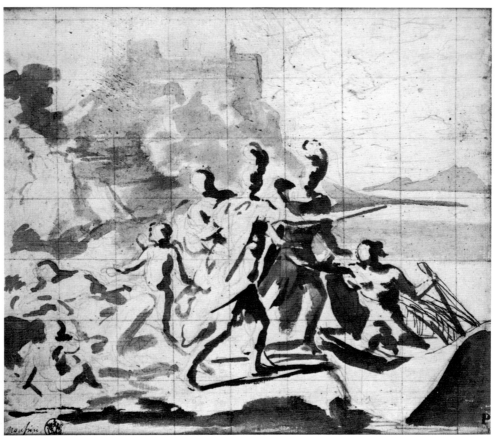

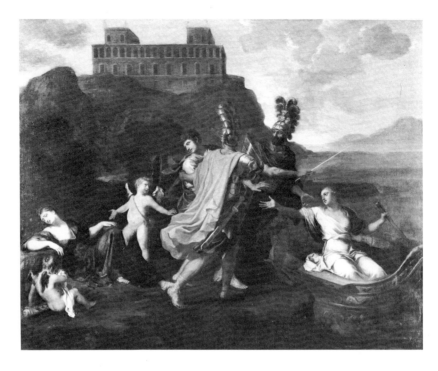

190. (upper left) French imitator of Poussin. *Rinaldo carried away from Armida by his Companions.* Philadelphia Museum of Art, Pennsylvania Academy of the Fine Arts Collection. Pen and brown wash.

191. (lower left) French imitator of Poussin. *Rinaldo carried away from Armida by his Companions.* Dahlem, Kupferstichkabinett. Brown wash with a little pen work. 217 x 259 mm. (see 'Vom späten Mittelalter bis zu J.L. David', Dahlem Museum, Berlin, 1975, No. 155).

192. (above right) French imitator of Poussin. *Rinaldo carried away from Armida by his Companions.* Shugborough, Collection of the Earl of Lichfield. Painting. 117 x 159 cms.

The painting and the two drawings on Plates 190-1 are all based on drawings by Poussin, of which two survive (Plates 188-9), and the artist has combined motifs from both in his own composition. The Berlin drawing has been ascribed to Poussin himself, but it is almost certainly by the same artist as the painting. This painting is certainly French and may conceivably be by the same hand as the two Potsdam canvases, that is to say Dufresnoy.

The Berlin drawing belongs to the group of wash drawings discussed above,[24] some of which are by Poussin, and others, very similar to these, by followers such as Blanchard or Mola. On purely stylistic grounds one would hesitate to allot the Berlin drawing to one group or the other, but in its relation to the other members of the series it must come after the two originals, and therefore cannot date from earlier than the late forties, by which time Poussin had, as far as we know, completely abandoned this style. Moreover this drawing and the Philadelphia sheet are both so close to the painting that it seems almost certain that they are by the same hand as the latter. Further it is hard to imagine that Poussin would have worked out a composition so fully and then handed it over to another artist to paint. This would be a very different process from giving a rough sketch or two to another artist for him to adapt to his own purposes.

The attribution of the paintings and the drawings which are not by Poussin is difficult, but the connections with Dufresnoy are close enough to suggest that he may be the author. As has already been said, the pen drawing is not unlike the Stockholm drawing for the *Zenobia*, which I have suggested is by him, and the drawing on the *recto* belongs to a series which I believe —

173

though the evidence is tenuous — may also be from his hand.[25] The painting is certainly by an artist of an older generation than Lebrun — and *a fortiori* than Verdier — and its style is not inconsistent with that of the Potsdam pictures. It would be unwise however to say anything more definite than this.

It remains to consider a group of very late drawings with which paintings by other artists are connected. The first of these represents the *Three Marys at the Sepulchre*, the drawing being at Windsor (Plate 193) and the painting in a private collection in Paris (Plate 194). The drawing at Windsor was found laid down on the same sheet as a small study by Andrea Sacchi among the large series of drawings by this artist which probably came from the Albani collection. This suggests that the Poussin drawing may have belonged to him and therefore that the painting based on it might possibly be by him, but this is impossible on stylistic grounds.

The painter — whoever he may be — has preserved the main features of the composition as shown in the drawing, and has followed the poses of the figures very carefully, but he has changed the grouping, moving the angel so that his head stands out against the opening of the cave, and bringing the kneeling figure of one of the Marys nearer to the angel, thus destroying the carefully composed triangular group which appears on the right in Poussin's composition. As with all the paintings based by other artists on drawings by Poussin, the painting is much softer and less dramatic than the drawing.

The drawing of *Venus at the Fountain*, already discussed as one of Poussin's most striking late works (Plate 97), was also used as the basis for a painting, now in a private collection in Paris.[26] The author of the painting is unknown but it has affinities with the Potsdam *Tintura della Rosa*, and Dufresnoy is a serious candidate for its authorship. On the other hand the drawing is on the back of a letter addressed to Poussin in 1657 by Antoine Bouzonnet Stella and this would suggest a connection with that artist, who went to Rome in the same year and was kindly received by Poussin. We know so little about his style however that any firm decision is impossible.

A member of the Stella family may also have been responsible for a painting, formerly on the London art market, representing children playing (Plate 195) which is based on a drawing by

193. Poussin. *The Three Marys at the Sepulchre*. Windsor Castle, Royal Library. Black chalk. 108 x 140 mm. (C.R. 402).

194. Imitator of Poussin. *The Three Marys at the Sepulchre*. Private Collection. The Windsor drawing must, on stylistic grounds, be dated to the 1650s and was certainly the model used by the unknown author of the painting as the basis for his composition.

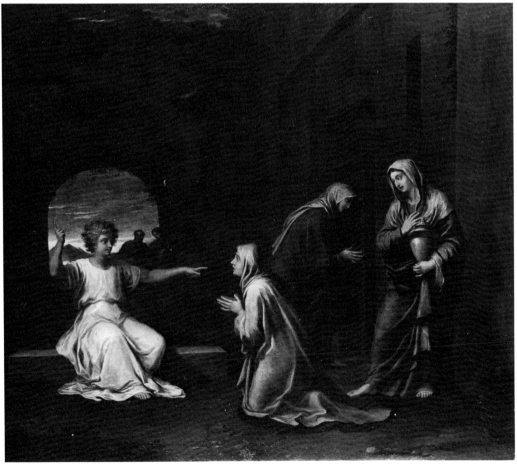

Poussin in the Gabinetto Nazionale dei Disegni, Rome (Plate 108). The theme of children playing was a favourite with the Stella family, and the painting is close in character to a series of engravings by Claudine Bouzonnet Stella after the designs of her uncle, Jacques Stella, published in Paris in 1657 under the title of *Les Jeux et Plaisirs de l'Enfance*. The painting follows the drawing very precisely except for the omission of the Bacchic vista between the two groups of putti and the addition on the left of two women leaning on the base of a statue probably representing the youthful Bacchus.

The last case to be discussed is the most curious of all. It concerns a group of drawings by Poussin representing the rare subject of the infant Pyrrhus received by Glautias (Plates 196-7).[27] The puzzle is that, though no painting by Poussin or by any close follower is known, the drawings are related in a quite specific manner to a composition by F.A. Vincent, shown in the Salon of 1791 (Plate 198), and to a drawing, probably dating from a slightly later period, which bears a false inscription: *Ingres*.[28] The problem is complicated by the fact that Vincent's painting and the 'Ingres' drawing are in reverse compared with the drawings. The obvious explanation of this would be that there must have been an engraving of Poussin's composition in reverse, but no such engraving is known. It is possible that the surviving drawing for the whole composition may have been known in Vincent's time, because, though its basic authenticity is proved by the drawing for the *Death of Sapphira* on the other side (Plate 92), the seated figures of Glautias and his queen are in a style very unlike the rest of the drawing and might have been redrawn in the late eighteenth century, but this still does not account for the reversing of the composition. For the moment no solution to this puzzle can be offered; but it is at least an interesting example of the influence which Poussin's ideas, even when only recorded in drawings, exercised on artists at the end of the eighteenth century.

It is difficult to generalize from the examples just discussed, but it seems certain that in his later years Poussin was not unwilling to hand over his drawings to other artists with the intention that they should be used by them for their own purposes. At first sight this seems contrary to Poussin's own dislike of any form of collaboration, but the explanation is probably that in his later

195. French imitator of Poussin. *Children Playing*. Present whereabouts unknown. Painting.
The painting is based on Poussin's drawing shown in Plate 108. It appears to be by the same hand as one of *Venus at the Fountain* in a French private collection which is based on another drawing by Poussin (Plate 97). The paintings may conceivably be by Antoine Bouzonnet Stella, the nephew of Poussin's friend Jacques Stella, who went to Rome in 1657 and was allowed access to Poussin's studio.

176

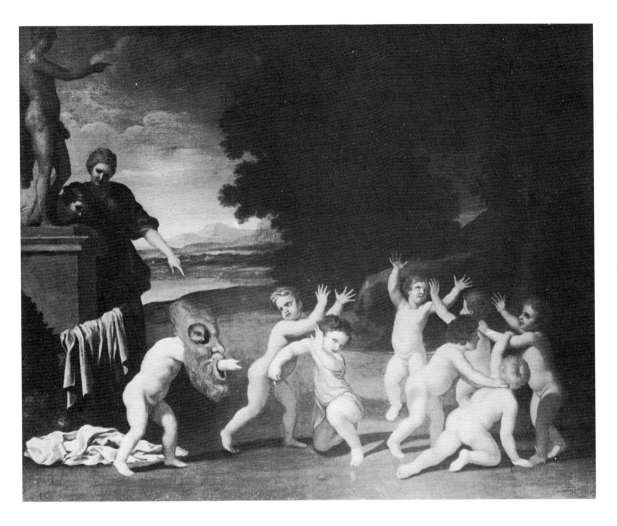

years, when he was tired, ill and overworked, he realized that he
would not be able to carry out many of the compositions which
he had conceived and was therefore willing to allow others to
make use of them.

The problem of the early drawings is more difficult. As has
already been suggested, Bourdon may have imitated the composi-
tion of the *Tintura del Corallo* drawing without Poussin's
consent, but we have no information about how the painter of the
San Francisco *Golden Calf* came to know the drawing now at
Windsor — or another drawing of the same composition now
lost. The Windsor drawing almost certainly belonged to Cassiano
dal Pozzo and so would have been available to artists working in
Rome, and it is possible in this case also that the borrowing was

177

made without Poussin's knowledge. This must however remain pure speculation.

So far in this section we have been concerned with the problems raised by paintings by other artists based on drawings by Poussin, but it is clear that from a fairly early date very exact copies of some of his drawings were made in the same medium. One such copy — after a drawing for the *Holy Family on the Steps* (C.R. 47) — belonged to Poussin's friend, Fréart de Chantelou, and is now in the Musée Bonnat at Bayonne (C.R. I,

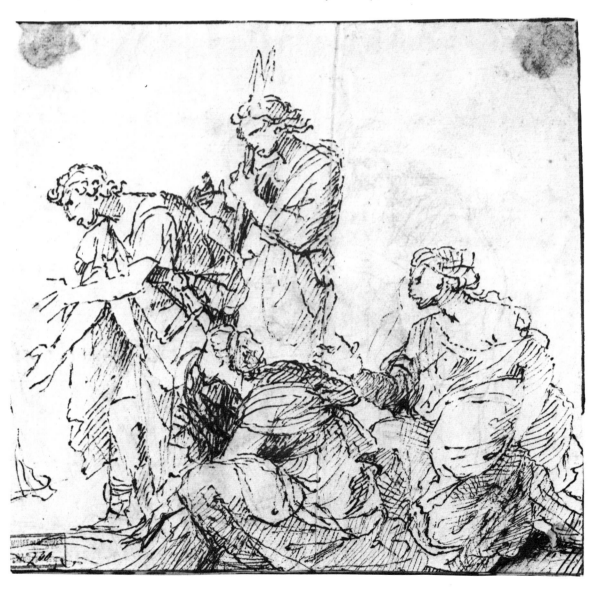

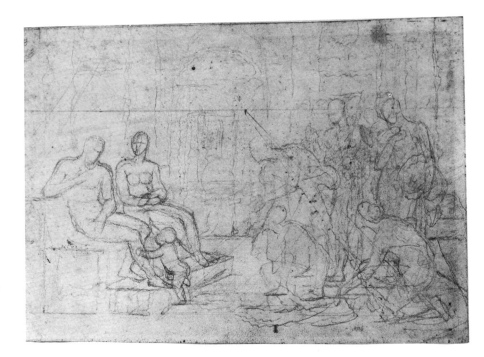

196. (left) Poussin.
*Study for the foreground
Group in the Infant Pyrrhus.*
Bergues, Musée municipal
du Mont-de-Piété. Pen and
brown ink. (*Master Draw-
ings*, XII, 1974, p. 242).

197. (upper right) Poussin.
*The Infant Pyrrhus received
by King Glautias of Epirus.*
New York, Private Collec-
tion. Black chalk. 195 x 302
mm. (C.R. 416).

198. (lower right) F.A.
Vincent. *The Infant Pyrrhus
received by Glautias, King of
Epirus.* Lidlochovice,
Museum. Painting.

The painting by Vincent
was shown in the *Salon* of
1791, but the artist must
have known Poussin's
composition of the same
subject, as recorded in the
drawing on Plate 197. It is
not clear however in what
form it was transmitted to
him, since no painting by
Poussin is known, nor was
his design engraved. If an
engraving had existed it
would account for the fact
that Vincent's painting is in
the opposite sense to
Poussin's drawing.

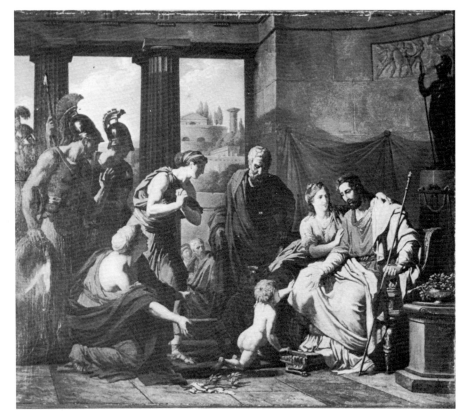

p. 20),[29] and another, after the *Mars and Venus* of which the original is in the Louvre, belonged to Massimi and is now in the Royal Library at Windsor (Plates 199-200). In the former case the copyist has included all the *pentimenti* visible in the original, and the distinction in quality between the two drawings is sufficiently marked to leave one in no doubt which is the original, but the *Mars and Venus* is a finished drawing, without alterations, and the two versions are so close that the decision is much harder. The main differences occur in the trees behind the central group and here the handling of the wash and the drawing of the heads in the Louvre version are more subtle and more elaborate than in the Windsor drawing. The face of Mars is also more convincing both in modelling and in expression. In this case, a very early engraving — made by Fabrizio Chiari and dated 1636 — exists, and it might be supposed that the copy was made for the use of the engraver, but the two drawings agree in all but the smallest details, and the engraving differs substantially from both in parts of the background, so that this solution does not seem to be valid.

Another exceptionally fine copy of an early drawing exists at Rouen (Plate 202) after the Marino drawing of *Apollo guarding the Herds of Admetus* (Plate 201). This copy is as faithful as that after the *Mars and Venus* and it is only in certain details such as the construction of the rock in the foreground or the shading of the underbelly of the bull that the Rouen drawing betrays — in my judgment — weaknesses in relation to the Windsor version.

Another alarmingly similar pair of drawings is composed of the *Diana hunting* (Plate 9) in the Royal Library, Windsor and a copy now in the Rosner Collection, Tel-Aviv (Plate 203). Here the copyist betrays himself by a certain carelessness in copying the details such as the feet of Diana and the back of the nymph lying in the right foreground. At first sight one would tend to assume that a copy such as this was likely to have been made at a very early date, possibly even under the eye of Poussin himself, but one feature of the two drawings seems to make such a hypothesis impossible. Both drawings are clearly cut at the top and the left and they are cut at exactly the same point. The copy must therefore have been made after the original was cut down. It is of course possible that this happened soon after it was drawn, but it

199. Poussin. *Mars and Venus*. Paris, Musée du Louvre. Pen and brown wash. 196 x 261 mm. (C.R. 206).

200. Copy after Poussin. *Mars and Venus*. Windsor Castle, Royal Library. Pen and brown wash. 211 x 272 mm. (C.R. A 50).
The Windsor drawing, which belonged to Cardinal Massimi, was accepted as an original till the discovery of the one now in the Louvre, which showed up its weakness, particularly in the drawing of the heads.

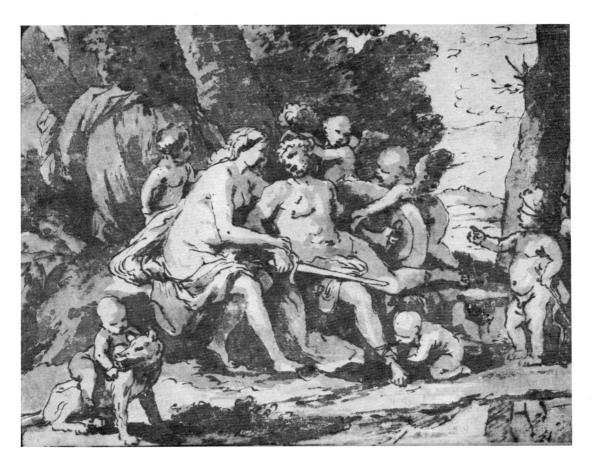

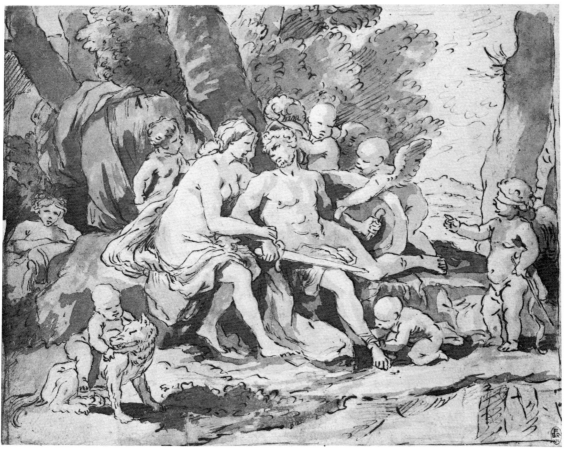

201. Poussin. *Apollo guarding the Herds of Admetus.* Windsor Castle, Royal Library. Pen and brown ink with grey-brown wash. 186 x 320 mm. (C.R. 159).

202. Copy after Poussin. *Apollo guarding the Herds of Admetus.* Rouen, Musée des Beaux-Arts. Pen and brown ink with grey-brown wash.

The Rouen drawing is an alarmingly good copy of the Windsor sheet, but where it differs — for instance in the rock in the foreground and the shading of the underbelly of the bull — it is perceptibly weaker.

is more likely to have occurred after the sheet had been lying about in the studio for some time and possibly even after it passed into the possession of Cardinal Massimi.[30]

Curiously enough there are relatively few drawings after compositions of Poussin's later periods which are nearly as deceptive as those after the early drawings. Many of them are after the paintings rather than the drawings and were evidently made by students anxious to note the general character of a design rather than to produce an exact imitation; and even those that are after known drawings are generally speaking of less high quality. Their distribution — as far as can be judged from surviving examples — is also curious. The Budapest drawing for the 1648 *Finding of Moses* in the Louvre is known in at least four copies — all rather good and one at least published early in this century as an original — but only about a dozen copies after the figure composition drawings of Poussin's mature years are known, and most of them are of mediocre quality.[31] An exception to this rule is the copy of the *Triumph of Bacchus* painted for Richelieu which belongs to Mr. T. Cottrel-Dormer and is now generally thought to be by Jan de Bisschop or a close follower (C.R. A 177).

Two other rather more surprising categories of copies are known. The first are copies after Poussin's drawings after ancient sculpture, of which the most remarkable example is the pair of drawings after ancient altars in the Musée Bonnat at Bayonne (Plates 149-50) discussed in Chapter IV. The second consists of a small group of good and apparently early copies after some of the landscape drawings of the later years. The Louvre possesses one after the heroic Düsseldorf landscape (Plate 86 and C.R. A 138), and two drawings are known which are almost certainly copies after lost drawings for the *Landscape with St. Francis* (in the National Gallery of Wales, C.R. A 188) and the *Autumn* (Pierpont Morgan Library, C.R. A 143), though in these cases no originals are known.

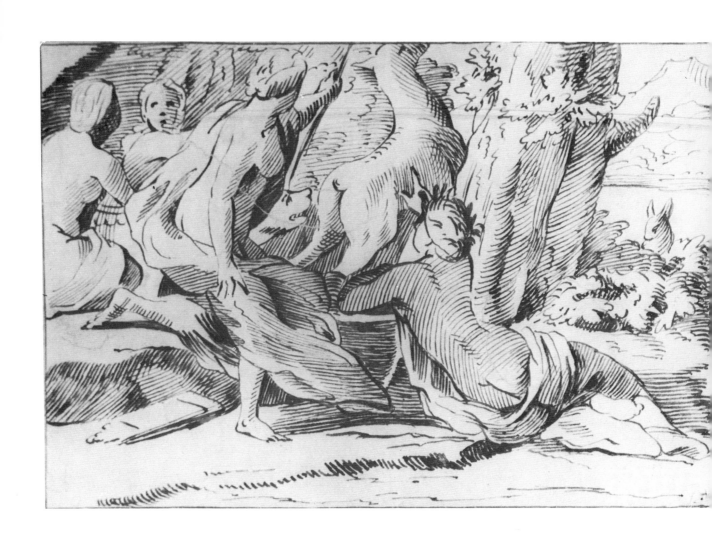

Conclusion

It is impossible to judge Poussin's achievement across the whole range of draughtsmanship because, as has been emphasised in earlier chapters, several categories of drawings have vanished. Of these the most important group is the drawings from the model, but even in this case I believe that the indirect evidence entitles us to conclude that the drawings were of high quality. We know that Poussin made his drawings from the life under the best available masters, Domenichino and Sacchi — which is of course in itself no proof — but the drawing of individual figures in the paintings, which must have been directly based on the lost studies, argues a similar quality in the drawings themselves. This argument does not apply universally — for instance a beautiful figure by Delacroix may be based on a relatively weak drawing — but in the tradition within which Poussin was working — for this purpose that of Annibale Carracci and Domenichino — the link between drawings from the model and figures in the paintings was so close that a painter can hardly have been successful in the one without being skilled in the other.

Poussin's surviving figure drawings go from the slightest notes with a pen to finished compositions fully worked up with wash. The pen-notes can be mere scribbles, recording the pose of a raving Maenad or a Bacchante (C.R. 191 and Plate 37), a mourning figure (Plate 37) or a tragic event like the suicide of Cato (Plate 133). These drawings which must have been made directly from an idea seen with the eye of the imagination, long before Poussin had begun to work out his composition on his miniature theatre, have extraordinary qualities of freshness and spontaneity which are rarely found in his finished drawings and never in his paintings, after the 'Venetian' period. They were qualities which Poussin regarded as of secondary importance and he willingly sacrificed them in his pursuit of his real aims — vividness of dramatic expression, suitability of the forms to the mood of the story, clarity of space construction and harmony and balance of the whole. That he made the sacrifice voluntarily is evident from an examination of any of the series of drawings leading up to one of the major compositions. Let us look, for

203. Copy after Poussin. *Diana hunting.* Tel Aviv, Rosner Collection.

A very competent copy after the original at Windsor (Plate 9). It must have been made after the latter was cut since it stops at exactly the same points, for instance in the stag's head, half of which is cut off by the edge of the paper.

185

instance, at the *Baptism* from the second series of *Sacraments*, the drawings for which have already been studied from the point of view of their formal evolution. The Uffizi drawing (Plate 121) is a luminous structure in rich and varied washes, which at first sight might be taken for the work of a Flemish or Dutch artist, and something of the same interest in overall effects of light and shade is apparent in the Louvre study which follows it (Plate 123). Even the two smaller studies for the groups on the right of the composition (C.R. 80, 82) are composed of strongly lit figures, with the shadows indicated by vigorous washes, but in the final study, also in the Louvre (Plate 124), the light has been deadened and the wash is applied in small purely functional touches, conceived to define the forms. In the painting (Plate 125) all chiaroscuro has disappeared and the light has been reduced to a strange, almost dead evenness. The liveliness of the early drawings is sacrificed to solemnity, gravity and clarity. In others of the *Sacrament* series less has been given up, and Poussin has allowed himself to introduce into the paintings themselves touches of light, as in *Eucharist* (Plate 60), or brilliant details of still-life, as in *Penance* (Plate 62), which remind one that he was not always as severe as he claimed an artist should be.

The sacrifice of these 'minor' qualities in favour of more important ones is also in accordance with what Poussin wrote about his art in general. He had a horror of what he called the *leccatura* — slickness — of some contemporary Italian painting; he consciously rejected the charms of colour, since they appealed only to the eye, not to the mind; he aimed at clarity, simplicity and concentration as opposed to the free invention of Baroque painting; in short he believed that art should be controlled, carefully thought out, and reasonable.

In this context it is significant that Poussin referred to his drawings as 'pensées';[1] they were the means by which he — almost literally — thought out his compositions. 'Je vous envoyerei la pensée du frontispice de la grande bible à la première occasion', he wrote to Chantelou on 16 June 1641 about the title page for the Bible which he had been asked to design.[2] In this case the word refers to an actual drawing, but on other occasions he uses it in a different sense. In another letter to Chantelou, written on 29 June, thirteen days after the one just quoted, he says that he will send Chantelou 'le squizze [*schizzo*, sketch] de la

pensée que j'ay trouvée pour le livre de la Bible',[3] and here *squizze* clearly refers to the actual drawings and *pensée* to the idea or general conception of the composition which he had conceived in his mind.[4] Even more revealing is a passage in a letter written in 1647 about a composition of the *Crossing of the Red Sea* which he had been asked to paint for a friend of Chantelou: 'Je lui ai trouvé la pensée et l'ouvrage de l'esprit est conclu',[5] that is to say, there remained only the 'mechanical' business of executing the painting on the canvas. It was for the 'ouvrage de l'esprit' that Poussin used drawings; they enabled him to produce the final clear and precise formulation of his ideas, which was his aim.

In Poussin's earlier period — up to the end of the 1630s — a considerable degree of the freshness of the first sketches survives till a late stage in the evolution of his compositions. For instance, in the Lille drawing of the *Massacre* (Plate 19) which I have argued in Chapter IV was made from wax models, and in the Uffizi *St. Erasmus* (Plate 17) which certainly represents a fairly advanced stage of the design, the line has as much energy as in any of Poussin's drawings, and in the studies for individual groups for the *Rape of the Sabines* (Plates 30-1), which are certainly after wax models, it is used with decisive precision — supported by firmly applied wash — to fix the complicated poses of the groups and the anatomy of the individual figures.

Even at the later stages in the grand orchestration of the religious and Bacchic themes of the mid-thirties the liveliness is unquenched. There is nothing staid about the studies for the *Crossing of the Red Sea* (Plates 27-8) or those for the *Triumph of Pan* (Plates 118-19), and the magnificent Windsor drawing for the Louvre *Saving of Pyrrhus* (Plate 33) — though very carefully worked out — is perhaps the most immediately and dramatically striking of all Poussin's drawings of the period made in preparation for a painting. Even in the 1640s, when he was working freely, as in the *Hippolytus* (Plate 74) which does not seem to have been made with a painting in mind, he can be as bold and as completely Baroque. Indeed if one considered the drawings alone it would be possible to see this group of works as representing a Baroque phase in his development. The drawings have as much movement, as much drama, as much chiaroscuro as those of his great Baroque rivals, Bernini and Pietro da Cortona,[6] and it is only in the paintings that this energy is tamed and the design

made to conform to a more calculated mode of expression and a more classical canon of beauty.

The rough drawings of the 1640s are slightly different in character. They tend to concentrate on the dramatic elements in the story is told, as in the *Death of Cato* (Plate 133), the *Medea* (Plate 68) or the scene on the *verso* of the *Hippolytus* (Plate 75) in which Aesculapius appears and saves the hero; or they already hint at Poussin's interest in the more abstract geometrical elements of the design, as in the first study for the *Holy Family in the Temple* (C.R. 44) in which the heads of the two figures are treated as simple ovals, foreshadowing the calm generalized treatment of the whole group in the drawing at Windsor (Plate 132), which shows the figures in the nude. Both these aspects of Poussin's interests are already traceable in drawings of the thirties, the dramatic in the Metropolitan *Lamentation over the dead Christ* (C.R. 401), the abstract in the beautifully worked out 'stage-design' for the *Death of Virginia* (Plate 32) or the relief-like drawing for the Wallace *Dance to the Music of Time* (Plate 48). One drawing of the forties, which seems to be unique in Poussin's work (C.R. 101), consists of a series of studies for the expression on the faces of Simon the Pharisee and his companions in the *Penance* belonging to the second series of *Sacraments*. One of these, not used in the painting, is the nearest Poussin ever came to making a caricature, but the others are a direct reflection of his interest in expressive gesture as means of making a dramatic incident intelligible to the spectator, which was one of his dominant interests in the 1640s.

The process by which Poussin developed his compositions from these first ideas to the finished versions has been analysed in connection with the drawings for the *Baptism* from the second set of *Sacraments*. Individual drawings show him developing one or another of the particular qualities which he sought in his finished compositions. Harmony and balance of composition are conspicuous in drawings such as the *Continence of Scipio* at Chantilly (C.R. 125), the *Sacrifice of Polyxena* at Windsor (C.R. 107) or the grand bas-relief composition of *Moses and the Daughters of Jethro* in the Louvre (Plate 77); the intensification of dramatic effect is the principal feature of the *Judgment of Solomon* (Plate 71) or the Leipzig *Crucifixion* (Plate 69).

In the last phase of Poussin's life, that is to say roughly the years after 1650, the categories which apply to the earlier

drawings break down. There are none of the brilliant studies of the earlier phases, because Poussin's hand was now so insecure that he could not make the decisive lines of, say, the *Sabines* sketches; but it is also true that he would not have wanted to make this kind of drawing, which he would probably have found flashy. In fact he hardly ever indulged in the sensuous charms of wash in his later drawings; everything that he needs to say can be said in line, even in the shaky line of his last years. Only when he comes to render the gaiety of the *Birth of Bacchus* (Plate 95) does he turn to wash for support, and something of its luminous quality survives into the painting (Plate 96) — the only one of Poussin's late canvases in which light plays a positive role — in the rays of the rising sun appearing in the gap over the cave where, in the drawing, we see the chariot of Apollo.

There are still rough direct sketches made, we must imagine, from imagination but embodying the quintessence of something seen in nature, such as the vibrating drawing of the dog in *Hercules shooting the Stymphalian Birds* (Plate 94) obviously inspired by some bristling mongrel that the artist had seen in the streets of Rome. But these studies are no rougher than most of the more elaborate figure groups in which Poussin plays with his mythological themes connected with Apollo (Plates 98-100). As has already been pointed out, these do not form a logical sequence and Poussin seems to have tried out combinations of various themes, some of which are dropped altogether from the painting. In the same way it is impossible to work out any logical development of the composition; each drawing must be regarded as a separate 'meditation' on the theme and a separate attempt to solve the compositional problems involved. There is no trace here of the carefully calculated method of work, based on the theatre and the wax figures; in fact we can be fairly sure that at any rate by the late fifties Poussin was too feeble to use the theatre at all, and probably made his drawings straight out of his head, struggling almost all the time to control his shaking hand.

The result is often a scribble of which many details are almost unintelligible, but the trembling of his hand did not prevent Poussin from conveying the mood of the subject, the strange apprehension of the nymphs in Plate 100, the pastoral gaiety of Plate 109 with its butting goats, naiads and peeping satyrs, and above all the grand philosophical calm of Plate 101 which has much of the poetry of the painting itself, Poussin's last work.

Poussin was not one of the great 'ideal' draughtsmen, like Michelangelo, who created a new concept of the beauty of the human body in his drawings; he did not have Rembrandt's supreme gift of rendering in line the subtleties of a dramatic or psychological situation; he did not have Degas's skill in seizing a particular movement; he was not a brilliant draughtsman like Giambattista Tiepolo or Stefano della Bella. His virtues are more modest. He sought and attained the power to put down on paper exactly what he needed to record for his particular purpose, that is to say the working out of a composition. His drawings have the economy, the integrity, the lack of showing off, the concentration on the essentials of the problem in hand which are also characteristic of his paintings. The pursuit of brilliance, the desire to create an effect, to catch the eye of the spectator with a clever touch — these are tendencies which he did not consciously put aside; they would simply not have occurred to him, and if anyone had pointed to them in the work of another artist he would have dismissed them as trivialities.

And yet these negative virtues cannot account for the greatness of some of the drawings. Poussin drew, as he painted, according to the laws of Reason, but for him, as for the Stoic philosophers whom he so deeply admired and studied, Reason was a creative faculty which included many of the attributes which we associate with the imagination. The *Death of Virginia* (Plate 32), the first *Sacraments* drawings, the *Europa* (Plate 87), the *Birth of Bacchus* (Plate 95) may be reasonable, but they are also poetical. The first group have a kind of open imaginative quality, like the paintings of the thirties and forties, the second a sophisticated, philosophical tone which appealed to a more restricted audience. The size of his audience however would not have worried Poussin. After his very first years he almost deliberately avoided public fame and worked more and more for the few friends who really appreciated his art. When one of the pictures which he had sent to his friend and patron Chantelou had been criticised by Parisian 'experts', he wrote, somewhat testily, that he expected and despised such ignorant criticism and added: 'je ferei tous mes effort pour satisfere à l'art à vous et à moi'.[7] His drawings are to be treated in the same spirit; they are not for public exhibition, they are for holding in the hand and enjoying in the privacy of the study; but looked at in this way they give very deep satisfaction.

Notes

NOTE TO PREFACE

1. The catalogue is still available, the first three volumes in a reprint by Kraus-Thomson, the fourth and fifth in the original edition.

NOTES TO CHAPTER I

1. G.P. Bellori, *Le Vite, de'pittori, scultori et architetti moderni...* (Rome, 1672), p. 437.
2. P.-J. Mariette, *Description sommaire des desseins des grands maistres...du cabinet de feu M. Crozat* (Paris, 1741), p. 114.

The original text is as follows:

L'on a un très-petit nombre de Desseins finis du Poussin. Quand il dessinoit, il ne songeoit qu'a fixer ses idées, qui partoient avec tant d'abondance, que le même sujet lui fournissoit sur le champ une infinité de pensées differentes. Un simple trait, quelquefois accompagné de quelques coups de lavis, lui suffisoit pour exprimer avec netteté, ce que son imagination avoit conçû. Il ne recherchoit alors ni la justesse du trait, ni la verité des expressions, ni l'effet du clair-obscur. C'étoit le pinceau à la main qu'il étudioit sur la toile ces differentes parties de son tableau. Il étoit dans la persuasion, que toute autre méthode n'étoit propre qu'à rallentir le génie, et à rendre l'ouvrage languissant. Son raisonnement étoit bon pour de petits tableaux, et le Poussin en a fait très-peu de grands; mais si l'on ne voit point de ses Académies, ni d'Etudes de têtes et autres parties en grand, il ne faut pas en conclure qu'il méprisât l'Etude de la Nature. Personne, au contraire, ne l'a consulté plus souvent, l'on ne peut même lui reprocher d'avoir jamais rien fait de pratique: c'est pourquoi il suivoit par rapport au Païsage, une méthode differente de celle qu'il tenoit pour la figure. L'indispensable nécessité d'aller étudier sur le lieu le modéle, lui a fait dessiner un grand nombre de Païsages d'après Nature avec un soin infini. Non-seulement il devenoit alors religieux observateur des formes; mais il avoit encore une attention extrême à saisir des effets piquans de lumiere, dont il faisoit une application heureuse dans ses tableaux. Muni de ces Etudes, il composoit ensuite dans son Cabinet ces beaux Païsages, où le spectateur se croit transporté dans l'ancienne Grece, et dans ces Vallées enchantées décrites par les Poëtes. Car le génie de M. Poussin étoit tout poëtique. Les sujets les plus simples et les plus steriles, devenoient entre ses mains, interressans. Dans les derniers jours de sa vie, qu'une main tremblante et appesantie lui refusoit le service, le feu de son imagination n'étoit point encore éteint, cet habile Peintre mettoit au jour des idées magnifiques, qui saisissent d'admiration, en même-tems qu'elles causent une sorte de peine de les voir si mal exécutées.

Mariette's statement that Poussin never made 'Académies', that is to say studies from the nude model is contrary to what Bellori tells us (see below, p. 15). Dezallier d'Argenville in his *Abrégé de la vie des plus fameux peintres,* published in Paris in 1745 (II, p. 253), elaborates Mariette's statement and adds one or two details. He notes, for instance, that Poussin sometimes draws a head as a simple oval without features (see Plate 30), and in connection with his technique he notes that he sometimes draws the outline in black pencil (*mine de plomb*) and adds wash, without

any drawing with the pen (see below, p. 91). He describes the washes as in *encre de Chine*, but Poussin in fact seems always to have used a rather pale brown ink, probably bistre. He also states that he sometimes made drawings 'tout à la plume sur du papier bistré avec des hachures légères et croisées', but this description does not correspond to any drawings known to us.

3. P.H. Gault de Saint-Germain, *Vie de Nicolas Poussin* (Paris, 1806). The original text is as follows:

Une des particularités de l'esprit de ce grand homme, quand on examine ses esquisses et ses projets, c'est que rarement on peut y suivre la succession de ses idées: on n'y voit point de traits inconstants, ni de ces variations du génie qui essaie, tâtonne, ou mûrit ses pensées à l'aide de l'art; ce qui prouve que son imagination n'étoit jamais séduite par des idées fortuites: penseur profond, il n'arrivoit sous son crayon que des méditations ornées de toutes les fleurs de la rhétorique, des actions grandes, élevées, convenables à son sujet, et toujours comme la nature pouvoit les produire.

4. Single drawings are reproduced by lithography in A. Strixman and F. Piloty, *Choix de dessins...tiré des musées de S.M. le Roi de Bavière* (Munich, 1808-15) and Vivant Denon, *Monuments des arts du dessin* (Paris, 1829).

5. B. Woodward and H. Triqueti, 'Catalogue of Drawings by Nicolas Poussin in the Royal Collection, Windsor Castle', *Fine Arts Quarterly Review,* I, 1863, pp. 263ff; II, 1864, pp. 175ff; III, 1864-5, pp. 105ff.

6. For details see the Bibliography, p.200.

7. For the story of the genesis and completion of this catalogue see my introduction to the fifth volume.

8. The most important were the general volume by Martine and Marotte (1921) and three dealing with individual groups: Malo on those at Chantilly (1933),

Rouchès on those in the Louvre (1939) and Wengström and Hoppe on those in Stockholm (1935).

9. Several of these were of fundamental importance. Jane Costello cleared up many of the problems which surrounded the early drawings made for the poet Marino; Käte Steinitz investigated the illustration to Leonardo's *Trattato* (1958 and 1960); T. Kamenskaya published unknown drawings in the Hermitage (1956, 1967, 1969); Georg Kauffmann analysed the preparatory drawings for the *Holy Family on the Steps* and discussed a puzzling volume of proportion drawings in the Ecole des Beaux-Arts (1960); Richard Cocke convincingly attributed to P.F. Mola a group of drawings traditionally ascribed to Poussin (1969). For details, see the Bibliography.

10. The question of his relation to Rubens is puzzling. Some at least of the Marie de Médicis cycle had arrived in Paris before he left the city at the end of 1623, but he does not seem to have been influenced by them. On the other hand Pierre Rosenberg has recently pointed out that he appears to have used a group from one of Rubens's tapestry cartoons in his *Germanicus,* painted in 1627 (see *La Mort de Germanicus de Poussin,* Les Dossiers du département des peintures, series 7 (Paris, 1973), p. 10).

11. These drawings are now at Windsor (see C. Vermeule, 'The Dal Pozzo-Albani Drawings of Classical Antiquities', *Art Bulletin,* XXXVIII, 1956, pp. 31ff). For their influence on Poussin see below, Chapter V.

NOTES TO CHAPTER II

1. Except a small sketch for one of the figure groups, now in the Louvre (see C.R. V, p. 126, No. 458).

2. The full text is as follows:
 Disegni diversi di monsieur Poussin

Un libro di disegni fatti da monsieur Poussin, cioe dal antico, da Raffaelle, et da Giulio Romano et d'altri, per suo studio, che contiene nel numero di fogli 160, alcuni disegnati da tutti due le bande; 200 doppie.

Un altro libro del sudetto, di diversi pensieri disegnati della sua inventione, che contiene fogli 160, alcuni disegnati dalle due bande; 200 doppie.

Alcuni disegni di paesi, numero 50, di animali, numero 20, con alcune teste, numero 70. 50 doppie

(*Archives de l'art français,* VI, 1858-60, pp. 251ff).

The last sentence is slightly ambiguous, but it seems to mean that there were a few drawings of heads among those of animals.

3. One drawing at Windsor (Plate 110) of a woman seated on her doorstep must, I feel, have been made from nature, but it appears to be unique.

4. See below, pp. 127, 137-9.

5. For a discussion of the history of this volume of drawings see A. Blunt, 'The Massimi Collection of Poussin Drawings in the Royal Library at Windsor Castle', *Master Drawings,* XIV, 1976, pp. 3ff.

6. For a discussion of this volume see A. Blunt, *The French Drawings...at Windsor Castle* (London, 1945), p. 33. Although the volume contains a few of Poussin's finest drawings, such as the *Death of Virginia* (Plate 32) and *Moses striking the Rock* (Plate 136) the general level of the series is much lower than the Massimi collection and the drawings include a large number of studio drawings, particularly from the time of the Paris visit.

7. See C.R. IV, pp. 34, 43.

8. See below, p. 155.

9. For the history of the Jabach collections see Rosaline Bacou's preface to the catalogue of the exhibition *Collections de Louis XIV,* Paris, 1978, pp. 10ff, and the same author's 'Everhard Jabach. Dessins de la seconde collection', *Revue de l'art,* 40-41, 1978, pp. 141ff.

10. Claudine Bouzonnet-Stella's inventory is printed in the *Archives de l'Art français,* 1877, pp.1ff. The drawings by Poussin are mentioned on pp. 49, 51, 58. In C.R. IV (p. 34) it was argued that the Drawing in the Louvre (C.R. 271) is the one of five trees mentioned in the inventory, but in fact an equally good claimant is the drawing formerly in Uppsala (Plate 144). Many of the drawings by Jacques Stella himself in the possession of his niece were bequeathed by her to a cousin Michel de Masso, who passed them off with some success as works by Poussin (see A. Blunt, 'Jacques Stella, the de Masso Family and Falsifications of Poussin', *Burlington Magazine,* CXVI, 1974, pp. 745ff).

11. One group of these drawings has been convincingly attributed to Pier Francesco Mola (see R. Cocke, 'A Note on Mola and Poussin', *Burlington Magazine,* CXI, 1969, pp. 712ff).

12. See C.R. IV, pp. 36ff, and V, pp. 123ff.

13. It is tempting to think that von Vries or Lagoy might have owned the whole volume of drawings after the Antique mentioned by Dughet in 1678, but Crozat owned fifty-five such drawings, and he is known to have acquired drawings which belonged to Dughet.

14. The whole group was published by H. Malo in *Chantilly, Musée Condé, Cent-deux dessins de Nicolas Poussin* (Paris [1933]), but of those listed and reproduced less than half are accepted by modern scholars.

NOTES TO CHAPTER III

1. C.R. I, p. 33, No. 62; III, p. 24, No. 188; V, pp. 90, 106.

2. The Ovidian subjects are C.R. III, pp. 9ff, Nos. 154-64 and the battles C.R. II, pp. 7ff, Nos. 110-13. Jane Costello has shown that the battle scenes form part of the series and

were normally included in illustrated editions of Ovid in the sixteenth century (see J. Costello, 'Poussin's Drawings for Marino and the New Classicism', *Journal of the Warburg and Courtauld Institutes,* XVIII, 1955, pp. 296ff).

3. This perhaps confirms the hypothesis that the drawings were not based on the original text of Ovid but on a free translation, probably by Marino himself. Such a hypothesis would fit with Bellori's statement that the drawings made for Marino illustrated 'le sue proprie poesie, e quelle particolarmente di Adone', though none of the known drawings seems to illustrate any part of the *Adone*.

4. To this early group should be added a drawing of a bride accompanied by a girl and two putti (C.R. V, p. 115, No. 444), perhaps connected with a *Nova Nupta*.

5. For the Lebel drawing see Blunt, 'Newly identified Drawings by Poussin and his Followers', *Master Drawings,* XII, 1974 p. 239. The Chantilly drawing is so unlike most of Poussin's drawings of this date that when I published the second volume of the *Catalogue Raisonné* I suggested that it must be for a second lost or unexecuted version of the subject. I am now convinced, however, that this is not the case.

6. I now think it possible that the Ambrosiana drawing (C.R. 409a) may be a copy, perhaps, in view of the inscription, by Ciro Ferri.

7. A further drawing in the same vigorous style is the study in the Fitzwilliam Museum, Cambridge, for the *Bacchus and Erigone* in Stockholm (C.R. III, p. 22, No. 184) which has on the *verso* sketches in red chalk for the *Massacre of the Innocents* and the *Kingdom of Flora*.

8. A drawing exists at Windsor for the *Kingdom of Flora* of 1630-1 (C.R. III, p. 35, No. 214), but its style suggests that it was made earlier, probably about 1626-7.

9. In the first volume of the *Catalogue Raisonné* the drawing was rejected, I now think, wrongly, as not being connected with Poussin (see I, p. 17 and V, p. 69, No. 389). The possibility must, however, be borne in mind that the drawing may be an old copy. For the dating of the painting see C.C. 32.

10. The *Mars and Venus* is C.R. III, p. 30, No. 206; for the painting now in Boston see C.C. 183. The *Putti* is C.R. III, p. 44, No. 232, and the painting based on it of which only a fragment survives is C.C. No. 194 (Michael Kroyer Collection, London).

11. C.R. III, p. 30, No. 207. The following drawings seem also to belong to this group: *Jupiter and Antiope* (Paris, Ecole des Beaux-Arts, C.R. III, p. 15, No. 170), *Apollo and Daphne* (Chantilly, C.R. III, p. 17, No. 171), *Theseus deserting Ariadne* (Uffizi, C.R. V, p. 113, No. 443a), *Acis and Galatea* (Chantilly, C.R. III, p. 37, No. 215), *A Nymph mounting on a Goat* (Albertina, C.R. III, p. 44, No. 230), *Abraham driving out Hagar* (Windsor, C.R. I, p. 3, No. B.3; V, p. 63, wrongly rejected in C.R. I), the *Assumption* (Uffizi, C.R. V, p. 82, No. 406) and a battle scene recently discovered in Berlin (C.R. V, p. 69, No. 389). Two drawings of mythological subjects — *Cephalus and Aurora* (C.R. V, p. 111, No. A180) and *Apollo and Clytie* (C.R. V, p. 105, No. A176) — are probably copies after originals belonging to this group.

12. Other drawings which belong to this group include four studies for the first series of *Sacraments: Extreme Unction* (Giraudoux Collection, C.R. 102), two drawings on the *recto* and *verso* of the same sheet for *Ordination* (Schilling Collection, C.R. 413); *Marriage* (Windsor, C.R. 90). A drawing of *Christ in the House of Simon* (C.R. B 20; wrongly rejected in volume I of the *Catalogue Raisonné*) may be a first idea for *Penance*. To these can be added the *Roger and Bradamante* (Private Collection,

C.R. 428), *Apollo and Daphne* (C.R. 173), *Allegory of Justice* (C.R. 430), the *Lamentation over the dead Christ* (Metropolitan Museum, C.R. 401).

13. On stylistic grounds three drawings for *Moses and the Daughters of Jethro* (C.R. 11, 12, A3) can be assigned to this period. Further two drawings of the *Baptism* (C.R. 75-6) must date from just before the visit to Paris since they are preparations for the painting belonging to the first series of *Sacraments* which was begun in Rome and taken by the artist to Paris in 1640 and finished there in 1642.

14. *Correspondance de Nicolas Poussin*, ed. Jouanny (Paris, 1911), pp. 182ff.

15. C.R. 272. Indeed the drawing has always been regarded as representing a site in the Campagna — partly on account of the Papal arms — but Mlle. Rosaline Bacou has pointed out that it is in fact a fairly accurate view of Villeneuve. The arch seems to have been demolished.

16. Three drawings (C.R. 281-3) are direct preparations for the National Gallery *Landscape with a Man killed by a Snake* of 1648.

17. See below, p.174.

18. The drawing of Autumn in the Pierpont-Morgan library (C.R. A 143) is probably a copy after a lost original.

19. The only exception is the drawings for the Richelieu *Bacchanals* where he seems to have hesitated — but only for a moment — about the precise themes which he was going to illustrate.

20. According to the inscription on the drawing it should date from 1629-30, and though I used to think that this was too early a dating I now believe it to be correct. The date 1665 given for this drawing in my abridged edition of Poussin's letters (Paris, 1964, p. 19) is due to the publisher who inserted the plate and the caption without my knowledge.

21. E.g. C.R. 183, 214, 224. Poussin uses the same technique in one much later drawing, the *Sacrifice of Polyxena* (C.R. 107).

22. It is perhaps worth noting that a drawing of a birth scene in Venice (C.R. III, p. 47, B. 27) which is in some respects like Poussin's red chalk drawings can be fairly confidently ascribed to Jacques Blanchard on account of its similarity to a study in a private collection for this artist's *Charity* in the Lee Collection of the Courtauld Institute, signed and dated 1636.

23. Two drawings in black chalk only are known from the twenties — a study for the *Golden Calf* of 1626 (C.R. 22) and a drawing of the *Victory of Godfrey de Bouillon* (C.R. 148) on the *verso* of an elaborate pen and wash drawing of the same subject, but in both these cases the chalk line is so faint that Poussin must have intended to go over it later in ink.

24. The painting has recently been acquired by the Galleria Nazionale d'Arte Antica, Rome.

NOTES TO CHAPTER IV

1. See Bellori, *Vite*, pp. 437ff, J. von Sandrart, *Teutsche Academie der... Künste* (Nuremberg, 1675-9), ed. A.R. Peltzer (Munich, 1925), p. 258 and Leblond de la Tour, *Lettre à un de ses amis touchant la peinture,* (Bordeaux, 1669).

2. The use of wax-models was not unknown before Poussin's time, and Tintoretto, Barocci and El Greco are recorded as using them (see J. Schlosser, 'Aus der Bildnerwerkstatt der Renaissance', *Jahrbuch der kunsthistorischen Sammlungen des allerhöchsten Kaiserhauses,* XXXI, 1913, pp. 111ff), but the idea of the stage seems to have been Poussin's own invention.

3. See C.C. No. 33.

4. It is possible that Poussin may have used lay-figures at some stage in working out the design of his paintings, but none of the early biographers mentions the fact. Lay-figures were used by a number of sixteenth-

century artists, including Dürer, Fra Bartolomeo and Raphael.

NOTES TO CHAPTER V

1. In volume V of the *Catalogue Raisonné* I have tried to separate what I believe to be the grain from the chaff, with the result that I listed eighty drawings as originals. To these I added a few more, some originals, some copies in 'Newly identified Drawings by Poussin and his followers', *Master Drawings*, XII, 1974, pp. 339ff, and four others will be added in a forthcoming article in the same journal.

2. For a discussion of the Pozzo drawings see Cornelius Vermeule III, 'The Dal Pozzo-Albani Drawings of Classical Antiquities', *Art Bulletin*, XXXVIII, 1956, pp. 31ff; 'Aspects of Scientific Archaeology in the Seventeenth Century, *Proceedings of the American Philosophical Society,* CII (2), 1958, pp. 193ff; 'The Dal Pozzo-Albani Drawings of Classical Antiquities in the British Museum', *Transactions of the American Philosophical Society*, N.S., L (5), 1960, pp. 3ff. Vermeule is only concerned with the archaeological aspects of the drawings not with their attribution. In my *Supplements to the Catalogues of Italian and French Drawings* (at Windsor) pp. 121ff, I set out the arguments in favour of ascribing the greater number of the drawings to Testa. E. Berckenhagen (*Die französischen Zeichnungen der Kunstbibliothek Berlin* (Berlin, 1970), p. 290, OZ 114, 4946) catalogues a series of 104 drawings after details of ancient architecture which according to an old inscription were bought in Rome by Clérisseau as coming from 'la collection faite par le Poussin' and as having been made in 1540. In spite of the fact that they are all inscribed in Italian Berckenhagen ascribes them to Etienne Dupérac. If the date 1540 is correct, however, the attribution cannot be

maintained, as Dupérac did not go to Rome till about 1559.

3. This is Windsor 11880 (Blunt, *French Drawings*, No. 272; but see also *Supplements*, p. 216).

4. Bellori (*Vite*, p. 412) states that Poussin made these measured drawings with his friend François Duquesnoy during his first years in Rome, but Félibien (II, p. 317) states that according to Jean Dughet he made them in collaboration with Algardi, and adds that those published by Bellori were not made by Poussin but by Charles Errard. In one of the *Conférences* given at the Academy in 1667 Sébastien Bourdon describes a method of measuring statues which he had discussed with Poussin while he was in Rome in 1634-7 and which had received the approbation of the latter. He passed on the system to his pupil Pierre Mosnier who also discussed it with Poussin when he himself went to Rome in 1664 (see H. Jouin, *Conférences de l'académie royale de peinture et de sculpture* (Paris, 1883), p. 139). This shows that throughout his life Poussin was interested in the question of measuring ancient statues.

5. For a drawing at Chantilly after the sarcophagus, which is probably a copy after a lost original by Poussin, see Blunt, *Master Drawings,* XII, 1974, Pl. 12.

6. The sarcophagus now in Munich was in Poussin's time in the Palazzo Accoramboni in Rome (cf. C.R. V, p. 39, No. 340).

7. This characteristic comes out very clearly if the genuine drawings are compared with one in the Musée Fabre at Montpellier (C.R. V, p. 52, No. B 42) wrongly ascribed to Poussin.

8. For a discussion of Poussin's use of Palladio, see Blunt, *Nicolas Poussin,* pp. 235ff.

9. Poussin used the Italian edition of 1632, not the Latin edition of 1651. For details about the sources of these drawings see C.R. V, pp. 46f.

10. The drawing, now in the Woodner Collection, New York, is reproduced in Blunt, *Master Drawings*, XII, 1974, Pl. 3.

11. The fact that many of these drawings were made after the engravings in the *Galleria Giustiniani* of which the first volume appeared in 1637 and the second a few years later might suggest that the drawings must date from the very last years of the thirties at the earliest, but this is not necessarily so, because the draughtsmen and engravers involved, who included Sandrart and Duquesnoy, were friends of Poussin and he would have had access to their drawings and engravings before the publication of the volumes.

NOTES TO CHAPTER VI

1. A. Félibien, *Entretiens sur les...peintres anciens et modernes* (Paris, 1685-8), I, Preface.

2. I for a time believed that the *Landscape with a Storm*, now in Rouen, was painted by both artists, but I have now been convinced by the arguments of Clovis Whitfield and others that it is a damaged original entirely by Nicolas (see Blunt, 'Landscape by Gaspard, Figures by Nicolas', *Burlington Magazine*, CXVII, 1975, pp. 607ff, and Whitfield, 'Nicolas Poussin's "Orage" and "Temps Calme"', *Burlington Magazine,* CXIX, 1977, pp. 4ff).

3. See below, p. 174.

4. C.R. 182. For Pierre Lemaire, see below, p. 159. Dezallier d'Argenville states in the *Supplément à l'abrégé de la vie des plus fameux peintres* published in 1754 (p. 295) that Poussin employed Jean-Pierre Rivalz, father of Antoine, 'à peindre les fonds de ses tableaux', but it is significant that in the second edition of 1762 (IV, p. 352) he adds the words 'à ce qu'on dit'. There is no confirmation of Dezallier's statement in other sources and it may safely be ignored.

5. In addition to the two Lemaire brothers Poussin also had Remy Vuibert as an assistant for his work during the visit to Paris.

6. In addition there are later copies among these drawings, some in reverse and therefore presumably after the engravings.

7. *Correspondance*, p. 86.

8. *Ibid.*, pp. 64, 80.

9. For a discussion of these drawings see C.R. IV, pp. 26ff, and K. Steinitz, *Leonardo da Vinci's Trattato della Pittura,* (Copenhagen, 1958). Drawings also exist made after the engravings in the French and Italian editions of 1650.

10. The Orléans drawing was shown at the exhibition *The Age of Louis XIV* (R.A. 1958, No. 272) and I was able to compare the two drawings side by side.

11. *Correspondance,* pp. 165f.

12. The drawing for the title page to Horace (C.R. II, p. 26, A 43) is in black chalk and therefore difficult to compare.

13. Three drawings at Windsor, all by the same studio hand, present a difficult problem. Two of them, the *Kingdom of Flora* (C.R. III, p. 35, A 58) and the *Origin of Coral* (Plate 177) are fair copies of originals also at Windsor which belonged to Cardinal Massimi (C.R. III, p. 35, No. 214, and p. 41, No. 224). For the third, *Le Tintura della Rosa* (C.R. III, p. 31, A 51) no original is known, but it clearly belongs to the series. The two surviving originals were certainly made between 1624 and 1630 (the painting of *Flora* is datable 1631; C.C. No. 155) and it seems obvious to suggest that the fair copies were made in Poussin's studio at that time; but Poussin did not have a studio in the 1620s, and the only solution seems to be that at a later period some patron saw the original drawings, which are very rough, and asked for finished versions to be made. The drawings are not exactly like those just discussed in style but they have features in common with the *Armida* and they might represent

the early stage of the student's style, in the years just before 1637.

14. *Correspondance*, pp. 477.

15. A drawing of Mercury and Argus in the Albertina (11753) has a traditional attribution to Pierre Lemaire. It has something of the same thin hesitant line as the drawings discussed here, but the fact that it is an architectural composition — in the manner of Jean — makes any exact comparison difficult. Moreover it is not known on what evidence the attribution is based or when it was made.

16. These drawings are discussed by the present writer in *Master Drawings*, XII, p. 1974, p. 244.

17. For the arguments against its authenticity see Rosenberg's catalogue of the exhibition of the *Germanicus* in the Louvre and my review of the exhibition (*Burlington Magazine*, CXV, 1973, p. 533).

18. See, for instance, C. Ponsonailhe, *Sébastien Bourdon* (Paris, 1883), pp. 22ff.

19. See the latest edition of the catalogue of the French paintings in the Pinakothek.

20. None of Dufresnoy's early biographers records that he knew Poussin, but given his devotion to the classical ideal which he expounds in his Latin poem *De arte graphica* (published in 1667, after his death) it is hard to believe that they were not in contact.

21. In the third volume of the *Catalogue Raisonné* (p. 33, B 24) I suggested that the drawing was either a copy of a lost original by Poussin or a work of an imitator, more probably the latter. Now I feel convinced that it is a copy of a lost original dating from the late twenties. It certainly has nothing in common with the style of Dufresnoy.

22. Tacitus (*Ann.*, XII, 51) tells us that while escaping with her husband from a rebellion Zenobia was seized with the pangs of childbirth. She begged Rhadamistus to kill her, but he failed, leaving her wounded by the river Araxes where she was found by

shepherds and saved. The Dufourny version is reproduced in C.R. II, Pl. 15, opposite p. 4, but it is there wrongly said to be the Hermitage picture. In C.R. II, No. A 35 (Plate 185 here) is wrongly described as probably a copy.

23. The painting by Vouet is reproduced in the second *Cahier de la Société Poussin*, 1948, p. 90.

24. See p. 91.

25. These drawings include two of triumphs at Besançon (D2673-4), one at Darmstadt (2554 *recto* and *verso*) probably representing Rinaldo and Armida and one formerly belonging to Edmund Schilling showing a soldier submitting to an imperator. The Besançon drawings seem to be connected with a painting of a triumph in the Prado (2278) which has been tentatively ascribed by Demonts to Henri Testelin but which might well be by Dufresnoy.

26. The owner believes it to be by Poussin himself, and it has therefore not been possible to reproduce it here.

27. The story of the *Saving of Pyrrhus* had been painted (and drawn) by Poussin in the 1630s (see above p. 41 and Plate 33).

28. Sold at Christie's, 2 December 1969, lot 302, under a different title.

29. Chantelou may possibly have had this copy made because he owned another — original — drawing for the same composition (C.R. 46).

 Another early collector to own copies of Poussin's drawings was Laurent le Tessier de Montarsy who was collecting about 1670 (see E. Bonnaffé, *Dictionnaire des amateurs français au XVIIe siècle* (Paris, 1884), p. 223), and whose name appears on a number of drawings after the Antique (e.g. C.R. A 153). These copies are dry and factual and were certainly not intended to deceive or even to imitate the character of the originals.

30. Other pairs of early drawings and copies exist but the copies are much feebler and

more easily detected than in the cases discussed above. The British Museum has a drawing of *Theseus abandoning Ariadne* (C.R. A 67) which was recognized and catalogued as a copy before the original was identified in the Uffizi (C.R. 443a).

The quality of these copies of early drawings by Poussin is so good that it is tempting to suggest that he might have made them himself. It is not inconceivable that in his early days in Rome he should have copied his own works in this way — though later, as we know from the correspondence about the second series of *Sacraments* such a practice would have been abhorrent to him — but it cannot be imagined that he would have made a copy of a drawing already damaged and cut down, as was the *Diana hunting*. We must therefore suppose that there were copyists active in Rome, probably during Poussin's lifetime, sufficiently skilful to produce these almost facsimile drawings.

31. The most important are as follows: *Moses and the Daughters of Jethro* (Valence, C.R. 15); the *Crossing of the Red Sea* (Albertina, C.R. 19); *Moses striking the Rock* (Louvre, C.R. 25); *Baptism* (Albertina, C.R. 81); *Holy Family* (Hermitage, C.R. A 9, and Louvre, C.R. A 10); *Crucifixion* (Uffizi, C.R. 399).

NOTES TO CHAPTER VII

1. Sometimes he uses the form *penser* or *pensement*.
2. *Correspondance*, p. 77.
3. *Ibid.*, p. 81.
4. It might be supposed that *squizze* referred to an oil sketch or *modello* but Poussin never uses it in this sense, and in any case the composition in question was a preparatory drawing for an engraving, not for a painting.
5. *Correspondance*, p. 376.
6. One drawing by Poussin, the *Victory of Godfrey de Bouillon* (C.R. 147) at Windsor, seems even to have been made as a direct answer to Cortona's *Victory of Constantine*, painted for Marcello Sacchetti and now in the Capitoline Museum. Each artist was giving his solution to the problem which Raphael and his studio had faced in the battle scene of the Sala di Costantino.
7. *Correspondance*, p. 354.

Bibliography

The following two works are referred to in abbreviated form:

C.R.: W. Friedlaender and A. Blunt, *The Drawings of Nicolas Poussin,* London, 1939-74.

C.C.: A. Blunt, *The Paintings of Nicolas Poussin, A Critical Catalogue,* London, 1966.

The following list includes books referred to in the text and others which can usefully be consulted in connection with Poussin's drawings. A more complete bibliography is given in C.R. V, pp. 13ff.

Andresen, A., *Nicolaus Poussin, Verzeichniss der nach seinen Gemälden gefertigten gleichzeitigen und späteren Kupferstiche*, Leipzig, 1863.
 Abridged and illustrated French translation by Georges Wildenstein, *Gazette des Beaux-Arts*, 1962, II, pp. 139ff.

Bacou, R., *Le Cabinet d'un grand amateur. P.-J. Mariette* (Louvre) Paris, 1967.

Bacou, R. *Collections de Louis XIV* (exhibition catalogue). Paris, 1978.

Bacou, R. "Everhard Jabach. Dessins de la second collection", *Revue de l'art*, 40-1, 1978, pp. 141ff.

Badt, K., *Die Kunst des Nicolas Poussin*, Cologne, 1969.

Baldinucci, F. *Notizie de' professori del disegno da Cimabue in qua...* , Florence, 1681-1728.

Barberino, F., *Documenti d'Amore*, Rome, 1640.

Bartoli, Pietro Santi, *Colonna Traiana... scolpita con l'historia della Guerra Dacica... Nuovamente disegnata et intagliata da Santi Bartoli, con l'espositione latina d'A. Ciaccone...* , Rome, n.d. [1673].

Bartoli, Pietro Santi, *Admiranda romanarum antiquitatum, ac veteris sculpturae vestigia...a Petro Sancto Bartolo delineata incisa...cum notis Io. Petri Bellorii illustrata*, Rome, 1693.

Bellori, G.P., *Le Vite de' pittori, scultori et architetti moderni...* , Rome, 1672.

Bellori, G.P., *Veteres arcus Augustorum triumphis insignes...nunc primum per J.-J. de Rubeis aereis typis vulgati,* Rome, 1690.

Bjurström, P., 'A Landscape Drawing by Poussin in the Uppsala University Library', *Master Drawings*, III, 1965, pp. 264f.

Bjurström, P., *National Museum Stockholm. French Drawings. Sixteenth and Seventeenth Centuries*, Stockholm, 1976.

Blunt, A., *The French Drawings...at Windsor Castle*, London, 1945.

Blunt, A., 'Poussin Studies VI: Poussin's decoration of the Long Gallery in the Louvre', *Burlington Magazine*, XCIII, 1951, pp. 369ff.

Blunt, A., 'Poussin et les cérémonies religieuses antiques', *Revue des Arts*, X, 1960, pp. 56ff.

Blunt, A., 'Poussin Studies XIV: Poussin's *Crucifixion*', *Burlington Magazine*, CVI, 1964, pp. 450ff.

Blunt, A., 'Poussin and Aesop', *Journal of the Warburg and Courtauld Institutes*, XXIX, 1966, pp. 436ff.

Blunt, A., *Nicolas Poussin* (The A.W. Mellon Lectures), London and New York, 1967.

Blunt, A., 'Newly identified Drawings by Poussin and his Followers', *Master Drawings*, XII, 1974, pp. 239ff.

Blunt, A., 'The Massimi Collection of Poussin Drawings in the Royal Library at Windsor Castle', *Master Drawings,* XIV, 1976, pp. 3ff.

Bonnaffé, E., *Dictionnaire des amateurs français au XVII^e siècle*, Paris, 1884.

Bosio, A., *Roma sotterranea*, Rome, 1632.

Both de Tauzia, Vicomte, *Notice des dessins de la collection His de la Salle exposés au Louvre*, Paris, 1881.

Both de Tauzia, Vicomte, *Dessins...exposés depuis 1879, deuxième notice supplémentaire*, Paris, 1888.

Cartari, V., *Le Imagini de i dei de gli antichi*, Venice, 1587 etc.

Caylus, A.C.P., Comte de, *Recueil de testes de caractère et de charges dessinées par Léonard de Vinci, Florentin*, Paris, 1730.

Chamberlaine, J., *Original Designs of the Most Celebrated Masters of the Bolognese, Roman, Florentine, and Venetian Schools*, London, 1812.

Chennevières-Pointel, C.P., *Recherches sur la vie et les ouvrages de quelques peintres provinciaux de l'ancienne France*, Paris, 1847-62.

Chiarini, M., 'Due mostre e un libro', *Paragone*, XVI, No. 187, 1965, pp. 66ff.

Cocke, R., 'A Note on Mola and Poussin', *Burlington Magazine*, CXI, 1969, pp. 712ff.

Correspondance de Nicolas Poussin, ed. Ch. Jouanny, *Archives de l'art français*, Nouvelle Période, V, 1911.

Costello, J., 'Poussin's Drawings for Marino and the New Classicism, I: Ovid's Metamorphoses', *Journal of the Warburg and Courtauld Institutes*, XVIII, 1955, pp. 296ff.

Delisle, L., 'Dessins, estampes et statues de la succession de Nicolas Poussin', *Archives de l'art français*, XI (Documents VI), 1858-60, pp. 241ff.

Denon, Baron Vivant, *Monuments des arts du dessin recueillis par le Baron Denon*, Paris, 1829.

Du Choul, G., *Discours sur la castramentation et discipline militaire des Romains...Des bains et antiques exercitations grecques et romaines. De la religion des anciens Romains*, Lyons, 1556-7. Italian translation by G. Simeoni, Lyons, 1559.

Félibien, A., *Entretiens sur les vies et sur les ouvrages des plus excellents peintres anciens et modernes,* Paris, 1685-8.

Fréart de Chantelou, P., *Journal du voyage du cavalier Bernin en France,* ed. L. Lalanne, Articles in *Gazette des Beaux-Arts*, 1881-2; reprinted, Paris, 1885. Abridged edition, Paris, 1930.

Friedlaender, W., *Nicolas Poussin. Die Entwicklung seiner Kunst,* Munich, 1914.

Galleria Giustiniana del Marchese Vincenzo Giustiniani, Rome, n.d.

Gault de Saint-Germain, P.H., *Vie de Nicolas Poussin,* Paris, 1806.

Grautoff, O., *Nicolas Poussin. Sein Werk und sein Leben*, Munich and Leipzig, 1914.

Guiffrey, J., 'Testament . . . de Claudine Bouzonnet Stella', *Archives de l'art français,* 1877, pp. 1ff.

Helsdingen, H.W. van, 'Notes on Two Sheets of Studies by Nicolas Poussin for the Long Gallery of the Louvre', *Simiolus,* V, 1971, pp. 172ff.

Jouanny, Ch., 'Correspondance de Nicolas Poussin', *Archives de l'art français*, Nouvelle Période, V, 1911.

Kamenskaya, T., 'K voprosu o rukopisi "Traktata o zivopisi" Leonardo da Vinci i jeje illustrecjach v sobranii Ermitaza, Trudi Gosudarstvennogo Ermitaza I', *Zapadnoevropejskoe iskusstvo*, I, 1956, pp. 49ff. English summary in *Burlington Magazine*, XCIX, 1957, p. 425.

Kamenskaya, T., 'Deux dessins de paysage par Nicolas Poussin au Musée de l'Hermitage', *Hermitage Bulletin*, X, 1956, p. 25.

Kamenskaya, T., 'Some Unpublished Drawings of Poussin and his Studio in the Hermitage', *Master Drawings*, V, 1967, pp. 390ff.

Kamenskaya, T., 'Further remarks on Poussin Drawings in the Hermitage', *Master Drawings*, VII, 1969, pp. 246ff, 425ff.

Kauffmann, G., *Poussin-Studien*, Berlin, 1960.

Kauffmann, G., 'Poussins letztes Werk', *Zeitschrift für Kunstgeschichte*, XXIV, 1961, pp. 112f.

Lugt, F., *Les marques de collections de dessins et d'estampes,* Amsterdam, 1921.

Magne, E., *Nicolas Poussin*, Brussels and Paris, 1914.

Malo, H. *Chantilly, Musée Condé. Cent-deux dessins de Nicolas Poussin*, Paris, [1933].

Mariette, P.-J., *Description sommaire des desseins des Grands Maistres…du Cabinet de feu M. Crozat…*, Paris, 1741.

Martine, C., and Marotte, L., *Dessins de maîtres français, I. Nicolas Poussin, Cinquante reproductions de Léon Marotte avec un catalogue par Charles Martine*, Paris, 1921.

Panofsky, E., 'Poussin's *Apollo and Daphne* in the Louvre', *Bulletin de la Société Poussin*, III, 1950, pp. 27ff.

Perrier, F., *Icones segmenta nobilium signorum et statuarum quae Romae extant*, Rome, 1638.

Reiset, F., *Notice des dessins…au Louvre, II: École française*, Paris, 1869.

Rogers, C., *A Collection of Prints in Imitation of Drawings*, London, 1778.

Rouchès, G., *Musée du Louvre. Collection de reproductions de dessins publiée sous la direction de Gabriel Rouchès, I: Nicolas Poussin*, Paris, 1939.

Sandrart, J. von, *Teutsche Academie der edlen Bau-, Bild- und Mahlerey-Künste*, Nuremberg, 1675-9 (ed. A.R. Peltzer, Munich, 1925).

Steinitz, K., 'Poussin, Illustrator of Leonardo da Vinci and the Problem of Replicas in Poussin's Studio', *Art Quarterly*, XVI, 1953, pp. 40ff.

Steinitz, K., *Leonardo da Vinci's Trattato della Pittura*, Copenhagen, 1958.

Strixman, A., and Piloty, F., *Choix de dessins d'après les grands maîtres…tiré des Musées de Sa Majesté le Roi de Bavière*, Munich, 1808-15.

Sutherland-Harris, A., 'A New Drawing by Nicolas Poussin in Berlin', *Burlington Magazine*, CX, 1968, pp. 89f.

Vermeule, C., 'Aspects of Scientific Archaeology in the Seventeenth Century', *Proceedings of the American Philosophical Society*, CII, 1958, pp. 193ff.

Vermeule, C., 'The Dal Pozzo-Albani Drawings of Classical Antiquities in the British Museum', *Transactions of the American Philosophical Society*, N.S., L, 1960.

Vermeule, C., 'The Dal Pozzo-Albani Drawings of Classical Antiquities', *Art Bulletin,* XXXVIII, 1956, pp. 31ff.

Vermeule, C., 'The Dal Pozzo-Albani Drawings of Classical Antiquities in the Royal Library at Windsor Castle', *Transactions of the American Philosophical Society*, N.S., LVI, 1966, pp. 170ff.

Wengström, G., and Hoppe, R., *Collection de dessins du Musée National Stockholm, II: Nicolas Poussin*, Malmö, 1935.

Wildenstein, G., 'Les graveurs de Poussin au XVIIe siècle', *Gazette des Beaux-Arts*, 1955, II, pp. 73ff (actually published in 1958; also published in 1958 as a separate volume with different pagination).
See also, *Andresen*.

Woodward, B., and Triqueti, H., 'Catalogue of Drawings by Nicolas Poussin in the Royal Collection, Windsor Castle', *Fine Art Quarterly Review*, I, 1863, pp. 263ff; II, 1864, pp. 175ff; III, 1864-5, pp. 105ff.

Index

208